FROM GIRL TO WOMAN

SUNY Series in Feminist Criticism and Theory
Michelle A. Massé, editor

AND

SUNY Series in Postmodern Culture
Joseph Natoli, editor

❖ From Girl to Woman

American Women's Coming-of-Age Narratives

BY Christy Rishoi

STATE UNIVERSITY OF NEW YORK PRESS

Published by
State University of New York Press, Albany

For information, address State University of New York Press,
90 State Street, Suite 700, Albany, NY 12207

Production by Christine L. Hamel
Marketing by Jennifer Giovani

Library of Congress Cataloging in Publication Data

Rishoi, Christy, 1958–
 From girl to woman : American women's coming-of-age narratives / by Christy
Rishoi.
 p. cm. — (SUNY series in feminist criticism and theory) (SUNY series in
postmodern culture)
 Includes bibliographical references (p.) and index.
 ISBN 0-7914-5721-4 (alk. paper) — ISBN 0-7914-5722-2 (pbk.: alk. paper)
 1. Women's studies—United States—Biographical methods. 2. Women—Identity.
3. Social role. 4. Maturation (Psychology) 5. Self-realization. 6. Autobiography—
Women authors. 7. Feminist criticism. I. Title. II. Series. III. Series: SUNY series in
postmodern culture

HQ1186.A9 R57 2003
305.42—dc21 2002030478

10 9 8 7 6 5 4 3 2 1

For Helen Rishoi

In memory of Don Rishoi

and

for Larry—

who makes my heart sing

I never read an autobiography in which the parts devoted to the earlier years were not far the most interesting.

—C. S. Lewis

I feel that I have had a blow; but it is not, as I thought as a child, simply a blow from an enemy hidden behind the cotton wool of daily life; it is a token of some real thing behind appearances; and I make it real by putting it into words. It is only by putting it into words that I make it whole; this wholeness means that it has lost its power to hurt me; it gives me, perhaps because by doing so I take away the pain, a great delight to put the severed parts together.

—Virginia Woolf

Contents

Acknowledgments

Throughout this project, I have enjoyed the collective and individual wisdom of a remarkable group of people. Diane Brunner's dedication to social justice through innovative teaching inspires my own practice, and Joyce Ladenson's consistent support and kindness by way of graduate assistantships, teaching opportunities, publication, and friendship saw me safely through the roughest stretch of my graduate years. To Dean Rehberger, I owe a debt of gratitude for introducing me to a body of theory that finally helped me make sense of my own worldview. Katherine Fishburn has been everything a mentor ought to be: supportive, patient, knowledgeable, and *there*, in every sense of the word. Not incidentally, she restored my faith in English teachers by putting Willa Cather on her syllabus.

My children—Katie, Benjamin, Leah, Brianna, and Kevin—have been as patient and supportive as one could hope children might be, enduring transitions, deadlines, and postponed plans. I'm so glad you're "mine."

And finally, my beloved husband, Larry Juchartz, read and edited my work when I could no longer see it clearly, encouraged me when I wanted to quit, listened while I thought out loud, fed me when I was hungry, rubbed my back when it ached, and played with our children when I could not. As it turns out, quest and romance are quite compatible. Looks like we made it.

1 ❖ Identity and the Coming-of-Age Narrative

> A great deal has been said about the heart of a girl when she stands "where the brook and river meet," but what she feels is negative; more interesting is the heart of a boy when just at the budding dawn of manhood.
>
> —James Weldon Johnson, *The Autobiography of an Ex-Coloured Man*

> Little by little it has become clear to me that every great philosophy has been the confession of its maker, as it were his involuntary and unconscious autobiography.
>
> —Friedrich Nietzsche, *Beyond Good and Evil*

"Read this—you'll love it." With these words, my mother hands me the copy of *Little Women* her aunt gave her when she was twelve and plants a seed that, three decades later, will grow into this study. At age twelve, I am beginning to balk at *everything* my mother suggests, but being constitutionally unable to resist any book, I grudgingly begin to read Louisa May Alcott's novel. And like generations of girls before me, I fall in love with funny, feisty Jo and weep when Beth dies. Like Jo, I try to be good, but I have big dreams that distract me from my daily duties. Jo voices my own secret desires when she tells her sisters that she wants to do "something heroic or wonderful that won't be forgotten when I'm dead. I don't know what, but I'm on the watch for it and mean to astonish you all someday" (172). My mother keeps me steadily supplied with "underground" literature—girls' books—and while I feign disinterest, she is right. I do love these books, all of them: Alcott's sequels to *Little Women*; Anne Frank's diary; *Jane*

Eyre; Willa Cather's complete works. At fourteen, I ask my ninth-grade English teacher if we will be reading Cather, but her face tells me she has never heard of my current favorite. I will have to wait twenty years, until graduate school, before I can talk about Cather in school.

While coming of age, my reading life is thus split between school reading and private reading, but it is women's literature that feeds my soul. It also confuses me. Many of the books my mother gives me glorify goodness, duty, and romance, but in the world outside those books, it is the early 1970s. Everybody says "do your own thing" and "if it feels good, do it." My own mother tells me I should never depend on a man to support me: "Go to college, be self-sufficient, so when you do marry, you won't be financially dependent." I agree wholeheartedly, but I am swept away by the romance in my books, which tell me, like Jo March's mother tells her, that "to be loved and chosen by a good man is the best and sweetest thing that can happen to a woman" (118). I am calling myself a feminist at fourteen, buying *Ms.* magazine, reading *Our Bodies, Ourselves*, and watching the horizon for the appearance of Mr. Rochester.

Nietzsche was right; all writing is autobiographical in some sense, regardless of the explicit subject matter and regardless of whether we call it fact or fiction. We write to extend our love affair with an idea or image, or we write to understand something we have experienced, directly or indirectly. The author of a book on "geek culture" tells a radio interviewer that in his youth he was smart and different, and thus ostracized. His book about the subculture of technologically savvy "geeks" is a recovery effort aimed at rescuing the image of people like himself in mainstream culture.[1] T. S. Eliot certainly wrote in part to prove his worthiness in elite British literary circles with whom he desperately wanted to be associated. Virginia Woolf's anger at her exclusion from membership in that same club is woven into much of her prose.[2] Simone de Beauvoir's massive study, *The Second Sex*, was called into being by its author's knowledge of her own status as Other. And my study is no different.[3] Its origins are in my own coming of age and the confusion I felt about what it means to be a woman. Faced with conflicting narratives of womanhood, none of which are explicitly spelled out, I committed many social blunders but eventually (well into adulthood) reconciled myself to being a walking contradiction. Still, there was—and is—great pressure on all of us to create order out of chaos and to present ourselves coherently. The world wants to know how to interact with us, and it does not know how to address itself to individuals who signal multiple or oppositional identities. The imperative to develop a coherent identity that meshes with society's

dominant ideologies is unspoken, but individuals who transgress cultural norms are quickly brought into line or ostracized. This dynamic reaches critical mass in adolescence, when individuals in the West are tacitly expected to coalesce their identities and complete the journey to a unified selfhood. Given the social pressure to conform, I began to wonder how an individual could find the courage and power to resist culturally sanctioned roles. More specifically, I wanted to understand how girls become women and how they cope with the conflict between their own desires and the social repression of women's desire. Though I came of age as the second-wave women's movement was gaining a foothold in American culture, I did not then believe that these conflicts mattered in any significant sense. Born too late for consciousness-raising groups, and too early to take our equality for granted, women of my generation, race, and class assumed we would go to college and "do" something, but we struggled with conflicting ideologies of femininity. We did not hide our achievement around boys, but we were thought pushy if we took the initiative in dating. We got the culture's messages about free love, but when we acted on them we were sluts. We were expected to excel, but quietly and passively. Worst of all, we did not talk to each other about these issues in the way that women ten years older than us did, as serious discourse about the place of women in Western society remained cloistered in relatively remote (from our adolescent lives) locations. Like our mothers, we did not know that other girls felt the same confusion and discontent that we did, leaving many of us convinced that we were aberrations.

My mother enrolled in college when I was coming of age, and I watched as she transformed into a blue-jean-wearing undergraduate who plunged into the history of American slavery because she had been profoundly moved by the civil rights struggle as it took shape in the late 1940s and 50s, when she was coming of age. Still unable to resist a book, I read much of what she read. *The Autobiography of Malcolm X. Manchild in the Promised Land. Soul on Ice.* I could not have articulated it then, but I was drawn to these texts because they showed me that I was not the only one who felt out of step with my culture. More than that, I learned that there were literally millions of alienated human beings in America who, for a variety of reasons not of their own making, did not flourish in mainstream society. But their stories—and my own—stayed on the sidelines of the American master narrative. The autobiographical texts that form the basis of my argument here thematize the cultural alienation and confusion that continue to resonate for me, leading me to ask how writers are able to overcome the socially determining limits faced by American women.

Stories of resistance and difference have always been in circulation, but they are typically silenced in public discourse because they fail to invoke the universal subject of liberal humanism. In general, narrative knowledge is delegitimated in Western societies when it fails to conform to the empirical knowledge that has been valorized historically by elite white males. Thus, the stories and experiences of everyone else have been suppressed by those who control the terms and conditions of scientific discourses. But as Jean-François Lyotard argues, the rules of empirical knowledge are established in a circular, self-referential fashion, so finally "there is no other proof that the rules are good than the consensus extended to them by the experts" (29). While the knowledge that is disseminated through narration is often dismissed by dominant ideology, for women and other socially marginalized groups traditionally excluded from socially sanctioned forms of learning, narrative has been the primary means of sharing the knowledge that is necessary for survival. Lyotard calls narration the "quintessential form of customary knowledge" in that it inscribes a society's criteria for cultural competence, and allows its members to determine the validity and performance of any given narrative (19–20). By means of narrative and anecdote, for instance, women have shared their unquestionably empirical knowledge of childbirth with each other and subsequent generations, though the validity of that knowing has often been ignored or dismissed in male-sanctioned medical discourse.

In the West, we have privileged the consensus of empirical experts' knowledge at least since the Enlightenment, and this consensus dismisses narrative knowledge as unverifiable and therefore worthless. Lyotard contends that narration helps create and sustain social bonds, unlike scientific knowledge, which is "no longer a direct and shared component of the bond" (25). Certainly, it is more than mere coincidence that groups who rely on narrative to create knowledge have been constructed as primitive or inferior by groups that seek to control knowledge by subjecting it to scientific proofs. Oral cultures and groups, traditionally excluded from elite education, have been subjected to the cultural imperialism of scientists who dismiss narrative knowledge as unverifiable through argumentation or proofs, and therefore not genuine. Such cultures are subsequently classified, according to Lyotard, as different: "savage, primitive, underdeveloped, backward, alienated, composed of opinions, customs, authority, prejudice, ignorance, ideology. Narratives are fables, myths, legends, fit only for women and children. At best, attempts are made to throw some rays of light into this obscurantism, to civilize, educate, develop" (27). Lyotard argues, however, that scientific and nar-

rative knowledges are each judged by a separate set of governing rules, and that the validity of one kind of knowledge cannot be judged by the rules of the other (26). Moreover, Lyotard correctly contends that scientific knowledge cannot prove its superior position as the "true knowledge without resorting to the other, narrative, kind of knowledge, which from its point of view is no knowledge at all" (29). In other words, in addition to presenting the requisite proofs and argumentation, scientific discourse—ironically— necessarily includes narration as it builds a case for its own superiority. Additionally, to qualify as true learning, scientific knowledge must present a coherent narrative without gaps or contradictions that might be construed as false proofs or faulty argumentation, and in this sense, scientific knowledge enjoys a symbiotic relationship with liberal humanist selfhood, which posits a similarly seamless account of the autonomous individual. But, as Lyotard contends, echoing John Donne's 1624 *Devotion*, "no self is an island; each exists in a fabric of relations that is now more complex and mobile than ever before" (15).[4]

Women have always understood identity as complex and interconnected, and we have historically relied on narrative to convey our contradictory, contingent truths and to foster that human connectedness. As Alison Jaggar wryly suggests, women never would have devised the liberal humanist account of identity with its conception of individual autonomy and its valorization of the mind over the body which sanctioned a division of labor that allowed a few elite males to concentrate on mental activity while everyone else attended to the quotidian, physical necessities of everyday life. Furthermore, argues Jaggar, "[i]t is even harder to imagine women developing a political theory that presupposed political solipsism, ignoring human interdependence and especially the long dependence of human young" (46). The story of human connection in Western societies, "the other side of the story" in Molly Hite's phrase, has been told by women and, for most of history, in private. Furthermore, the relatively few women's narratives that did gain public recognition have been viewed as if they were merely a mimetic transfer of the author's life into text (Hite, *Other Side* 13). As Michel Foucault has argued, every member of a society knows the "rules of exclusion"—the production of discourse is at once controlled, selected, organized and redistributed according to a certain number of procedures, whose role is to avert its powers and its dangers, to cope with chance events, to evade its ponderous, awesome materiality" ("Discourse" 216). Because women's discourses were potentially dangerous to the continued dominance of Western liberal ideology, women's narratives and texts have been carefully regulated to allow for

inclusion only those accounts that confirm dominant ideology. The medieval definition of madness exemplifies Foucault's understanding of how exclusionary practices work: "a man was mad if his speech could not be said to form part of the common discourse of men. His words were considered null and void, without truth or significance" (216). We need only substitute the word "woman" for "man" in Foucault's formulation to find a profound description of the place of women in Western culture, for while a madman might reverse his exclusion by reinscribing dominant ideology, a woman who shifts course and voices the same discourse is still "just" a woman. Her discourse can never be that of the "common discourse of men." For Foucault, discursive exclusion relies on institutional reinforcement from schools, the publishing industry, and other practices to police its borders and "exercise a sort of pressure, a power of constraint upon other forms of discourse" (219). The exclusion of women's experiences and points of view from public discourses is the direct result of these institutional pressures that have silenced the experiences of women and other marginalized groups. Women's knowledges remained largely underground, dispersed, because they were publicly constructed as insignificant for failing to reflect universal truths. And what was true for women's experiences was, in turn, reflected in social attitudes toward the experience of girls. Nothing in female experience resonated with the common discourse until very recently in history, and so it has been defined as insignificant.

Now, at the dawn of the twenty-first century, we might agree with James Weldon Johnson that a great deal has been said about "the heart of a girl" as she makes the transition into womanhood. We have witnessed nothing short of a revolutionary shift in paradigm about women in American society in the last forty years as nearly every assumption about women has undergone intensive scrutiny, questioning, and reassessment. But in 1912, when *The Autobiography of an Ex-Coloured Man* appeared, the details and meanings of a girl's passage from childhood to womanhood held significance primarily in the circumscribed private domestic sphere inhabited by women. Denigrated for lacking universal values and consigned to the sentimental realm, literary texts focused on girls' coming-of-age issues received scant public or scholarly attention before the final decades of the twentieth century.[5] A great many assumptions lie at the core of this ancient silence; the idea that woman is an uncomplicated being whose life course is dictated by biology and nature has been argued and defended by thinkers from Aristotle to Freud and beyond. Indeed, this is *the* master narrative of womanhood in Western society and it carries the weight and authority of more than two thousand years of philo-

sophical and scientific traditions. Yet in spite of that tradition, the lives of American women have changed more radically in the last forty years than in any other comparable period in history. This sea change became possible because women not only *imagined* a changed social landscape, in Raymond Williams's terms, they also took action to overcome the "determining limits" of white patriarchal capitalist hegemony (86). In Carolyn G. Heilbrun's view, the task of her generation of feminists has been more "to dismantle the past than to imagine the future" (72), but articulation of women's lives under patriarchy could not avoid imagining alternate ways of being.[6] The work of imagination and deep social change has reached every sector of American life where women exist, from the small consciousness-raising groups of the 1960s to organized activist groups to rigorous scholarship in the academy, and while there continues to be vocal, sometimes violent resistance to the increased social and political power women wield, there is little question that feminism has succeeded in changing American culture. To all appearances, *this* women's movement has created lasting social change. Even the most strident enemies of feminism acknowledge by their energetic attacks its far-reaching impact and influence—even acceptance—but I find myself returning again and again to the narrator of *The Autobiography of an Ex-Coloured Man* and his comparison of male and female coming-of-age experiences. It might be easy to dismiss his statement as a typically male view of womanhood, but I wonder if Johnson has in fact articulated what women themselves feel. *Little Women*'s Jo March wants desperately to be a boy because she understands that adventure and power belong to males while women must be content with "working and waiting."[7] But even in the twentieth century, Maxine Hong Kingston writes of her longing to be a boy, that her parents might take pride in her achievements. I can dismiss the first part of Johnson's statement—"A great deal has been said about the heart of a girl when she stands 'where the brook and river meet'"—as the dubious assertion of an earlier age, but it is much more difficult to dismiss what immediately follows in Johnson's text: the narrator's assertion that "what she feels is negative" puzzles and angers me simultaneously. Do most girls feel negatively about becoming women? What is the cause and nature of that negativity? What *does* it mean to become a woman in twentieth-century America?

These are the foundational questions of my study, and while I cannot claim to answer them empirically or definitively, I have undertaken the work in part to take issue with the continued devaluation of girls and women in American culture, which also grounds the implicit assumption in some feminist theory that a negative view of womanhood *by women* is "natural" and

understandable given the many restrictions and the suppression of self that are ostensibly unavoidable when a girl comes of age. While it has been politically necessary and expedient (in order to force social change) to highlight the ways and means of women's oppression, chapter and verse, here I will argue that in spite of the unquestionably repressive culture faced by American women of all backgrounds throughout history, female writers of what I call the coming-of-age narrative resist negative constructions of womanhood and actively create oppositional identities for themselves. In order to create such an identity, however, the writer must also reject conventional literary genres, whose ideologies make the construction of alternative identities impossible.[8] Instead, women writers created a specific type of text—the coming-of-age narrative—that subverts traditional literary forms in order to construct new forms of subjectivity and resist the male-defined discourse of womanhood.[9] While it would be naive to ignore the ambivalence with which many girls have approached a future of performing a socially acceptable American womanhood, which Annie Dillard compares to a living death, in the coming chapters I will argue that girls do not suffer gladly the inevitable march to their socially mandated adult roles. As powerful as the master narratives might be, they are riddled with contradictions and outright lies, a fact recognized and exploited by female American memoir writers as they resist hegemonic interpellations and attempt to claim a degree of agency while still acknowledging the ineluctable social contexts that help determine their identities. Moreover, it is apparent that women who write coming-of-age narratives construct these oppositional subjectivities only in retrospect. In other words, the act of writing one's coming-of-age experience is also the act of ordering the conflicts and confusions—even chaos—related to the construction of identity in adolescence, a feat not easily accomplished *in medias res.* Women who write coming-of-age narratives construct discursive selves actively engaged with American ideologies of womanhood in its myriad manifestations. In addition, these texts violate the traditional boundaries of autobiography and fiction by subverting the reader's desire for coherent narratives that clearly signal their status as either truth or fiction and that will reinscribe and verify a unified selfhood. By fusing and blending narrative devices, these texts use language and the act of narration to challenge hegemonic constructions of identity and womanhood, and create a form of what Catherine Belsey has termed the "interrogative" text, which positions the author as a contingent, contradictory subject and raises more questions than it answers for the reader (91). While realist texts present a fixed identity that reinforces the reader's identification with the universal subject, the interrogative text calls

forth a reader who is similarly alienated from dominant discourse and who identifies with a fluid, often contradictory subject position. As Leigh Gilmore writes of postmodern autobiographical practices, these texts constitute a "site of identity production . . . that both resist and produce cultural identities" (4). Moreover, these sites of identity production are constantly shifting, and privilege contingent subjectivities by refusing to repress discourses that contradict the assertion of autonomous selfhood. The coming-of-age narrative foregrounds the pain and confusion that accompanies a conflicted subject position—we all want to *belong*, somehow, to a culture that recognizes only the coherent subject as normal—but these texts argue that normality is, in the end, chimerical. And that insight is finally productive of power and agency for women. By focusing on adolescence, by definition a time of rebellion and resistance, and by foregrounding contradictory desires and discourses, the coming-of-age narrative provides a congenial form for women writers to successfully question the power of dominant ideologies to construct their lives.

The proliferation of second-wave feminism, as well as critical theory's movement toward poststructuralism, has helped to encourage and validate a massive increase in the publication of women's narratives. However, with few exceptions, previous studies implicitly view women (to recast Sartre's famous critique of Marxism) as if their lives began with their first romance, or with marriage. Even those studies that focus on the female *Bildungsroman*, such as Rachel Blau du Plessis's work on the narrative strategies of twentieth-century women writers and Barbara White's work on fictional representations of female adolescence, often focus on the teleology of adolescent quest, rather than with the childhood that preceded it. Indeed, the most influential studies to date have mainly been concerned with fictional representations of women's lives, and use autobiographical and other nonfiction texts of women writers primarily to bolster their claims. Furthermore, previous studies have argued that quest and romance are rendered mutually exclusive in women's literature, and implicitly suggest that romance always forecloses quest. In contrast, many coming-of-age narratives refuse the either/or opposition, insisting instead that romance *and* quest are entirely compatible, and thus valorize *both* the self-in-relation and individual quest. My intention is to broaden the scope of literary and cultural analysis of women's lives by focusing on the transition from childhood to womanhood as it is constructed in autobiography and memoir. And because there is a deeply ingrained tendency to read autobiography as unproblematically truthful, I make extensive use of feminist poststructuralist theory, which

suggests that, while experience plays a major role in determining what sort of woman the child becomes, what is critical is how she creates meaning from those experiences from the discourses available to her *when she writes*. The Freudian narrative of so-called normal femininity is regularly challenged in twentieth-century coming-of-age narratives, as is the conception of an essential womanhood (defined as self-in-relation) offered by liberal feminist interventions such as that of Belenky, et al. While these texts do lend credence to poststructuralist theories of subjectivity as a process, they repeatedly assert the primacy of experience as producer of truth. But truth here is a local and specific truth; few female autobiographers in any historical era have rhetorically suggested that theirs are universal stories. Furthermore, most of the writers in my study tacitly recognize the unstable nature of truth.

These texts demonstrate how twentieth-century autobiography constitutes a sphere in which the dominant American ideologies of womanhood are frequently and radically challenged and profoundly revised. While I do argue that all writing is autobiographical in some sense, and further that texts identified as autobiography are nonetheless fictions constructed by the writer to make "sense" of her life, these narratives present a far more complex picture of female gender formation and practices than that found in most fiction precisely because of the ideological restrictions of fictional forms. And while I would agree with du Plessis that the twentieth century has seen a shift in the teleology of women's lives as depicted in fiction, I argue further that many autobiographies go beyond simply *imagining* a different life trajectory for women—they show women *living* it, full of contradictions, but effectively resisting society's scripts for women.

RECREATING WOMANHOOD

My goal is to build on a growing body of scholarship that deals with the construction of womanhood by analyzing the ways in which subjectivity and identity[10] are constructed in twentieth-century American coming-of-age narratives by women. While these texts do provide evidence that growing up female in America is still a sometimes painful experience, they also demonstrate a great diversity of experience, much of which is joyful and gives lie to the considerably flattened and simplistic view of women's lives expressed most memorably by Sigmund Freud in his exasperated question: "What do women want?" Freud arrogantly answered his own question at great length,

assuming he was more qualified than women themselves to answer the question; Virginia Woolf imagined Freud writing on women as "labouring under some emotion that made him jab his pen on the paper as if he were killing some noxious insect as he wrote, but even when he had killed it that did not satisfy him; he must go on killing it" (31), and contends that only by calling women inferior could he see himself as superior (35). Women's own narratives of coming of age answer Freud's question quite differently than he did; any acceptance of a "lack" based on gender is entirely missing from these memoirs, although their authors certainly recognize that, as women, they are perceived as inferior by American society. Instead, these narratives often reflect the widening horizons for women in American culture and a strong resistance to normative femininity; female quest takes many forms, and successful resistance to gender norms becomes possible and even acceptable, if still sometimes unconscious or covert. Du Plessis argues that when women as a group are successful in questioning social gender norms, female quest narratives in novels will no longer routinely resolve in marriage or death for the heroine (4). In the memoirs I examine in the chapters ahead, there is a consistent thematization of quest in lives that span the twentieth century, but here, unlike in the novels discussed by du Plessis, narrative choices are not finally limited by the romance plot. I suggest then that the narrative choices in fictional accounts of women's lives have been far more constricted than those found in women's coming-of-age narratives.

Women autobiographers are no freer from gender norm pressures than their fictional counterparts, but their narratives resist the suppression and limitations of their opportunities and choices, and this resistance is ultimately productive. In addition, the arguably artificial boundaries between fiction and autobiography produce a paradoxical reader reaction; we are less forgiving of seemingly unlikely events or attitudes in fiction, but in a nonfiction text there is a greater suspension of disbelief, allowing the writer greater latitude in the construction of truth. Of course, in real life, preposterous (or what Nancy Miller would call "implausible") events and coincidences do indeed occur, but as readers we have more structured expectations of fictional plot movement and character behavior.[11] This phenomenon may explain why female autobiographers construct themselves as less restricted in life choices than their fictional counterparts, even at this late date. Although she did not write an autobiography, Louisa May Alcott will serve as an example of this point. Alcott never married, choosing instead to support her parents and sisters through her writing, while she does not (or cannot) allow her fictional alter-ego, Jo March in *Little Women*, to break with social norms. Indeed, Jo is

persuaded to give up her career of writing adventurous "sensation" stories so that she may become a more suitable wife in her fiancé's eyes. Alcott's life was more complex than this brief rendering suggests, but the point is that while women might commonly live lives that do not measure up to the mythic norm, their fictional narratives suggest much less room to negotiate gender norms than actually exist. While this might suggest the writers are exhibiting classic false consciousness, I see this pattern as a example of counterhegemony at work. Raymond Williams defines hegemony as a complex concept of political and cultural dominance, gained through an ongoing process of consent,[12] and argues that the window for resistance to hegemony lies in the imagination of individuals (86). Thus, by imagining an altered view of the self, the individual reclaims agency and resists society's interpellation. And, as Barbara Bellow Watson contends, women's literature enacts the abstract politics of womanhood through highly specified characters, contexts, and meanings (112). The writers considered here do not consciously set out to reimagine womanhood, but in carving out space for alternative subjectivities, they are rewriting the social scripts allotted to women.

My purpose then is to examine the ways women from a variety of backgrounds construct their subjectivity in their coming-of-age narratives. Following a theoretical thread on the nature of subjectivity beginning with Hegel and Marx and continuing through the feminist poststructuralist revisions offered by critics such as Chris Weedon and Patricia Waugh, I argue that the texts of women's coming-of-age narratives contest the tenacious hold of the liberal humanist notion of self on Western notions of subjectivity. Implicitly and explicitly, these texts assert that the self does not exist outside of language, historical context, or culture, and they echo Simone de Beauvoir's assertion that women are made, not born (301).[13] Yet, coming-of-age narratives also assert the embodiedness of identity, often through an apparently unconscious search for bodily knowledge. The physiological changes of female puberty seem to work against the cultural pressure to ignore the body, resulting in a notable bodily presence in the narratives I examine here. A woman's understanding of her identity and how she came to be the person she is, as related in these narratives, generally resists socially determined roles and life trajectories, if sometimes in less than forthright ways. This is in marked contrast to women's writing of the eighteenth and nineteenth centuries, when the hegemony exerted great pressure on girls who longed to "jump at the sun," in Zora Neale Hurston's phrase (*Dust* 21), to come back into line and fulfill their womanly destiny as defined by social and cultural norms.[14] Further, the texts I consider here refuse the overdetermined sub-

jectivity suggested by Louis Althusser's theory of interpellation by ideological state apparatuses (ISAs) as well as later poststructuralist assertions that pronounced the "death of the author." Considered as a body of texts, twentieth-century women's narratives argue that it does indeed matter who wrote the life being examined and that the writer's agency is a given while simultaneously acknowledging that gender and other subject positions are socially constructed. This view is no less ideological than the one that burdened previous generations of women writers, but it does modify the strict opposition of individual agency and constructed identity, a significant move toward the self-determination called for by the women's movement. American women's coming-of-age narratives demonstrate the complexity and infinite diversity of American women's lives; once we read them, we realize it is nearly impossible to essentialize women as long as their stories are told—and heard.

Furthermore, these texts evince a complex subjectivity which cannot ultimately be reduced to archetypes or to a single philosophical stance. The liberal humanist paradigm of human nature retains a tight grip on Western culture, if these texts are any indication, because most reflect the cultural imperative to fix subjectivity and produce noncontradictory narratives of self-hood. While race and sex theoretically should not figure in the liberal notion of human 'essence', in practice these discourses and others do indeed work to fix subjectivity. Some autobiographies will inadvertently encourage a reader to interpret the subject's identity through a single lens, resulting in, for example, Elizabeth Wurtzel's subjectivity seeming to originate in her clinical depression in *Prozac Nation* (1994); likewise, Richard Wright's *Black Boy* seems to suggest that his subjectivity is determined by race. The implications of their titles aside, Wurtzel and Wright both actively resist narrow identities as, respectively, a "depressive" and a "black boy" with all the cultural baggage those terms imply. Both seek to deepen their subjectivity through assertions of intelligence and multiple subject positions beyond the ones suggested by their titles. However, adolescence—coming of age—is by definition a time when identity is fluid and contradictory, and thus provides solid evidence for the notion of constructed subjectivity. And, as I argue in detail later, while there is the appearance of fixed subjectivity in the texts, readers, as well as the autobiographers themselves, deconstruct and reconstruct the subject in light of what Norman Holland calls their own "identity theme" (815). Thus, while there might be a sense of coherent subjectivity on the part of the autobiographer at the time of writing, readers reinterpret the text in light of the immediate cultural context in which they read, creating additional opportunities for subversive or alternate meanings.

Although philosophy and the social sciences can provide literary analysis with useful insights, it is difficult to use social theory unproblematically to analyze women's coming-of-age narratives since it tends to describe human development in prototypes and universals that invariably reflect normative male development. But even for male development, psychology theory makes broad assumptions about class, race, and ethnicity, which results in partial insights and a great many caveats. Nonetheless, I will make limited use of psychological theory in the coming chapters to pinpoint the discursive practices that create the boundaries and teleologies of coming of age in a particular time and place. In part, my analysis is modeled on the aims of contemporary anthropology, which is to say that my intent is to describe the specificity of cultural experience through the examination of coming-of-age narratives. These texts are what Clifford Geertz defines as "first-order" interpretations—the creator of the text is playing the part of the "native" in cultural anthropology, and in that role, she lays claim to being the primary and privileged interpreter of her experience. But it is important to emphasize that the writer's role in narrating her own life is an *interpretive* one; even she has no direct access to the "truth." As a literary critic, then, I am here creating second- or even third-order interpretations (15). Applying Geertz's framework of ethnography to the study of the coming-of-age narrative encourages a healthy, respectful stance to the exercise and, most important, privileges the *interpretation* of experience rendered by the autobiographer. While I will offer an analysis of subject construction in a number of texts, I will attempt to do so from an "actor orientation." In order to understand—and interpret—the social, political, and historical forces that help the narrator to construct her identity and subjectivity in particular ways. Geertz points out that this is ultimately an unattainable goal, but a necessary foundation for doing ethical and informed ethnography—and by extension, interpreting narratives of real peoples' lives. Mindful of Rabinow's critique of Geertz's removal of himself as subject in his ethnographic writings, I have provided what I hope is a sufficient sense of the "identity theme" that I bring to my readings of these narratives. I choose them (or they chose me) because, in one way or another, each reflects some aspect of my own experience, so in attempting to make sense of the meaning of the texts, I am also creating meaning of my own experiences.[15]

Having defined a distinct genre of American women's literature that I call the coming-of-age narrative, I will explore the implications of my argument in the context of the current debate on identity politics in the academy. As Linda Martín Alcoff notes, "[t]he constitutive power of gender, race, ethnicity, sexuality, and other forms of identity has, finally, suddenly, been

recognized as a relevant aspect of almost all projects of inquiry" (*Who's*), and thus, the fact that the narratives I have discussed here provide evidence of the social construction of subjectivity is hardly a radical assertion at this historical moment. But I want to argue that, for women writers, the coming-of-age narrative constitutes an alternative literary form that allows the writer to claim agency in the construction of her identity, while also acknowledging the role of social discourses in determining subjectivity. Because these texts often deny the distinction between fiction and fact as key to the truth value of a text, the coming-of-age narrative is a genre that resists discourses that fail to describe the writer's knowledge and experience by subverting the ideological premises of traditional literary genres. In other words, the conventional plots, characters, themes, and ideological bases of fiction and autobiography are revised or erased in the coming-of-age narrative, which allows the writer to inscribe an alternative subjectivity and reclaim agency in defining herself. The writer's self-definition arises from direct experience in the world as well as from the discursive formations specific to her historic location, and these narratives strongly affirm the role of experience in identity formation. Arguing against the notion that experience is a direct source of truth, the coming-of-age narrative demonstrates the ways in which the meaning of experience is mediated, not only by ideology but also by other experience. Identity is thus conceived of as cumulative, with each experience mediated by everything that has come before and subject later to reinterpretation in light of new experiences.

Furthermore, while I have carefully avoided making generalizations about women's lives in my readings of these texts, by locating the coming-of-age narrative in texts across race, class, and time, I implicitly suggest that commonalities do exist. More specifically, the central ideological assumption of the coming-of-age narrative is that identity is created in the context of human relationships. All acknowledge the power and pressure of social norms, but the specific norms vary according to the writer's historical and cultural location. There is, therefore, no monolithic femininity invoked in the coming-of-age narrative, but rather, many versions of femininity, which are highly specified within racial, class, and ethnic discourses. Often, too, a girl coming of age will have to contend with the discourses of womanhood as it is defined within her community, as well the definitions imposed from outside. What remains, then, when all the historically and socially specific factors eliminate the possibility of essentializing what it means to become a woman in America, is a self that, like other selves, "you find through love and through your relations with family and friends" (Culler 115).

The credit for this view of subjectivity and identity formation belongs to feminist theorists such as Carol Gilligan and Nancy Chodorow, who have been subject to much criticism in recent years for purportedly essentializing women but whose description of female development has not only evolved into the master narrative of womanhood—it has gained widespread currency across the gender divide as well. Before feminists described the ways in which women construct identity, the master narrative of American identity held that the individual is autonomous and that identity is inherent within each person; the world of relationships and ideas was irrelevant to the nature of the true self. Imperceptibly, however, the master narrative has radically shifted to valorizing the self-in-relation to such a degree that it has become hegemonic. Women continue to be held accountable for their ability to nurture relationships, and if a woman does not define herself in terms of her relationships (wife, mother, daughter, friend), she runs the risk of being an "unnatural" woman (or worse). Increasingly, however, public discourse is acknowledging the centrality of relationships for American men as well. But while American culture periodically suffers spasms of backlash against the "feminization" of selfhood, through comic jabs at the "sensitive" male who is in touch with his feminine side, and through the attempts of some feminists to divest themselves of any vestiges of traditional signs of femininity, the discourse has changed. In her 1999 study of American men, Susan Faludi argues that the grand narratives of American manhood evinced an opposition between

> the vision of the man who stood apart from society and the man who was a part of society; the loner was not the ideal. The "Indian Fighter" was ultimately a homesteader. Daniel Boone was not simply a tale of a frontiersman taming the world with his rifle and his knife. Essential to the myth of his journey into the wilderness was his return from it to retrieve his family and establish a new community (10).

Unable to live according to the myth that has been handed down to them, American men are, according to Faludi, deeply alienated and disillusioned. The myth has worked to isolate men from the people most likely to care for and about them while simultaneously encouraging them to devote their "true" selves to the public world of work. Yet men who have given the best of who they are to faceless corporate entities too often find that their loyalty is not returned. Having thus neglected self-in-relation in favor of self-in-isolation, many American men feel, as Faludi puts it, stiffed.

Men feel the need to come home after conquest

Related to the recognition that men have been as alienated as women by the myths of the autonomous individual is a trend in popular psychology that is concerned with the nurturance of boys in American culture. In his 1999 book *Raising Cain*, Daniel J. Kindlon argues that boys are harmed by the cultural perception that their primary developmental task is to separate from relationship and establish themselves as independent, self-sufficient individuals. As a result, boys are emotionally conflicted because, according to Kindlon, a great need for connection clashes with a boy's recognition that he is expected to sever his dependence on relationships (3).[16] The current assumption about manhood is that, to be healthy, it must be nurtured through a variety of relationships, including those with women, beginning with the mother. Though I do not argue that this account constitutes a universal narrative on manhood, it has gained cultural capital in the past twenty years, and there is little public debate about its merits. Counterhegemonic discourse on identity formation has thus become hegemonic, and evidence for its dominance can be found in the fact that many male coming-of-age narratives written in the latter part of the twentieth century thematize the self as constructed in relationship.

But in an article for *The Nation*, Patrick Smith critiques what he considers the excesses of contemporary memoirs, calling the worst of them "intellectual frauds" for valorizing the private realm at the expense of what he considers the much more valuable public realm. Smith produces only women's texts as examples of memoirs that "privatize" history and "refus[e] the challenge of unburying the past as it really was," and thus he reproduces the ancient critiques of women's literature. In other words, Smith argues that by articulating the private realm, women writers do "violence" to history. But Smith praises *Angela's Ashes* and other (mostly male) texts for their "dedication to public discourse . . . or to some object or event outside the self. . . .The power of [*Angela's Ashes*] lies in its account of an emerging consciousness—a universal experience that is rarely articulated well." The traditional critiques of women's texts are, in other words, alive and well, even in ostensibly left-wing periodicals. Smith's definition of the correct purpose of autobiography as that of articulating the "emerging consciousness" *within* public discourse is limited and limiting in its notion of what constitutes consciousness, and it is resisted in both male and female coming-of-age narratives. To suggest that consciousness is significant only in the context of public discourse is to deny the constitutive element of the vastly more influential private world of relationship. The world of the child and adolescent is almost by definition private, and it is during this time that

most individuals consolidate and define the major elements of their identities. In other words, to recast the example that Smith finds exemplary, *Angela's Ashes* follows the emerging consciousness of a boy within the context of the domestic sphere of family relations, and gradually widens the scope of that consciousness as McCourt enters the adult world. Indeed, the very title of McCourt's text—referring to his mother—is suggestive of the critical determining influence of human connection upon identity construction.

In my view, the problem lies in the fact that the canonically exemplary coming-of-age narrative of the socially isolated and alienated individual is rarely successful. Huck Finn's coming of age is arrested because finally he is unable to reconstitute the self in light of his experiences. At the end of the narrative, Jim has joined his family, and Huck is left standing on the margins of society, attempting to persuade himself that a solitary life in the territories is preferable to the comforts and supports of human company. And Holden Caulfield, that other archetypal American literary male, has a mental breakdown because the prospect of being emotionally self-sufficient is simply too painful—the expectation that he do so creates an untenable inner conflict. The autonomous individual is profoundly alone and lonely. In contrast, women, who have long labored under the expectation that they *must* cultivate relationships to the exclusion of all else, have created a rite of passage in the coming-of-age narrative that refuses the binary opposition and recognizes the multivalent desires of the individual—for relationship *and* for agency.

In order to contextualize my argument, in the next chapter I provide a brief overview of the significance of women's narratives in the American feminist movement. In my view, the core issue at the heart of all feminist scholarship and activism is the struggle over female subjectivity, and so I have situated my analysis in Western philosophical theories of the subject in order to trace the origins of current autobiographical practices. Women's political activism has been deeply informed by and responsive to the Enlightenment ideal of selfhood, and consequently, autobiographical texts by women political activists, artists, and scholars have contributed significantly to dismantling that ideal.

In the third chapter, I examine the evolution of adolescence as a concept in American culture generally, and in American literature specifically. Recognized as a distinct phase of development only in the last century, adolescence and its specific features are now the focus of greatly detailed study in certain fields, most notably in psychology. Until very recently, most such studies have used male models as the norm and, as a result, their findings are often

[handwritten notes in margins and at bottom: "?", "Men see their role models as alone. Women try to combat this in coming of age novels"]

of limited use in understanding female development. I also review an anthropological perspective of adolescence, beginning with Margaret Mead's influential study of Samoan culture. Although her work has become highly controversial, I borrow from her methods (albeit lightly) and that of more recent anthropological theory to widen the lens in my analysis of literary texts. Finally, I explore the idea of "coming of age" as it occurs in literature beginning with the *Bildungsroman*, and the ways in which women writers have altered the traditional genre to reflect diverse patterns of development. The aims of *Bildungsroman* and autobiography converge in the latter part of the twentieth century, resulting in blurred genre distinctions and a radically revised narrative structure. I offer my views of what coming of age means, and argue that the proliferation of its treatment in American letters provides a useful indicator of the changing conceptions of identity.

Next, I turn to Annie Dillard's 1987 *An American Childhood* and Anne Moody's 1968 *Coming of Age in Mississippi*. While these texts are radically different in form and content, their authors from opposite ends of the social spectrum in terms of privilege and social standing, I have chosen to discuss them in tandem to highlight how those differences function in an autobiographical text and indeed might serve to determine its form. As Sidonie Smith has written, Dillard's very title seems to invoke a universal subjectivity with the modifier "American" attached to another general category, "childhood" (*Subjectivity* 131). Dillard makes a seemingly transparent assumption that she is describing a universal version of childhood, an observation borne out in the text by numerous references to what "any" child feels or experiences, but also contradicted by a richly specific textual self. Following Smith's observation, I argue then that, in contrast, Moody's title invokes a highly specified subjectivity, placing her text/life story in a particular locale, and thus creating specific expectations in the reader. Unlike Dillard, who writes that she "slid into [herself] perfectly fitted" (11), Moody slides into herself and finds the fit uncomfortable and ill-sized. The pain and conflict that accompany her attempts to create an identity she is comfortable with are never fully resolved in her text, and she remains an unfinished subject to a greater degree than is evident in traditional autobiographies. Indeed, the coming-of-age narrative is distinguished in part by a provisional subjectivity forged in ideological conflicts and subject to change as a direct result of subsequent experiences.

Chapter 4 considers the problem of genre boundaries and truth in autobiography in my discussion of Mary McCarthy's *Memories of a Catholic Girlhood* (1955) and two texts by Zora Neale Hurston: *Their Eyes Were Watching God* (1937) and *Dust Tracks on a Road* (1942). McCarthy answers anticipated

questions about the reliability of memory through the use of italicized passages in which she deconstructs her narrative, and explicitly admits to using the conventions of fiction to fill in the gaps. In contrast, Hurston's autobiography is, according to Robert Hemenway, full of unacknowledged lies, while *Their Eyes Were Watching God* is widely understood to be an "autobiographical" novel that is revealing of aspects of Hurston's life about which she remained silent in *Dust Tracks*. These texts raise complex questions about the writer's obligation to be truthful, and the complementary problem of how, as readers, we ought to address the unavoidable gaps and silences (in Macherey's terms) of any autobiography.

In chapter 6, I discuss the conflicts and issues surrounding the hybridization of identities—national, ethnic, religious—that are the hallmark of many immigrant coming-of-age autobiographies. The tension and confusion that accompany a child's negotiation of her parents' identity with an "American" identity results in a particular and specific journey through adolescence that differs substantially from that of a child whose parents' national/ethnic identity is not in flux. The autobiographical text of a first-generation American girl is deeply informed by the conflicts between two cultures in addition to the contradictions already inherent in a single culture. In addition to the usual host of identity issues that beset a girl as she comes of age, she must also negotiate the difficult terrain of ethnic subjectivity. Textual representations of these issues are as varied as the number of combinations of cultures possible, and while I do not suggest that the texts I have chosen for this discussion are necessarily representative of all such autobiographies, they do illustrate the specific difficulties of identity formation in the context of major cultural differences. Maxine Hong Kingston's *The Woman Warrior* (1975) begins with her mother saying, "You must not tell anyone what I am about to tell you," thus setting the stage for Kingston's difficult lessons in the secrecy and silence surrounding women's lives that is typical of Chinese culture in opposition to the relative openness of American culture. Kingston's text juxtaposes myth and realistic narrative as a formal device that highlights the conflicting discourses and ideologies she negotiates in the process of constructing a workable identity. Kate Simon's 1982 *Bronx Primitive* also exhibits the tensions inherent in immigrant subjectivity, but where Kingston is sometimes paralyzed by the conflicts between Chinese and American norms, Simon quickly learns to take advantage of the contradictions in order to do as she pleases, even though she is initially confused by the contradictory messages of her parents and the wider society. As she grows older, she flatly rejects much of the Old World interpellation of Jewish female subjectivity

offered by her parents. Furthermore, *Bronx Primitive* provides a reasonably explicit model of Williams's model of imagining agency, and the ways in which naming the contradictions in ideology allows for resistance to the norm.

Arguing that the construction of identity varies according to the particular historical moment of the events narrated (but perhaps more importantly, the moment of writing), I interrogate the construction of female identity in the coming-of-age narrative. The institutions, practices, and prevailing hegemony at the time of writing exert certain limits on what the writer can and cannot say, and on what discourses of womanhood will be tolerated. While I would not argue that the decisions a girl makes in adolescence will determine the woman she will become in any permanent sense, the process of coming of age does involve examining one's choices and deciding—consciously or not—what direction one's life will take. Alternatively, she might watch in dismay as her horizons shrink, her choices become limited, and her life is seemingly mapped out for her. Nonetheless, it is in adolescence that she learns, sometimes forcefully, exactly what forms of subjectivity and narratives are available to her and which forms will cause her to be marginalized. Of course, assenting to one of the socially sanctioned subjectivities available to her will still not guarantee social acceptance. If Anne Moody had accepted the hegemonic view of black womanhood, for example, it might have resulted in her personal safety but not widespread social approval and acceptance. It is in adolescence that the child becomes mother to the woman.

Throughout the study, I'm making a primarily positive argument about the apparent increase in a woman's range of acceptable subjectivities, and their ability to resist social "limits and pressures" to create new discourses of womanhood. I do not deny the genuine pain and conflict that are the consequences of rejecting received notions of womanhood, but ultimately, this dynamic makes alternative forms of subjectivity possible—even necessary.

2 ❖ Feminism, Autobiography, and Theories of Subjectivity

> [O]ne is not born, but rather becomes, a woman. No biological, psychological, or economic fate determines the figure that the human female presents in society; it is civilization as a whole that produces this creature.
>
> —Simone de Beauvoir, *The Second Sex*

A principal goal of the feminist movement has been to recover and honor the specificity of women's experience, history, and cultural significance by making women's voices and stories heard. But paradoxically, this same movement often acted to suppress differences among women in its early years. In her 1997 memoir, *Rita Will,* novelist Rita Mae Brown recounts the banishment she endured at the hands of Betty Friedan and other white middle-class NOW members, who "just about tore their Pucci dresses jamming the door to get out" after Brown proclaimed her love for women at a 1969 meeting (228). Dubbed the "lavender menace" by Friedan, Brown and other lesbian activists sought other, more inclusive venues for their work (235). Historically, argues bell hooks, "the racial apartheid social structure" has been reflected in every American women's movement (*Ain't* 124) as mainstream feminists attempted to replace the American master narrative of womanhood with another, equally monolithic paradigm, thus tacitly acknowledging the rhetorical power of narratives to construct subjectivity. But the new master narrative replicated the structures of the old by presenting a two-dimensional history focused on female heroes who are stripped of ambiguity, complexity, and human faults. Here, the story of Elizabeth Cady Stanton will serve as an example. Standard histories of American feminism detail Stanton's involvement in the Women's Rights convention at Seneca Falls in 1848

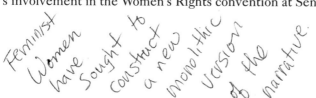
Feminist Women have sought to construct a new monolithic version of the narrative.

23

and the Declaration of Sentiments which critiqued the civil "death" of married women, the male monopoly on paid employment, the exclusion of women from the professions, and the differing moral codes for men and women. But few accounts of Stanton's contribution to American feminism examine her as a three-dimensional figure, contenting themselves instead with a catologue of her public accomplishments. As James W. Loewen suggests, "heroification" is "a degenerative process . . . [that] turn[s] flesh-and-blood individuals into pious, perfect creatures without conflicts, pain, credibility, or human interest (9). Loewen further argues that we tend to present heroes of history as ideal figures in order to inspire emulation, but with the result that an individual's heroism is decontextualized to such a degree that few become useful role models (23, 27). Complicating this process further, sometimes individuals present themselves to the public as uncontradictory, unambiguous figures, and here again, Stanton is illustrative. As a radical critic of patriarchal society, Stanton's feminism is presented as a *fait accompli;* that is, there is very little sense of the processes and experiences that resulted in Stanton's feminist consciousness. In Jill Ker Conway's reading of Stanton's 1898 autobiography, *Eighty Years and More,* Stanton herself contributes to the sense of an unconflicted selfhood by downplaying her personal life, particularly the unhappy marriage which contributed enormously to her incisive critique of women's social position. Most remarkably, this uncompromising critic of the institution of marriage reveals a highly contradictory attitude when she writes of her children's marriages in decidedly romantic terms (*When Memory Speaks* 91–98). Elsewhere, Conway reminds us that female public figures have always had difficulty in achieving public support for their reforms if they did not fit romantic stereotypes of womanhood (*True North* 152). Thus, social reformers such as Stanton, Jane Addams, and Florence Kelley tended to present themselves in their memoirs as, in Conway's words, "the ultimate romantic female, all intuition and emotion, tugged by the heartstrings of random encounters with the important causes" (150), which they had, in fact, defined and led. The contradictions women have confronted historically between cultural norms and their desire to reject those norms create a necessary space for resistance, but when the dynamic history of women is transformed into a series of hagiographies, the radical critique of feminism becomes a muted, static, moribund narrative that fails to capture the imagination of many living individuals. As Jonathan Culler argues, narrative has the ethical function of giving us access to points of view far removed from our own—no matter what subject positions we hold. Through a variety of narrative devices, we are better able to understand what motivates behav-

ior that might otherwise be unintelligible to us (Culler 93). The process of "heroification" renders the behavior of heroes unintelligible and eliminates them as usable models. Although the feminist narrative of womanhood provided a productive counterpoint to the universal male paradigm, the new model nevertheless effectively silenced women whose experiences diverged from that of the white middle-class women who led the mainstream American women's movement in the early 1960s. In addition to deifying certain figures in women's history, the mainstream feminist movement often failed to be inclusive in its explicit valorization of women's experience, and left it open to a wide-ranging critique by women of color, poor women, and lesbians. The desire to understand and account for the experience of women in all of its specificity and complexity created a need to study women, not simply to advocate for women's rights. And it resulted in a proliferation of women's narratives, authorized and privileged by the burgeoning discipline of Women's Studies. To its credit, American feminism eventually accepted the challenge—indeed, the ethical imperative—to value the power attendant to the recognition that women differ in experience.

In recent years, the struggle for control over the discourse of feminism has, generally, given way to a postmodern acceptance of the inadequacy of a single grand narrative. In the final analysis, the lack of a master narrative of womanhood (or manhood or any other subject position) is liberatory for all concerned. Furthermore, poststructuralist theory suggests that narrative point of view is a critical factor in articulating the contours of ideology. Du Plessis, for instance, argues that cultural products such as narrative serve to reinforce gendered discourse and ideology, and that, for instance, "the romance plot in narrative thus may be seen as a necessary extension of the processes of gendering" (38). Culler also reminds us that stories serve to "police" on behalf of hegemonic discourses: "Novels in the Western tradition show how aspirations are tamed and desires adjusted to social reality" (93). The trope of dashed dreams is conventional in the literature of marginalized groups, but Culler suggests that the entire Western tradition, which is by and large that of white males, thematizes the necessity of relinquishing ways of being not sanctioned by dominant discourse. In other words, Culler implies that *all* members of society are channeled into the dominant structures—often unwillingly—even if some groups or individuals benefit from the system more than others. As Althusser argues, we are all trapped and implicated in ideology (*For Marx* 235). Nonetheless, the power of narrative to shift paradigms has been an important catalyst of change for the second-wave women's movement. Stories told in public over many years have resulted in a massive cultural shift in point

of view about the experiences of womanhood as well as the widespread disillusionment of women across class, race, and ethnic lines.

FEMINISM AND THE AUTOBIOGRAPHICAL ACT

The feminist critique of women's role in society is largely responsible for an explosion of scholarship examining every facet of life over the past two generations. Feminist scholarship is far-reaching, but here I will focus on just one area in which feminist theory has created a significant paradigm shift in Western views of womanhood. There has been an ongoing analysis and dismantling of Western theories of identity in feminist studies as a means to disrupt hegemonic notions of selfhood in order to make room for alternate subjectivities. Thus, narratives, in the form of public testimonial, have been an effective feminist rhetorical strategy for raising awareness about, for instance, rape and its violent, antifemale basis in order to underscore the fact that these acts are much more common than public discourse previously admitted, and furthermore that the prevalence of violence against women is irrefutable evidence of their inferior social position.[1] Public autobiographical acts of previously private experiences were—and are—useful as political tools for bringing about social change.[2] These autobiographical acts by everyday women formed the basis of the early feminist critiques of patriarchy. Before the twentieth century, autobiography was the province of the exceptional individual, and because "exceptional" individuals were usually public or artistic men, written accounts of women's lives tended to grow out of such extraliterary forms as diaries and letters, neither of which garnered much respect as "literature" unless of course they were written by acknowledged literary "masters." Caroline Kirkland's remarkable fictionalized 1839 account of her experiences in settling the western frontier of Michigan, and Mary Boykin Chesnut's extraordinary diary of the Civil War South were not originally intended for publication, and thus were constructed very differently from such canonical autobiographies as Benjamin Franklin's and Henry Adams's. Significantly, Chesnut's diary first came to prominence as a historical document illuminating the views of individuals whose opinions were not widely heard during the Civil War. The few women's autobiographies that were published and widely circulated throughout history were usually penned by "extra"-extraordinary women, such as Teresa of Ávila and Margery Kempe, both medieval Christian mystics, whose texts exist only, the writers make clear, so that they may share their extraordinary spiritual experiences with others.[3] Estelle Jelinek notes

that, until recently, few male *or* female autobiographers revealed details of their quotidian existence, and since few women lived "public" lives, their life stories remained unpublished—and unheard (5).

Critical to the feminist literary project has been the recovery of a female literary tradition, since central to feminist ideology is the recognition that women's literature has been suppressed throughout history. Further, feminists have argued that a reconsideration of what constitutes literature is necessary, putting us in the vanguard of the canonical debates of the last thirty years. Feminists have recovered many long-forgotten works by women in the process of reconstructing the lives of women. The proliferation of literary criticism by and about women that began in the 1960s shows no sign of letting up, nor any sign of stagnating in its range of concerns. After the initial years of defining the position of women in literature by men and women, feminist literary criticism has gradually moved from a largely historical project to a spectrum of theoretical concerns. Black feminists realized early on, for instance, that the "madwoman in the attic" paradigm rarely applied to the black artist, and began to theorize the particulars of art by black women.[4] Literary critics were among the strongest and earliest proponents of the belief that art is created in a particular historical and social context, arguing that the identity of the author was crucial to the art she created. In spite of the fact that Barthes was proclaiming the "death of the author" at roughly this time, feminist literary critics are generally in agreement that the specificity of the author is of great importance.[5]

One prominent example of the recovery of a woman's text is that of Harriet Jacobs's 1861 *Incidents in the Life of a Slave Girl*. Buried in obscurity and dismissed as fiction until Jean Fagan Yellin documented the text in 1987, *Incidents* has taken its place in the canon of women's literature as well as women's history. Its value lies in what it reveals about the particulars of a slave woman's life and how that differs from that of a male slave. Until Jacobs's text was recovered, the male experience of slavery was assumed to be universal and the issues of sexual double jeopardy were rarely dwelt on except as it applied to how enslaved men felt about the rape of their wives and daughters. *Incidents* allowed the woman narrator to speak as subject in her own history and gave historians and literary critics alike a different paradigm with which to view slavery.

In its early years, feminist criticism also focused on the critique of male literature and how it contributed to and reflected the oppression of women. Judith Fetterley, for instance, argued that reading canonical literature historically has been a profoundly alienating experience for women. Demonized or

canonized or simply invisible in so much literature written by men, women readers experience(d) powerlessness. As Fetterley wrote in 1977:

> To be excluded from a literature that claims to define one's identity is to experience a peculiar form of powerlessness—not simply the powerlessness that derives from not seeing one's experience articulated, clarified, and legitimized in art, but more significantly the powerlessness which results from the endless division of self against self, the consequence of the invocation to identify as male while being reminded that to be male—to be universal, to be American—is to be *not female* (xiii).

Fetterley's analysis (and reader response theory as a whole) opened up the possibility of radical new readings of literature by male as well as female writers. The subject position of the reader is critical in this paradigm, forcing a critique of the social effects of literary depictions as well as their ideological underpinnings. While critique of male canonical literature was one of the earliest manifestations of feminist literary criticism, in recent years we seem to have to turned away from that focus to emphasize the history and production of women's literature. It is almost as if, collectively, feminist critics decided they had spent enough time on images of women in men's literature, and that the more important task was to validate women's literature and theorize female subjectivity.

The creation of a feminist poetics has been formulated in part to counteract the images of women in male-authored texts explicated by Millett, Fetterley, and others, as well as to privilege a distinct female literary history. As Elaine Showalter put it in her influential 1979 [1985] essay, "Toward a Feminist Poetics,"

> [T]he program of gynocritics is to construct a female framework for the analysis of women's literature, to develop new models based on the study of female experience, rather than to adapt male models and theories. Gynocritics begins at the point when we free ourselves from the linear absolutes of male literary history, stop trying to fit women between the lines of the male tradition, and focus instead on the newly visible world of female culture (131).

This effort has drawn on theorists in a number of disciplines, particularly philosophy and psychology. Psychoanalytic assertions of essential womanhood

by some feminists, postcolonial explications of the diversity of women's experience by others, and minority women theorists' arguments against universalizing the experience of women have provided grist for the mill; consensus will certainly never come but the attempts to construct a feminist poetics have been responsible for great vitality in literary studies.

As feminist literary scholars sought to recover "lost" texts, to rehabilitate previously shunned texts and to create new woman-centered literature, they were able to demonstrate that women have identities unaccounted for by dominant ideology. These efforts resulted in the recovery of such literary gems as Kate Chopin's *The Awakening* (1899), Zora Neale Hurston's *Their Eyes Were Watching God* (1937), and Rebecca Harding Davis's *Life in the Iron Mills* (1861)—and forced a reexamination of the literary canon. Feminist critics such as Jane Tompkins and Cathy N. Davidson have helped to rehabilitate the image of literature written for women, demonstrating the serious and influential "cultural work" (in Tompkins's phrase) of sentimental fiction and detailing the ways in which women's literature was systemically devalued by the male literary establishment.[6] Feminist literary critics generally agree that literature is a political site shot through with ideology, which may acquiesce to or resist a particular set of circumstances. Jane Tompkins, for example, in her work on *Uncle Tom's Cabin*, shows how Stowe's novel (and other sentimental novels, which were written by, for and about women) encoded the domestic values of the nineteenth century. She writes that, "[o]ut of the ideological materials they had at their disposal, the sentimental novelists elaborated a myth that gave women the central position of power and authority in the culture" ("Sentimental" 83). Tompkins's work on nineteenth-century fiction is in part a reexamination of the cultural significance of women's fiction, a body of literature long dismissed by the New Critics in part because its popularity eclipsed that of canonical contemporaries such as Hawthorne and Melville. According to Tompkins, the cultural work of sentimental fiction served to validate—for women—the crucial role played by the feminine sphere in the functioning of American society.

The contemporary proliferation of writing by American women, ordinary and extraordinary, is partly the result of two generations of women insisting on seeing *their* lives, *their* narratives—in myriad variations—represented in art, but these texts also serve the ideological goals of the women's movement. The sum of these efforts has brought to light a fuller account of the rich diversity of women's lives than ever before, as well as a significant challenge to the structure of male domination in the United States and elsewhere. But the massive social changes wrought by the women's move-

ment are not simply the result of women speaking and writing their lives. The consciousness raising led inevitably to women's realization that they have been invisible in history, in science, in psychology—in short, everywhere in the academy and the larger world. In disciplines as diverse as psychology and anthropology, scholars have illuminated what it means to become a woman in a particular cultural (and disciplinary) context. In carrying out her groundbreaking 1982 study on female identity formation and moral development, Carol Gilligan, for example, described a process that differed from the male pattern and noted that previous psychoanalytic theory focused solely on males. From Freud to Erikson, female development has been constructed as stunted or inferior because it usually differs from that of males. Moreover, patriarchal signifying practices serve to naturalize this ostensibly empirical inscription of woman through cultural images that reinforce hegemonic inscriptions of women as culturally insignificant (e.g., as workers), or conversely, so significant as to engender romanticized myths (e.g., as mothers). Gilligan's *In a Different Voice* and Nancy Chodorow's 1978 *The Reproduction of Mothering* were instrumental among the early studies in delineating and detailing a specifically female version of psychological development, with the explicit goal of depathologizing female psychological development.

The degree to which American women writers have successfully challenged liberal humanist notions of selfhood that have historically excluded women is largely due to the extended and thoroughgoing critique of patriarchal social structure by early feminists, but also, significantly, to the feminist critiques of the construction of womanhood that implicitly inscribed the specific oppressions of middle-class white women as universal.[7] In other words, there is a discernible progression leading from a generalized discourse of femininity as constructed by privileged white males throughout history to the current recognition that femininity cannot be construed as a single discursive practice, even for an individual woman. This insight was born of protracted, sometimes acrimonious debate surrounding issues raised by the new discipline of women's studies, issues often dismissed by the current generation of feminists as antiquated. I want to recognize, however, that the revolution had to begin somewhere, and in mapping previously uncharted territories, scholars such as Gilligan, Chodorow, Showalter, and many others built a platform for the much more complex edifice now in place. For example, the 1986 study *Women's Ways of Knowing* by Belenky et al. builds on Gilligan's and Chodorow's studies by delineating a specifically female path in the development of selfhood, voice, and authority, thereby putting forward a significant

argument that at least one alternate epistemology to the liberal humanist model must be acknowledged.[8] Lyn Mikel Brown and Carol Gilligan's 1992 study of female psychology in *Meeting at the Crossroads*, which acknowledges the need to specify whose experience is being named, examines a relatively privileged group of girls at a Cleveland school and concludes that "[f]or girls at adolescence to say what they are feeling and thinking often means risking . . . [the loss of] their relationships and finding themselves powerless and alone" (217). Louisa Pipher's 1994 bestselling *Reviving Ophelia* describes the deep pain of contemporary adolescent girls as they try to negotiate their way to adulthood in a culture that Pipher calls "poisonous" for girls and women. A 1995 AAUW study challenges the cherished notion that boys and girls are treated equally in U.S. schools, and found that girls are still treated as second-class citizens even at this late date.[9] And these are only the most well-known efforts of scholars to study and describe what it means to be female in this culture. Significantly, most of these studies err in the same way that *The Feminine Mystique* did in 1963, by primarily describing the experience of middle-class white women and girls—there are no equivalently well-known studies of working-class females or of females of color. Although the studies I cite above do not explicitly claim to be describing universal phenomena, the fact that these are indeed the best-known studies contributes to the misperception that they are describing *all* girls, regardless of class, race, ethnicity, or geographic location. In contrast, historical studies such as Deborah Gray White's *Ar'n't I a Woman? Female Slaves in the Plantation South* (1985) and Gerda Lerner's *The Majority Finds Its Past: Placing Women in History* (1979) are exemplars of the work of recovery essential to the feminist project without sacrificing the specificity we have come to understand as necessary to the demands of good scholarship.

In literary studies there has been a significant body of scholarship devoted to the specific traditions and themes of women writers as well as a growing recognition that the goals defined by the white middle-class founders of the modern feminist movement were often too narrowly confined to the concerns and issues of that group. In the time since second-wave feminism altered the scholarly landscape in literary studies by questioning and revising the canon, recovering silenced texts by women, and asking questions once considered unworthy of literary study, many excellent studies have addressed the gap in knowledge about women's literature. The pioneering studies of Sandra Gilbert and Susan Gubar, as well as Elaine Showalter, examine the specific issues women writers faced as they defied cultural expectations in the very act of writing; Annis Pratt's work on archetypes in

women's fiction argues for a coherent, if problematic, set of thematic concerns.[10] To a great extent, however, women's narratives—and coming-of-age narratives in particular—remain undertheorized, perhaps due to critics' unwillingness to appear unsympathetic as they seem to dismantle women's agency through a critique of social and discursive practices that construct the individual's identity. Most significantly, the American woman's coming-of-age narrative details the cultural work of women who, although they were generally not on the frontlines of the feminist revolution, nonetheless carried out the real work of social change at the individual level. Furthermore, in my view, it is not only productive but necessary to critique women's autobiographies through a poststructuralist lens. If poststructuralism is the coin of the realm, when we refuse to consider the constructedness of women's autobiographies and subjectivity, we risk further marginalization of women's literary works. As Molly Hite argues, women writers are generally thought to be formally conservative in their texts, merely transcribing their lives on the page. This view "presumes a 'natural' or 'straight' style and structure subordinate to and in service of content" (*Other Side* 15), which is another way of subordinating women's texts. Thus, my project is motivated in part by a desire to describe the formal properties of the coming-of-age narrative, which I see as an innovation originating in women's texts, and is now widely used in men's autobiographies as well. I do want to emphasize, however, that I do not accept mainstream poststructuralist theory unproblematically, but feminist revisions of poststructuralism are illuminating and useful in reading women's coming-of-age narratives, precisely because these theories often accurately explain why women commonly experience confusion and alienation as they come of age.

Furthermore, several of the coming-of-age narratives I examine in the chapters ahead contest the possibility of ever telling a verifiable truth in the course of writing a memoir or life story. Mary McCarthy's 1957 autobiography, *Memories of a Catholic Girlhood* begins with a lengthy, italicized "To the Reader" section. Throughout the text, McCarthy intersperses straight narrative with italicized passages in which she comments on the events she has related, and in particular, she deconstructs her own memory. The following passage is typical of these sections:

> There are some semi-fictional touches here. My midyear exam paper for instance: I do not really know whether or not I was asked to contrast the two Haeduan brothers or whether I wrote, "The death of Dumnorix is ironic because a fickle man dies adjuring his

followers to keep faith with him." But this was the kind of question Miss Gowrie would have given and the kind of answer I might have made (164).

McCarthy is ahead of her time in her use of the conventions of fiction to compensate for the lapses in her memory, but readers of autobiography are often on guard for hints of fictionalizing. McCarthy merely finds those places where she imagines a reader might question the veracity of the account and then attempts to answer possible objections. Despite her preemptive strike, however, the boundaries between fiction and autobiography are blurred, leaving a reader off balance, uncertain about whether McCarthy has given a fair and truthful account or an embroidered, fictional rendering. Recently, Ronald Reagan biographer Edmund Morris was excoriated for inserting a fictional version of himself into his narrative in order to create an eyewitness account of Reagan's entire life. And Nobel Peace Prize winner Rigoberta Menchú was the subject of a 1999 study by David Stoll, whose research uncovered evidence that Menchú could not have witnessed or experienced a number of the events she describes in her acclaimed 1987 autobiography, *I, Rigoberta Menchú*. This new evidence has given rise to a heated debate between those who believe that Menchú's entire account is now discredited and those who believe that her political purpose—bringing world-wide attention to the plight of Guatemalans—justifies the use of a "composite" autobiography.[11] Clearly, many readers expect autobiography to present only the "truth," and find fictional elements suspect. In recent years, theorists have increasingly categorized these genre-bending texts as a "fourth genre," or creative nonfiction, but it seems that readers still want a clear distinction between fact and fiction.[12] For example, readers of autobiography are frequently puzzled by Maxine Hong Kingston's *The Woman Warrior*, which intersperses realistic narrative passages with mythology, both familial and cultural. What are readers to make of the story of Fa Mu Lan, the mythic woman warrior of Chinese lore, and its relationship to the actual events of Kingston's life? Kingston does not provide a concordance the way McCarthy does, but in the act of juxtaposing the real with the mythic as if they were equally influential in constructing her identity, Kingston effectively redefines the nature of truth as it is understood in Western culture, and in the process stretches the generic boundaries of autobiography.

This elemental tension between truth and fiction is not new to twentieth-century autobiographical texts, nor is it unique to women's texts. In 1861, Harriet Jacobs wrote "reader, be assured this is no fiction" (1) to no effect;

readers treated her narrative as fiction for more than a hundred years. While former slaves, male and female, felt the need to authenticate their stories through various means, it was particularly necessary for any woman to justify her writing with arguments about the worthiness of her story or its value to anyone but herself and with statements to the effect that, while her memories may be somewhat faulty and her education stunted due to the evils of slavery, she has done the best she could. In contrast, Frederick Douglass seems to feel no such need to apologize for the quality—or justify the existence—of his 1845 *Narrative of the Life of Frederick Douglass*, although it too is accompanied by authenticating testimony.[13] Women's rhetorical positions are in marked contrast to those of canonical male autobiographers, many of whom seem to accept their memory of events unproblematically and who apparently felt little anxiety about the inherent value of their stories. Benjamin Franklin affects a small degree of humility in tone as he opens his narrative with a letter to his son, but he is explicit about the inherent value of his story:

> As constant good fortune has accompanied me even to an advanced period of life, my posterity will perhaps be desirous of learning the means, which I employed, and which, thanks to Providence, so well succeeded with me. They may also deem them fit to be imitated, should any of them find themselves in similar circumstances (1).

Rhetorically, Franklin's text uses understatement to invoke his enormously privileged life, already well known to his readers, as an assumed rationale for the act of writing. In contrast, in the preface to her narrative, Harriet Jacobs writes with a degree of self-effacement typical of women autobiographers before the twentieth century:

> I wish I were more competent to the task I have undertaken. But I trust my readers will excuse deficiencies in consideration of circumstances. I was born and reared in Slavery; and I remained in a Slave State twenty-seven years. Since I have been at the North, it has been necessary for me to work diligently for my own support, and the education of my children. This has not left me much leisure to make up for the loss of early opportunities to improve myself; and it has compelled me to write these pages at regular intervals, whenever I could snatch an hour from household duties (1).

Of course Jacobs is employing the same rhetorical strategies used by male slave narrators to address a particular purpose; in this case, to demonstrate the detrimental effects of slavery on an individual's intellectual development,[14] and certainly to preempt the inevitable criticism leveled at any woman who entered the public arena.[15] Franklin's text is canonical because he is an accomplished, revered public servant, while Jacobs's text is valued for its propagandist properties (and undoubtedly for its prurient, though discreet, glimpse into the sexual double jeopardy facing enslaved women).[16] She is an extraordinary woman by virtue of her life in slavery, her escape, and her unusual (for a former slave) ability to write her experience, but even so, she seems to feel that she is overstepping her place by daring to write her story. More to the point, Franklin's text narrates the events of his "public" life for the purpose of revealing the secrets of his success, an account that does not include recognition of the domestic labor performed in his home that enables him to be successful in the public realm—culturally sanctioned content for autobiography. In contrast, Jacobs's narrative relates events that take place in the private domestic sphere, and therein lies the source of her authorial anxiety. Those dynamics have changed dramatically of course, and the autobiographies discussed later are the beneficiaries of that change. None have yet reached the status of, say, Benjamin Franklin's *Autobiography*, but autobiographies by women are inexorably changing the canonical firmament.

Autobiography provides an especially productive site for the examination of the constructedness of identity; it is "obvious" to many readers that a fictional character possesses a "constructed" identity. There is, after all, an author who had to sit down and create a believable human being. But in autobiography there is no such immediately obvious distinction between the author and the subject "created" in the text, and many readers accept the truth value of such texts unproblematically. The presence of an "I" that corresponds to the name on the title page authorizes the text in ways that novels do not. Therefore, the temptation is to assume that the autobiographer has direct access to the truth, having lived the experiences described. Phillipe LeJeune calls this assumption part of the "autobiographical contract," by which readers understand how to read a text when they realize that the named author is synonymous with the 'I' of the text, and thus is a reliable narrator of the truth (193). Regardless of readerly (or authorly) assumptions, however, autobiographical truths are as much constructed out of the ideologies and discursive practices in circulation at the historical moment of *writing* as any work of fiction. While childhood experiences undoubtedly shape the

textual rendering given at a later date, it is impossible for the autobiographer to recapture the ideology that gave the experiences meaning at the time they occurred. Rather, the autobiographer sees the past through the ideological lenses available to her to make "sense" of her experience as she writes. In the case of the texts considered here, most of which reach back into early childhood, we see the pact begin to unravel. Few of us remember conversations or events from the age of two or three in detail, yet a significant number of female autobiographers venture into this territory, (re)constructing elaborate dialogue and narratives with a proper beginning, middle, and end from early childhood.[17] In her extensive survey, Estelle Jelinek notes that, in contrast to male texts, the female autobiographical tradition since antiquity has been marked by childhood memories and family history (13), providing strength to the argument that female identity formation occurs in the context of relationships.

WESTERN THEORIES OF SUBJECTIVITY

The nature and origin of the self are clearly as central to the study of autobiography as they have been to Western philosophers since Plato, and even though the discussion has by now evolved into postmodern conceptions of the self as constituted in language and through society, the gravitational pull of liberal humanism retains its powerful hold on the Western imagination. Even as postmodernism argues that individuals possess multiple identities that are never fixed, there are myriad textual moments when individuals do appear to have stable identities. In contemporary criticism the order of the day is a dispersed subjectivity, and yet in the process of practicing literary criticism, it is nearly impossible to avoid the appearance that meaning and subjectivity can be fixed once and for all.

Strictly speaking, René Descartes was a precursor of liberal philosophy, but nonetheless, liberal humanism is most often associated with his "*cogito ergo sum*" dictum, arguing first for a deep separation of mind and matter, but also crucially valorizing the mind *over* the body. A "man" may take any bodily form, but as long as "he" is capable of thinking he may be considered human.[18] As Bertrand Russell notes, ". . . the Cartesian system presents two parallel but independent worlds, that of mind and that of matter, each of which can be studied without reference to the other. That the mind does not move the body was a new idea. . . . It had the advantage of making it possible to say that the body does not move the mind" (567). Coupled with John

Locke's idea that the mind is *tabula rasa* until it is filled with experience (620–21), liberal humanism can posit man as being distinguished by his ability to think, and thus to reason as a direct result of experience. Classical liberal theorists subscribe to a metaphysical dualism, a belief that the mind and body constitute two distinct spheres that are only slightly related. Alison Jaggar argues that contemporary liberal philosophy does not explicitly accept metaphysical dualism, but it does accept that "what is especially valuable about human beings is a particular 'mental' capacity, the capacity for rationality," which Jaggar terms "normative dualism" (28). However, the belief that human nature is essentially fixed remains the most lasting and influential element of Enlightenment philosophy, and it is this aspect of liberal humanism that contemporary theory argues against by claiming that human identity is contingent, constructed, and multiple.

Also central to liberal humanist thought is the concept of abstract individualism, which Jaggar defines as "the assumption that the essential human characteristics are properties of individuals and are given independently of any particular social context" (42). For Hegel, nothing external to the mind of the individual affects what he terms "self-consciousness," because

> [T]he world of the individual is only to be understood from the individual himself; and the influence of reality upon the individual, a reality which is represented as having a being all its own . . . receives through this individual absolutely the opposite significance—the individual either lets the stream of reality flowing in upon it have its way, or breaks off and diverts the current of its influence (335).

Feminists and theorists of other marginalized groups have implicitly challenged this tenet through extensive research which demonstrates that the difference between dominant and subordinate groups is the result of different social experiences.[19] Still, such research falls on the deaf ears of Westerners, many of whom insist that since we are all born with equal capacities, we are all the same and therefore any failure of an individual to attain full social and political status is the result of that individual's failure to develop the inherent mental capacity.

Writing in the early nineteenth century, Hegel expanded Descartes's thesis by describing the role the mind plays in determining selfhood and arguing that "[s]elf-consciousness is mind, which has the assurance of having . . . its unity with its own own self" (374). Hegel's discussion in *The*

Phenomenology of Mind of the master/slave relationship illustrates the some-what contradictory assertion that man must engage with the outside world in order to define himself and achieve the desired unity of self. As Kathy E. Ferguson phrases it: "The Hegelian subject always has to go outside itself in order to know what is inside; by seeing itself reflected in the world it discovers relations constitutive of itself" (41). In the case of the master/slave example, it is the struggle for domination that brings about self-consciousness; in the battle for dominion, each finds his place in the social order regardless of whether he wins or loses.

The struggle for dominance marks the nature of the Hegelian subject in several realms. In the course of attaining self-consciousness, man's spirit detaches from nature and eventually incorporates and transcends it. All manner of passions, including sexual relations, family, and death, are to be conquered through reason in order to reaffirm man's primacy in the (male) order of things, which is public and universal. Women are defined as "the everlasting irony of the community" (496), and, Hegel makes clear, are therefore unable to participate in public universal citizenship. In Ferguson's view, the Hegelian process of becoming a subject involves rampant consumption: "Hegel's subject literally eats its way through the world, consuming and destroying . . . the objects of the life world. . . . Taking its identity from destruction, the self-conscious self needs what it destroys and destroys what it needs" (48). Feminists have longed both to be seen as equal to the Hegelian subject and to generate viable alternatives to it. The primary basis of much feminist thought has been an appeal to liberal humanism's promise of equality for all by demonstrating women's equal capacity for reason. Mainstream feminism has thus attempted to revise liberal philosophy by changing its terms, but not its premises.[20] On the other hand, some versions of feminism reject the Hegelian norm of domination, seeking alternatives to consuming and conquering nature and arguing for more peaceful and cooperative ways of attaining subjectivity.[21]

Nonetheless, Hegel's system remains quite powerful in Western culture in spite of later philosophical attempts to dismantle his arguments. Karl Marx was trained as a Hegelian philosopher, but he eventually rejected Hegel's metaphysical dualism, arguing instead that humans are merely one biological species among others, and it is the need to satisfy biological requirements that defines human nature rather than the capacity for rationality (*German* 150). In Marx's view, Hegel's error was in seeing consciousness as produced by thought, whereas Marx argued that external circumstances were unavoidably constitutive of the real. According to Marx, human nature is determined

by social relations, and most particularly by an individual's position in the prevailing mode of production: thus, "[i]t is not the consciousness of men that determines their being but, on the contrary, their social being that determines their consciousness" (*Contribution* 4).

Louis Althusser's understanding of ideology constitutes a revision of the view that *The German Ideology* seems to promote; rather than a set of illusions, ideology becomes a system of representations of the real relations in which people interact and which serve to ensure that the forces of production are reproduced. Ideology does not, however, represent the "real relations which govern the existence of individuals, but the imaginary relation of those individuals to the real relations in which they live" ("Ideology" 165). Ideology for Althusser is thus both real and imaginary—it constitutes the way in which people go about the business of living their lives, but it is imaginary in the sense that it discourages or prevents a full recognition of the real conditions of existence. It is not an illusory sense of consciousness, nor an abstract expression of real material conditions, but the prerequisite for action in the social structure. Ideology exists in the "behavior of people acting according to their beliefs" ("Ideology" 155–59), and it exists in an individual's concept of what is "common sense" as well. Where we perceive an idea to be "natural" or "true" or "right," we see the contours of ideology, in the gaps and contradictions in the cultural narrative. Ideology smooths over contradictions, seems to answer questions that it actually ignores, and attempts to provide a coherent worldview in service of the existing mode of production.

According to Althusser there are no individual purveyors of ideology designed to keep workers in line and reproducing themselves. Ideology exists *necessarily* for Althusser, but is supported by the practices and institutions that he labeled "Ideological State Apparatuses," which include education, religion, the family, the law, and the arts. The ISAs help to reinforce the existing social formation by perpetuating the myths and beliefs necessary to secure the reproduction of the state, and thus the reproduction of the relations of production, especially, for Althusser, the "capitalist relations of exploitation" ("Ideology" 154). Further, ideology's main function, for Althusser, is to construct people as subjects:

> [T]he category of the subject is constitutive of all ideology, but at the same time and immediately I shall add that the category of the subject is only constitutive of all ideology in so far as all ideology has the function (which defines it) of constituting concrete individuals as subjects ("Ideology" 171).

The importance of the assertion that the subject is constitutive of ideology is in its suggestion to subjects that they are autonomous individuals who enjoy complete freedom to decide who and what they are and will do at any given time. In Michel Foucault's description of the same dynamic, liberal humanism secures consent to the social order by telling the individual, "Even though you don't exercise power, you can still be a ruler. Better yet, the more you deny yourself the exercise of power, the more you submit to those in power, then the more this increases your sovereignty" ("Revolutionary" 221). Ideology convinces individuals that they are unique, irreplaceable in society, which in turn prompts a certain acquiescence to the social order that constructs them in this way. Thus, individuals who believe they are irreplaceable in their jobs will continue to go to work, even if they are exploited, demeaned, and otherwise dehumanized, because the prevailing ideology convinces them of the importance of their contribution to the labor force. Althusser conceives of this as "the elementary ideological effect" ("Ideology" 172).

Catherine Belsey sees Althusser's ideas as a reworking of Lacan's "imaginary," in that the relationship of an individual to society is analogous to Lacan's rendering of the child's experience in the mirror phase. In both formulations, subjects are given a unitary sense of self by supplying them with an object that reflects back this satisfying image. Each of these images gives rise to a misrecognition because they idealize and misrepresent the subject's real circumstances. A child in the Lacanian mirror phase is not as whole as that reflection suggests, nor are individuals as free and coherent as ideology tells them they are. Rather, both are pleased with the image of wholeness given back to them, and so submit to it, in the process becoming subjects. But Althusser's theory is ultimately unsatisfactory, according to Belsey, because its definition of ideology is reduced to being primarily an oppressive force that subjugates and suppresses, and because it fails to account for ideological struggle. However, the usefulness of Althusserian theory comes in large measure by extension of the Lacanian insight that language is not only a social activity but also significantly constitutive of social reality and being. According to Lacan, when the child enters the symbolic realm, he does so because he needs a way to account for 'not-I'. The process of understanding the difference between 'I' and 'not-I' involves imagining one's relationship to the world, and in order to do that, the child must enter into language, or the symbolic realm. In this sense, the child's (and subject's) unconscious is not an interior phenomenon but the result of social relations. It is difficult for the subject to access the unconscious because it permeates our being; never

fixed, language—and therefore subjectivity—for Lacan is a process of desire set in motion by difference. Since an autobiography is literally a life constructed with words, the assertion of language's constitutive properties is a highly productive insight for autobiography studies, suggesting as it does the ideological nature of language and its role in determining how we see the world and how the world sees us. Nonetheless, the Lacanian account is problematic in its assumption that women, lacking the phallus, have no access to the symbolic order, resulting in a patriarchal construction of femininity that represses and controls female subjectivity and desire. As such, Lacanian psychoanalysis defines women by lack, and is therefore ultimately an inadequate theory of difference. Always in the process of becoming, the Lacanian woman never reaches full subjectivity. As with the grim determinism of Althusser, Lacan's construction of woman fails to adequately account for the large numbers of women who do in fact resist and act as agents, despite their supposed lack of access to the symbolic order of language.

Invoking Engels's assertion that "[w]e make history ourselves, but in the first place under very definite assumptions and conditions" (761), Raymond Williams argues for a restoration of the notion of direct agency against Althusser's overly deterministic view of human subjectivity. Williams agrees that humans are 'interpellated' by ideology, but sees the location of ideology in a wider range of practices than allowed for in Althusser's theory. Where Althusser sees the purveyors of ideology in the ISAs of school, church, and government as well as in the Repressive State Apparatuses of the police and military, Williams argues that the subject is constructed in language, which he also views as ideological. Beyond its constitutive property, language is historically and socially determined. Warning against the tendency to see ideology as fixed the moment it is named, Williams argues that only the dead can reasonably be reduced to a stable identity. As for the living, "[a]ll the known complexities, the experienced tensions, shifts, and uncertainties, the intricate form of unevenness and confusion, are against the terms of the reduction and soon, by extension, against social analysis itself" (130). For women, a group whose nature has been seen as fixed in time and space throughout history, the implication of Williams's argument is profoundly radical; taking Marx's insight that social being determines social consciousness and extending it logically beyond Marx's own primarily economic, class-based critique, Williams opens up a space for change and resistance, not just for women, but for members of all socially powerless groups. But he also warns us that the claim that people "define and shape their whole lives is true only in abstraction. In any actual society there are specific inequalities in means and therefore in capacity to

realize this process. In a class society these are primarily inequalities between classes" (108), but there are clearly other categories of inequalities in class societies—race, gender, religion, sexual orientation, ethnicity, to name but a few of the more prominent types of social stratification. Conversely, Williams argues that the "totality" of hegemony is an abstraction that fails to account for the active, contingent processes of hegemony in practice (113).

Williams uses Antonio Gramsci's work on hegemony to problematize the Marxist notion of ideology as the "expression or projection of a particular class interest" (108). Hegemony, in Gramsci's formulation, is quite different from either brute force or the duping of unsuspecting subalterns. It often relies on more subtle forms, such as appropriation of discourse and co-opting of interests to gain the consent of subordinate groups. Hegemony is most often negotiated terrain, although of course there are no summit meetings to hammer out these sorts of negotiations. It evolves, and is constantly in the process of changing due to the continual need to renew the hegemony by incorporating and appropriating the interests of dominated groups. Even so, the hegemonic is never able to dominate all aspects of society; there are always spaces of resistance, some implicitly sanctioned as "acceptable" forms of oppositional or alternative culture. In Williams's terms, hegemony is a "whole body of practices and expectations, over the whole of living: our senses and assignments of energy, our shaping perceptions of ourselves and our world. It is a lived system of meanings and values—constitutive and con- stituting—which as they are experienced as practices appear as reciprocally confirming" (110). In other words, social and cultural practices are interlock- ing in that they serve to mutually reinforce the hegemonic. Williams further argues that although agency is expressed in the imagination of individuals, external social forces exert "limits and pressures" on individual desire to resist hegemony, thus coercing consent to normative subjectivity (87).[22]

Although now somewhat discredited, both Althusser and Lacan have provided productive points of departure for more recent theoretical revisions of subjectivity. Stuart Hall, for instance, has found Althusser's theory of inter- pellation useful, but he revises it to reflect concerns beyond the economic sphere. Terming Althusser's definition of ideology too static and lacking in sufficient problematizing of how ideology is created, Hall sees it instead as the vehicle by which we interpret experience. That is, ideology constructs the definitions of our lived realities, but we cannot distinguish ideology from the "real" because ideology *creates* reality. Moreover, for Hall, it is not possi- ble for a single ideology to construct us as subjects; instead, *ideologies* function as systems of representation, with each nodal idea leading inexorably into a

"whole chain of connotative" associations. It is therefore impossible to isolate or identify a pure or unified ideology. As a result, Hall argues (along with most poststructuralist, postmodernist, and postcolonialist critics) that "[t]here is no essential, unitary 'I'—only the fragmentary, contradictory subject I become" ("Signification" 109). This assertion directly opposes Althusser's argument that when the subject is interpellated, s/he is "fixed" as a subject, leading to a monolithic, essentialist view of subjectivity, which Hall argues is erroneous. He sees the interpellation of the subject as an ongoing, plural, and contested process, never finally fixed or unified—how can any one interpellation truly be made to represent and define us? The subject becomes contested terrain as various ideologies and discourses are articulated in and through the subject. Hall's move is reflective of more recent trends to see the subject as constructed of multiple and sometimes conflicted identities, and while this might leave individuals confused by their inability to make their lived experience fit into a neat schematic, it also opens up space for resistance and change. The lack of fixed subjectivity contributes to an anxiety in some texts: for Maxine Hong Kingston, the inability to pin down a stable identity creates a tension between the social imperative to present a unified self and the lived reality of occupying multiple, often contradictory, subject positions.

FEMINIST POSTSTRUCTURALIST REVISIONS OF SUBJECTIVITY

Feminist poststructuralism is particularly useful in the analysis of coming-of-age narratives as many of these texts implicitly theorize subjectivity and explicitly problematize the unitary subject. But these texts also argue against the lack of agency suggested by much Althusserian Marxism and poststructuralist theory; far from showing how women's choices are dictated by social and cultural ideology, many demonstrate the power of those who occupy the social margins. That is, while conventional wisdom might see women as powerless to shape their destinies against the forces of cultural imperatives, the women in these narratives often find ways to define themselves and resist society's interpellation. The more powerless the subject is, the more inventive and creative she tends to be in shaping her life. Foucault reminds us that power is never absolute or wholly negative; it also produces pleasure, discourse, and productive resistance ("Truth" 61). The narratives I consider here in detail provide numerous examples of the ways in which girls and women circumvent society's power plays. Gramsci points out that counter-

hegemonic discourses always exist, thus allowing some room for the subject to maneuver around the ideological imperatives found in school, home, church, and other ideological spheres.

Patricia Waugh notes that the shift from a liberal humanist to a post-structuralist conception of subjectivity is primarily a move away from consciousness and toward language (*Feminine* 7). The subject is thus constructed in language, and since language is characterized by unstable, constantly deferred meanings, the subject too is constantly in process, always denied a fixed identity. Although at first glance this notion seems to make the full range of choices available to each individual, Chris Weedon argues that

> individual access to subjectivity is governed by historically specific social factors and the forms of power at work in a particular society. Social relations, which are always relations of power and powerlessness between different subject positions, will determine the range of forms of subjectivity immediately open to any individual on the basis of gender, race, class, age and cultural background. Where other positions exist but are exclusive to a particular class, race or gender, the excluded individual will have to fight for access by transforming existing power relations (91).

Language or discourses will construct various meanings for the subject, which will open a space for different subjectivities. The difficulty for individuals occurs when they seek to adhere to a unified, uncontradictory identity in the face of often contradictory discourses. As Jane Flax writes, "[t]he unitary self is an effect of many kinds of relations of domination. It can only sustain its unity by splitting off or repressing other parts of its own and others' subjectivity" (109), a move that sometimes leads to madness.[23] Many feminist theorists have noted the irony in the fact that, at a historical moment when women finally began to be recognized as subjects, poststructuralists such as Roland Barthes and Michel Foucault were declaring the "death of the author" and the fallacy of individual agency.[24] But feminists working with poststructuralist theory have substantially revised the rigid determinism associated with early poststructuralism such that agency and social construction of subjectivity are not mutually exclusive theories of identity. Nancy K. Miller argues that postmodern theory's assertion that the author and the subject are of no significance does not

necessarily hold for women, and prematurely forecloses the question of agency for them. Because women have not had the same historical relation of identity to origin, institution, production that men have had, they have not . . . felt burdened by *too much* Self, Ego, Cogito, etc. Because the female subject has juridically been excluded from the polis, hence decentered, "disoriginated," deinstitutionalized, etc., her relation to integrity and textuality, desire and authority displays structurally important differences from that universal pattern (*Subject* 106).

Waugh argues further that it has been necessary for women to pass through a stage of seeking a unified identity, having been denied access to subjectivity throughout history. In recent years, however, women's texts often suggest that "it is possible to experience oneself as a strong and coherent agent in the world, *at the same time* as understanding the extent to which identity and gender are socially constructed" (*Feminine* 13).

A second major assertion of poststructuralism is the notion that experience only attains meaning through language, and since language is constitutive of reality, human beings cannot directly access the truth or meaning of experience without the mediation of language. Since feminists have long asserted the primacy of experience as a producer of knowledge, this is a contentious suggestion. However, Weedon argues that we "must be able to address women's experience by showing where it comes from and how it relates to material social practices and the power relations that structure them" (8). That is, even the meaning of experience is controlled by discourses often unrecognized as such by an individual. A rapist, for instance, might be experienced as criminal by some, and "just a typical male" by others, but how many other ways are available to "read" the actions of a rapist? It is difficult to control the range of meanings assigned to experience precisely because of the available range of discourses to explain it. While it can be difficult to live with contradictory subject positions, the multiplicity of available discourses has proven ultimately liberating for women and others in American culture. As soon as the contradictions are named, a resistance to hegemonic rule becomes possible. The patriarchal hegemony may not be easily overthrown, but it will be altered, and, if Gramsci was right, it will have to change to incorporate new discourses or face its own demise.

3 ❖ Coming of Age in America

We are born, so to speak, twice over; born into existence,
and born into life; born a human being and born a man.
—*Émile*, Jean Jacques Rousseau

"Coming of age" is an imprecise, romantic phrase evoking the period in life during which a child is physiologically, sexually, morally, and socially transformed into an adult. The bodily transformation is involuntary, of course, but when children reach a certain age, nebulously defined as puberty, they are expected to gradually assume adult responsibilities and interests. It suggests a process with no clear beginning or ending and is usually depicted nostalgically only in retrospect by an adult—adolescents themselves rarely display a misty romantic view of their coming of age. In the United States there are few—if any—universally celebrated rites of passage that specifically mark either the beginning of the journey or its successful completion, although there are rituals that are tied to specific communities and cultures, and most depend on class, gender, ethnicity, and historical location: quinceañeras, debutante balls, a first pint of stout, the completion of formal schooling, a first job, marriage, parenthood. In some cases the markers are tied to a specific chronological age, but parenthood, for instance, may be reached with full cultural approval well before the agreed-upon age in another group. An individual of thirteen or fourteen may, for instance, be confirmed in the church or bar/bas mitzvahed in the synagogue, signifying the attainment of spiritual adulthood and the right to participate in the institution's most sacred religious rites—taking communion or reading the Torah. As important as these rites of passage are, in the West no one milestone confers full adult status; children who are recognized as adults by their religious group are unlikely to be considered adults in other ways such as sexually, economically, or politically.

The journey of adolescence is also a physiological process that gradually transforms the body of a child into a sexually mature adult body, and while most social scientists now believe that the nature of adolescence is a culturally specific phenomenon unrelated to the universal physiological changes, popular lore in the West still blames the hormonal changes of puberty for the emotional upheavals of adolescence. In their anthropological study of adolescence, Alice Schlegel and Herbert Barry III note that the transition from girlhood to womanhood in many primitive societies necessitates little change in status since girls are already working alongside their mothers and performing the same tasks and roles that they will later assume as adult women, a dramatic contrast to Western society's mandate that children decisively differentiate from their parents quite early in life (30). In societies where the collective good is privileged over individual desire, "the struggle over individuation may be absent or slight" (Schlegel and Barry 31), clearly suggesting the social construction of adolescence. J. M. Tanner writes that little has changed *biologically* about adolescence for many generations, although those events occur at earlier ages than they did only two or three generations ago. In 1932, a typical English girl would reach menarche at age fifteen, whereas in 1972 the average age was thirteen (2). A 1997 study found that the average age of menarche for U.S. girls is twelve; however, it is important to remember that puberty and the development of secondary sexual characteristics usually begins approximately two years before the first menses, so the changes we associate with adolescence are occurring much earlier than the generally agreed-upon age of thirteen.[1] Biological variations at the end of the twentieth century are primarily due to genetic factors according to Tanner, forcing the examination of social and cultural factors to understand and interpret differences in coming-of-age experiences.

But coming of age is more than milestone events and physiological changes: in the clichéd literary terminology, it is the journey "from innocence to experience" that language-arts readers often thematize; in Joseph Campbell's mythological formulation, it is the death of the child's personality followed by the rebirth of a responsible mature adult, achieved through some trial (123); in the view of many psychologists, it is the birth of moral and sexual consciousness; according to Jung, it is a "psychic birth" that accompanies puberty (7). In short, coming of age is a complex of biological, cultural, psychological, and political events and changes whose meaning is largely determined by the expectations of the culture in which it takes place. And, although the bodily changes that accompany adolescence *are* universal, the meaning of those changes is socially articulated through discursive practices

that serve to define and articulate the parameters of adolescence. The adolescent body is thus disciplined and rendered docile, in Michel Foucault's terms, through the organization and regulation of daily life in space, time, and movement.[2] According to Susan Bordo, "the discipline and normalization of the female body . . . has to be acknowledged as an amazingly durable and flexible strategy of social control" (14); for many adolescent females, the bodily changes of puberty result in new restrictions on their freedom of movement as family and society strive to control their sexuality.

Western discourse of adolescence tends to paint it monolithically as a bittersweet time when brutal truths about life must be learned, and when the pleasures of (heterosexual) love are suddenly apparent and desirable. This narrative universalizes experience by glossing over innumerable possible variations on the journey that affect the epistemic location of an individual, and ultimately it serves to erase difference from the social landscape. Because women, minorities, and the poor traditionally have been excluded or pathologized in major discourses of adolescence—historical, psychological, and literary—which described and valorized white male experience, these exclusions must be named and the pathologies denaturalized to reveal the tensions inherent in coming-of-age narratives that do not fit the paradigm.

HISTORICAL ACCOUNTS OF ADOLESCENCE

The concept of adolescence as a distinct phase of life is usually attributed to eighteenth-century philosopher Jean Jacques Rousseau, who first defined the period between puberty and the attainment of full adult social status as a separate and valuable stage of life in his 1780 philosophical romance, *Émile.* Arguing that the adolescent "would be a very feeble man, but . . . a strong child" (128), Rousseau's aim was to extend childhood—and innocence—as long as possible. For Rousseau, adolescence was a second birth characterized by moral and sexual anxiety that reaches resolution in adulthood, as well as the emotional mood swings now commonly seen as markers of the onset of puberty:

> As the roaring of the waves precedes the tempest, so the murmur of rising passions announces this tumultuous change; a suppressed excitement warns us of the approaching danger. A change of temper, frequent outbreaks of anger, a perpetual stirring of the mind, make the child almost ungovernable (172).

Rousseau claimed that early sexual experience caused young men to be cruel, obsessive, and temperamental, whereas prolonged innocence allows nature to follow its preordained course in creating a compassionate, loving adult (181–82). Removed from the corrupting influence of society and cloistered in nature, the youth is then open to fulfill his biological destiny of becoming a good man in Rousseau's terms. "[A] youth of good birth, one who has preserved his innocence up to the age of twenty, is at that age the best, the most generous, the most loving and lovable of men" (182). For Rousseau then, the moral development of an adolescent must precede sexual development; sexual knowledge and experience rupture the lessons nature will teach if left to work its magic. In other words, the emotional nature of the adolescent creates the compassionate, empathic adult Rousseau views as ideal.

In his monumental two-volume 1905 study, *Adolescence*, G. Stanley Hall "rediscovered" adolescence in the early twentieth century, arriving at many of the same conclusions as Rousseau. Assuming that the age-specific characteristics of adolescence were behavioral extensions of physiological changes, Hall's work is an interdisciplinary study of the emotional turbulence that he sees as a consequence of the physiological processes of puberty that finally abate in early adulthood. Arguing that adolescence is a universal feature of human development, Hall saw its characteristics caused only by physiological events, an assertion that Margaret Mead, for one, attempted to disprove through her study of adolescence in Samoa. In the introduction to her book *Coming of Age in Samoa*, Mead criticizes social theorists like Hall for overgeneralizing about adolescents:

> They observed the behaviour of adolescents in our society, noted down the omnipresent and obvious symptoms of unrest, and announced these as characteristics of the period. Mothers were warned that "daughters in their teens" present special problems. This, said the theorists, is a difficult period. The physical changes which are going on in the bodies of your boys and girls have their definite psychological accompaniments. You can no more evade one than you can the other; as your daughter's body changes from the body of a child to the body of a woman, so inevitably will her spirit change, and that stormily. The theorists looked about them again at the adolescents in our civilization and repeated with great conviction, "Yes, stormily." (12).

It is difficult to miss Mead's irony as she challenges the scientific methods of her fellow social theorists. In light of the calls in recent years to "anthropologize the West,"[3] Mead's articulation of the need to study "primitive" peoples seems simplistic and naive. She argues that the central question of her Samoan research—"Are the disturbances which vex our adolescents due to the nature of adolescence itself or to the civilisation?" (16)—could be answered more reliably through anthropological study of a vastly different civilization, and that the study of a so-called simple society would reduce the number of experimental variables.

Although Mead's study has been criticized in recent years for drawing conclusions unsupported by her own field notes, her conclusion that "adolescence is not necessarily a time of stress and strain" (137) resonates today for several reasons pertinent to my purpose here. Because female development has long been held up to the normative male model and found wanting, the simple insight that any number of variables might alter the paradigm is liberating. Secondly, although Mead saw her Samoan informants as culturally remote from American girls, and further exhibited a certain blind spot regarding their "primitive" simplicity, her basic conclusion is still instructive.[4] If society views adolescence as an inevitably turbulent period, it has more to do with cultural factors (and perhaps self-fulfilling prophecies) than with the forces of biology. Hall's view that the course of adolescence is predetermined by the biological events of puberty is precisely analogous to the historically contemporaneous arguments that women's lives will "naturally" be determined by their reproductive capacities. But whereas boys become men and hence theoretically free of their biological disturbances, girls become women who will ever after be slaves to their biological destiny. Thus, Hall and others created a master narrative of adolescence, characterizing it as a difficult and unhappy time for both the adolescent and society at large. The discourse of adolescence and womanhood alike became rigidly codified through the increasingly "scientific" study of both groups by people who were neither adolescents nor women in a colonizing move similar to one described by Edward Said in his 1978 book, *Orientalism*. Said traces the modern colonization strategy to Napoleon's 1798 invasion of Egypt, noting that instead of plundering the conquered land in the manner of earlier colonizers, Napoleon brought scientists from all disciplines to "take the measure" of Egypt and its people. Turning its mastering gaze on the Egyptians, France studied the "other" in order to create a narrative that justified colonization (80–87). Similarly, adolescents and women have been studied and scrutinized

by the gaze of men of intellect who presumed they understood both groups better than members of the groups themselves, and ultimately asserted mastery through scientific discourse that allowed them to define women and adolescents in similarly negative terms. Just as there was no equivalent study of France by the Egyptians, women (and adolescents) did not launch similar studies of men, a fact that Virginia Woolf noted with some dismay in *A Room of Her Own:*

> Have you any notion how many books are written about women in the course of one year? Have you any notion how many are written by men? Are you aware that you are, perhaps, the most discussed animal in the universe? (26).

Before the systematic study of adolescence, and before the industrial revolution changed American family life once and for all, the adolescent did not labor under the sort of negative perceptions Margaret Mead describes. Adolescents provided considerable and valuable labor to assist the functioning of family life, either by working within the family or doing similar work for others. They assumed the responsibilities of marriage and parenthood at a much earlier age than now considered desirable. According to David Bakan, the concept of adolescence emerged in America largely as a response to late nineteenth- and early twentieth-century industrialization. Its principal purpose was to lengthen childhood in order to allow sufficient preparation for work in the growing urban industrial centers. The massive social and cultural changes wrought by industrialization raised new concerns about how to manage the growing number of people who were no longer children, but not yet legally adults. Bakan notes that three significant social movements during this time period—mandatory public education, child labor laws, and a separate set of legal procedures for adolescents—helped to consolidate and codify adolescence as "the period of time between pubescence, a concrete biological occurrence, and the ages specified by the law for compulsory education, employment, and criminal procedure" (75). That is, legal definitions of who must go to school, who can work and when, and who qualifies for merciful (juvenile) justice helped to bring adolescence forward as a social reality.

Sustaining the idea of adolescence as it evolved historically, Bakan argues, has been the implicit belief in what he calls "the promise," which not incidentally echoes the American dream: ". . . if a young person does all the things he is 'supposed to do' during his adolescence, he will then realize success, status, income, power, and so forth in his adulthood" (83). Implicitly,

Arthur L. Stinchcombe agrees, arguing that rebellion and alienation occur only in high school students who do not expect to gain socially or materially as adults by conforming to the requirements of the unstated social pact (49). But alienation is not solely the province of marginalized people. The alienated white, middle-class male became codified in American culture in the late 1950s with James Dean's *Rebel Without a Cause;* indeed, it could be argued that the foundation of 1960s disaffection with authority originated with the alienation of middle-class white males who consistently positioned themselves as outsiders to the so-called Establishment.

On closer examination, Bakan's social compact could not reasonably be taken seriously by girls until very recently; women's status has changed considerably in the past few decades, but a cursory look at the history of women's lives in America would certainly yield a different set of requirements leading to an entirely different definition of success. Stinchcombe skirted the edge of recognizing the existence of at least two social agreements when he noted in 1964 that high school girls were not as likely to rebel because they saw marriage as a probable career (5–6). Revising Bakan's universal promise to suit the specificity of women's lives might yield a culturally constructed expectation that if a young girl does all the things she is supposed to do during her adolescence, she will then realize a successful marriage to a prosperous man who will provide her with status, a house, children, and a reason for being. But on further analysis, this narrative articulates the goals and aspirations of primarily middle-class white women. How does it sound in the ears of, say, working-class women, or poor women whose status may appear permanent, and who may view home ownership as beyond the realm of possibility? What incentive is there for a nonwhite, nonmiddle-class individual to meet the terms of the agreement that theoretically guarantees success, but in reality operates more like the proverbial carrot on the stick? The emptiness of the promise becomes painfully clear as soon as we shift the context out of small-town white America, since untold numbers of people of color and women have faithfully carried out their end of the bargain—done all they were "supposed to do" to ensure the fulfillment of their fondest dreams—and have been rewarded with disappointment. But broken social compacts do not usually bring about revolutions, because the key phrase here, "If you do everything you're supposed to do, you'll be successful," suggests that any failure to attain the desired goals is the fault of the dreamer, not the dream—or indeed the entire social structure which bases itself on the possibility of the dream's fulfillment. Those for whom the dream does not materialize turn the blame inward, believing they somehow failed to meet the terms of the agree-

ment.[5] Those who know that there are highly specific, but unstated, entrance requirements may doubt the validity of the promise, but they are likely to be defined by society as too lazy or too focused on their victimization to be successful, and thus are silenced. The requirements for adolescents are equally unspecified, and yet most adolescents are well aware of the criteria by which they will be judged.

There is a similar problem with the gendered discourse of adolescence, which typically has established a tenaciously normative model of adolescence; Rousseau's archetypal Émile is a male adolescent, and, except for one chapter on girls in an otherwise minutely detailed study of adolescence, G. Stanley Hall's paradigm of adolescent development is also male. Until the late 1960s and early 1970s, few psychologists, social theorists, philosophers, anthropologists, or literary theorists understood that to describe or theorize about a universal adolescence was to erase myriad variations on the theme in favor of a normatively white, middle-class, male paradigm. When feminist scholars began to study women's development in the seventies, new models and possibilities came to light as the old paradigms were deconstructed, unpacked, and challenged. And, when it became apparent that many early feminist studies created a monolithic portrait of oppressed womanhood meant to account for all women, later theorists sought to describe the ways in which multiple factors such as ethnicity, class, sexuality, religion, temporal and geographic location affect the experience of being female.[6] The discourse of psychology and the social sciences continues to profoundly affect cultural perceptions of adolescence, so while I believe that the tendency of these discourses to create grand narratives obscures difference, and enables society to categorize and thus master the others, it is critical to define the contours of the master narrative in order to weaken its hold on the social imagination.

PSYCHOLOGICAL ACCOUNTS OF ADOLESCENCE

In Louise J. Kaplan's wistful phrase, adolescence marks the "farewell to childhood" as the child begins the journey to adulthood in earnest, grappling with issues of identity, morality, and sexuality. Much psychological theory foundationalizes adult personality and character through an examination of early childhood experience; in this view, the successful resolution of the oedipal phase lays the groundwork for an emotionally healthy adulthood as Freud defined it—later life events are determined by the course of the oedipal

sequence, and none are as critical in the formation of personality. The classical account of the female oedipal drama holds that the little girl learns that she does not have a penis at about age three. Her automatic assumption is that she was castrated, and thus is inferior. This "lack" injures her self-esteem as she becomes preoccupied with her imagined loss, which she experiences as a wound. Since her mother and other women share her lack, they become objects of contempt and the mother is specifically blamed for the loss. The girl then rejects her mother—her first and primary love object—and turns to her father who has the prized appendage, and, she imagines, might provide her with one as well. The girl begins to view her mother as a rival for her father's love, eventually wanting a baby instead of a penis from him. In Freudian theory, the proper outcome of this sequence is a heterosexual orientation.[7] Thus, an incomplete or unresolved oedipal sequence is partly responsible for a girl's inability to shift the locus of her sexuality away from the infantile preoccupation with the clitoris to what Freud sees as the correct origin of a healthy female libido—the vagina (*Three* 614). Failing to shift into a sexuality that allows the female to become the object of sexual relations creates problems for the female adolescent that continue into adulthood, giving rise, in Freud's view, to hysteria and other psychopathologies.

According to Nancy Chodorow, in her influential 1978 study, *The Reproduction of Mothering*, the social organization of gender originates with the fact that, in our society, women do the mothering, and thus raise daughters who can and wish to mother, and sons whose ability to nurture has been suppressed. Chodorow confirms Freud's description of the oedipal phase, but differs with his interpretation of its proper outcome. Whereas Freud argued, for instance, that boys must reject their mothers in order to identify with their fathers, for Chodorow, this system leads to emotionally detached men and to emotionally nurturing women who are thus prepared for future mothering roles. Furthermore, daughters feel less need to separate from their mothers than boys, leading to more fluid ego boundaries and the tendency to define themselves in relation to others (93). However, the valorization by feminists in several disciplines of the communal, relational subjectivity described by Chodorow as the central characteristic of female development ignores the cost of fluid ego boundaries and self-in-relation socialization. Lyn Mikel Brown and Carol Gilligan argue that the cost is no less than the loss of voice and a strong sense of selfhood; girls struggle between wanting what Brown and Gilligan term "authentic relationship" and "fearing that if they voice their feelings and thoughts they will jeopardize relationships" (176). The result is that girls struggle to trust what they know from their lives against a

social imperative to relinquish their selfhood in the interest of cultivating relationship. In adolescence, then, girls struggle *not* to lose what they know from childhood, as their coming-of-age narratives movingly demonstrate. That is, acting to preserve relationships improves girls' social and cultural capital, but often results in a loss of self and voice because many girls fear the isolation that often accompanies a woman who attends to her own wishes and feelings.

Chodorow's concept of self-in-relation has proved useful in understanding and reframing normal female development beyond the borders of her own discipline. Indeed, her arguments are among the primary assertions that reopened the question of the value of women's texts that were once routinely dismissed because they were said to fail to describe universal experience. Feminist theorists used Chodorow's insights to argue that the universal experience was in fact code for male experience, although, it must be noted that however useful it has been, her theory nonetheless reinscribes another master narrative that also essentializes gender characteristics. In addition, Chodorow's use of the Freudian oedipal framework has been critiqued as a continuation of phallocentric theory that many believe to be of limited use. And, as Kaplan notes, Freud's revolutionary emphasis on theories of early childhood has caused subsequent psychological theorizing to obscure and even ignore the vast changes wrought by adolescence (15), in addition to elisions of sexual, racial, and class difference.

Further, Freud's assertions—that infantile desires and the eventual differentiation from the mother are of primary importance in the development of healthy adult personality—have led to a tacit assumption by many psychologists that the adolescent is merely reenacting the earlier individuation from the mother, on a larger and more permanent scale. But Chodorow argues that "mother and daughter maintain elements of their primary relationship which means they feel alike in fundamental ways" (110), resulting in less perceived need for daughters to separate from their mothers. Although this sameness seems to lead, in practice, to many adolescent girls' desire to see themselves as distinct and separate from their mothers, Chodorow views the fulfillment of this desire as finally impossible, since girls are in fact raised by their mothers, who see their daughters as essentially similar to themselves. Furthermore, the supposed universality of the requirement that girls differentiate from their mothers is seriously undermined when the relationships of nonwhite, nonmiddle-class families are examined. Brown and Gilligan, in their 1992 study of adolescent girls at a Cleveland private school, for example, found that the girls who were marginalized by color or class in the predominantly white school often reported close relationships with their

mothers in which conflict was not feared, where both mother and daughter felt free to voice a range of feelings, which allowed "both mother and daughter [to] feel the power they have to affect one another and thus the depths of their connection and love" (226). But this is not the dominant view of mother-daughter relationships, and it remains on the margins of mainstream psychological discourse, which retains significant traces of Freudian theory.

Few psychologists who write about female development are able to avoid Freudian terminology, paradigms, and biases. Peter Blos, for instance, argues that normal female development calls for the adolescent girl to emotionally disengage from her mother, and that this task can only be accomplished with the mother's assistance and guidance. Part of this desirable turn from the mother is accomplished by a new focus on relationships with boys, which he describes as emotional, romantic, possessive, and envious. Some girls attempt to negate their inevitable feminine role by being tomboys or by focusing on their studies, which Blos maintains is "counterbalanced by her turn to the other sex." Further, Blos claims that what girls achieve at this stage is not "genuine" femininity because their relationship to boys is marked by aggression and possessiveness, and that "[t]hese infantile modes of object relation barely hide the narcissistic aspect of her yearnings—namely the need to find a sense of completeness through object possession" (62). Blos fails to imagine both the possibility of positive and desirable relationships between females in a variety of contexts and the possibility that a girl might find fulfillment in other spheres beyond the (hetero) sexual. And finally, Blos's biases do not allow for an analysis of the cultural context and ideological origins of the behavior he describes as normal.

Attempting to redefine normal development, Erik Erikson argues that many psychoanalytic theories about womanhood depend on acceptance of the idea of genital trauma, that moment when the girl suddenly realizes she does not have a penis and never will. This theory, according to Erikson is faulty because it exposes "truths especially true under the circumstances created by the method" (274); that is, Erikson is suggesting that there are inherent biases in the Freudian account that predispose its practitioners to diagnose women's development as problematic. Erikson argues instead for a paradigm shift that creates a normative theory of female development that privileges the psychological significance of what Erikson terms a "productive interior":

> This would allow, then, for a shift of theoretical emphasis from the loss of an external organ to a sense of vital inner potential; from a hateful contempt for the mother to a solidarity with her and other

women; from a "passive" renunciation of male activity to the pur-
poseful and competent pursuit of activities consonant with the pos-
session of ovaries, a uterus, and a vagina; and from a masochistic
pleasure in pain to an ability to stand (and to understand) pain as a
meaningful aspect of human experience in general and of the fem-
inine role in particular (274–75).

Erikson's assertions represent the beginning of the movement away from
pathologizing female psychology and mother/child relations taken up and
legitimized by the women's movement. Although Erikson was unable to con-
ceive of healthy female identity and development that did not include a
woman's eventual commitment to the "love of a stranger and to the care to
be given to his and her offspring" (265), the move away from woman's lack is
an important one in psychological theory. More generally, Erikson argued the
destiny of any individual is a blend of anatomy, history, and personality—not,
as in Freud's formulation for women, simply anatomy (285). Finally, as
Joseph F. Kett notes, Erikson sees identity formation as an "interchange
between the individual and his community, a process by which the commu-
nity recognizes a young person as distinct from other youth" (80), signaling
another crucial move away from the self-absorbed, interior, and individualis-
tic Freudian model of personality formation, one that prefigures feminist the-
ories of female psychology that have tended to emphasize communal and
collaborative models.

The mistake of most psychology theorists beginning with Freud,
according to Kaplan, lies in an overemphasis on sexual development as *the*
determining factor of the course of adolescence. Rather, Kaplan sees ado-
lescence as a period in which humans develop into socially, emotionally,
morally, and sexually mature individuals—a training period, as it were, in
preparation for the adult assumption of power in all its manifestations. For
Kaplan, as for many contemporary psychologists, neither biology, nor society,
nor experience will alone determine the self that emerges at the end of
adolescence:

> In human psychology the direction of causality is not linear. Past
> and present overlap. Present conditions can and often do determine
> the effects of the past. How much and in what ways the precondi-
> tions of infancy and childhood will exert their influence on adult-
> hood is largely contingent on the solutions that emerge during the
> adolescent passage (108).

The solutions that are available during any adolescence are largely dependent on the discourses available to understand and/or resolve the past.

LITERARY ACCOUNTS OF COMING OF AGE

In literary history, the *Bildungsroman,* or novel of development, and the slave narrative appeared at the same historical moment as Rousseau's *Émile,* reflecting the Enlightenment preoccupation with the achievement of the autonomous individual. Both genres are highly formulaic, and both privilege a male paradigm of rugged individualism wherein the hero is nearly always self-reliant. Originating in eighteenth-century Germany with Goethe's 1795 novel *Wilhelm Meister's Apprenticeship,* the *Bildungsroman* rested on a male paradigm of education and experience until well into the twentieth century. A traditional *Bildungsroman* describes the journey of a sensitive boy from childhood through his coming of age as an adult. Schooling is often depicted as a stifling form of education in contrast to the value of educative experiences in the wider world. Frequently, generational conflict develops between the protagonist and most of the adults in his world, although there is often a mentor figure who helps usher the boy into adulthood. The boy's search for his true vocation is the outward manifestation of his simultaneous search for selfhood, usually requiring him to leave his family and home at a young age to find his own path as an individual. Moving from a rural, protected home to a dangerous urban setting brings about the most significant educational experiences of his life, leading first to self-doubt, but ultimately to a reconciliation with the world as he finds it. In adapting to the world and deciding on his vocation, the protagonist finally comes of age as a man.[8]

In defining the *Bildungsroman,* I have specified a male protagonist because the tradition begins with a male model, and because the plot prototype simply does not reflect the development of female protagonists until well into the twentieth century. Joanna Russ notes that a major difficulty for women writers historically has been the severe limitation on the number of plot patterns allotted to heroines; in much of literature, women figure instead as representations of social roles with little existence outside their social functions (4–5). As Elizabeth Abel et al. have observed, the development of an individualistic, solitary figure rarely reflects the developmental path of females. Novels depicting female coming of age diverge from the normatively male *Bildungsroman* through different values and experiences in that "[t]he heroine's developmental course is more conflicted, less direct: separa-

tion tugs against the longing for fusion and the heroine encounters the conviction that identity resides in intimate relationships, especially those of early childhood" (10–11). Furthermore, the *Bildungsroman* constitutes a European male modernist tradition emanating from Enlightenment ideals of integrated universal selfhood and is "animated by a concern for the whole man unfolding organically in all his complexity and richness" (Swales 14). The word "organic" here is highly suggestive of Hegelian selfhood, achieved "by exclusion of every other from itself. It takes its essential nature and absolute object to be Ego; and in this immediacy, in this bare fact of its self-existence, it is individual. That which for it is other stands as unessential object, as object with the impress and character of negation" (Hegel 231). This model of selfhood, although hegemonic in the Western literary tradition, fails to reflect the lived realities of individuals who are not of white male European background. As a model, it may fail to account for the developmental path of individual white males as well, many of whom feel pressure to conform to the paradigm regardless of need or desire, a point to which I will return shortly.

In the last twenty years, critics have routinely pronounced the traditional male *Bildungsroman* dead; it is now commonly seen as an anachronistic genre that survives only as parody in such novels as John Irving's 1976 *The World According to Garp.* The contemporary male *Bildungsroman* "denies the individual's ability to achieve any sense of personal identity and worth in an era of alienation from the society whose values in former times might have confirmed selfhood" (Braendlin 75), but female revisions of the model demonstrate the continuing vitality of the genre, as well as an ongoing cultural preoccupation with how identities emerge and evolve.[9] Esther Kleinbord Labovitz argues that the female *Bildungsroman* only appeared when *Bildung* was genuinely available to women—"[w]hen cultural and social structures appeared to support women's struggle for independence, to go out into the world, engage in careers, in self-discovery and fulfillment, the heroine in fiction began to reflect these changes" (7).

According to Abel et al., there are two main narrative patterns in the female *Bildungsroman:* first, the chronological narrative of apprenticeship that most closely resembles the traditional novel of development, and second, a narrative of significantly delayed development that describes a heroine who might have initially fulfilled traditional roles of wife and mother, but who then "awakens" to her own lack of self-development and begins a process of self-discovery (11). Beyond structural differences, however, female *Bildungsroman* diverges significantly from the male model in terms of thematic

focus. As pioneering feminist literary critics such as Elaine Showalter and Jane Tompkins reexamined fictional heroines through the lens of *Bildungsroman*, the definition gradually evolved to refer to all experience, not simply education (*Bildungsroman* is sometimes translated as "novel of education"), but they were unable, according to Labovitz, to fit the prototypical quest motif into most female fictions of development (245). Thus, *Jane Eyre* and *Little Women* are now often described as *Bildungsromans* although they do not meet the traditional definition.[10] Noting that it is traditional among critics of *Bildungsroman* to revise the genre's definition, Abel et al. have adapted the original critical model to reflect a female path of development (13). Annis Pratt's work with Jungian archetypes in women's fiction, for instance, has been critical to the revision of the definition of *Bildungsroman*, as have studies by Barbara White and Rachel Blau du Plessis, among others. The challenge remains to conceive of a genre flexible enough to encompass various paths of development, and while feminist critics have succeeded in recovering the *Bildungsroman* for female use, there is still a tendency to describe a one-size-fits-all journey of development, one that ends up sounding as much like a grand narrative as the earlier model.

Replacing one grand narrative with another is perhaps the result of recycling an already-established literary form that restricts the norms of male development in the first place, and has in any case proved entirely unsuitable to female narrative. If, as I believe, the goal of liberatory critiques and literary practice is to release individuals from the straightjacket of cultural interpellation, perhaps the mold should be discarded. In my view, twentieth-century American women's autobiography has already parted ways with traditional forms of autobiography and *Bildungsroman*, finding them to be unsatisfactory models, and has created a genre that I am defining as the coming-of-age narrative. This genre has its origins in the earlier forms, which developed simultaneously in the eighteenth century and reflected the philosophical rise of individualism and the consolidation of the liberal humanist subject. However, as Sandra Frieden notes, the lines between autobiography and *Bildungsroman* have been blurred in the latter part of the twentieth century. As the idea of Truth has been challenged and even discarded, many contemporary theorists assert that autobiography is simply a fiction created by the self.[11] Fiction writers, in turn, now routinely blend their personal experience into purportedly fictional narrative. The result is the effective end of traditional forms of autobiography, for both female and male writers. Frieden points out that the moralizing tone found in such canonical works as

Benjamin Franklin's *Autobiography* is now nearly extinct, as autobiographers no longer "humbly portray their erring ways as a negative illustration nor self-righteously present themselves as exemplary" (305).

Perhaps the most intriguing influence on the modern American woman's coming-of-age narrative is that of the slave narrative. Although the archetypal slave narrative is structured by norms of male development, I suggest that it is the most direct literary ancestor of the type of women's narratives I'm concerned with in this study. Concerned with demonstrating how "a slave became a man" in Frederick Douglass's words (294), these narratives thematize the conscious and unconscious aspects of identity formation. In showing that the former slave is capable of gaining his freedom and manhood through his own resourcefulness and conscious decisions, the slave narrative generally privileges rugged individualism and a liberal humanist conception of identity over a conflicted, multiple subjectivity. But these generalizations apply primarily to male narratives. Turning to female narratives such as Harriet Jacobs's *Incidents in the Life of a Slave Girl*, a significantly different model gains purchase. In contrast to Douglass, who seems to have escaped to freedom without assistance of any kind, Jacobs consistently emphasizes that her freedom was achieved through the efforts of many people in her community. In resisting the social definition of herself as chattel, and particularly as sexual object, Jacobs negotiates an identity that attempts to merge ideals of white womanly virtue with pride in the community to which she belongs. It is an uneasy merger; Jacobs herself is well aware that she is not readily given the opportunity to blend subject positions to suit her own preferences. Nonetheless, she succeeds to a remarkable degree in resisting the limited subjectivity that is imposed on her, choosing instead to exercise power in determining her life course. It is difficult, for instance, to imagine Jacobs choosing to hide in a tiny garret for seven years, but in doing so, she claimed agency in piloting her own life.

Unlike the slave narratives, however, the coming-of-age narrative is not constrained by a generic formula. As Olney has written, the white abolitionists of the nineteenth century imposed a uniform and consistent structure on the slave narratives they sponsored and, in some cases, wrote. In their zeal to abolish slavery, abolitionists consistently invoked the subject of liberal humanism through rhetorical gestures designed to elicit sympathy from abolitionists and epiphanies from slavery's advocates. In particular, the slave narratives thematize the separation of families, the cruelty of slavery, the equation of literacy and freedom, and the heartfelt desire of the former slave to participate in mainstream American society. The coming-of-age narrative generally moves in the opposite direction, away from acceptance of main-

stream values and toward a uniquely hybrid subjectivity. Differing in rhetorical purposes, the slave narrative and the coming-of-age narrative serve somewhat divergent political needs. Most critically, however, both genres share a thematic focus on the individual's exercise of power and agency in determining subjectivity.

While most of the texts I discuss in the next chapters are explicitly categorized as autobiography or memoir, they also owe a debt to the *Bildungsroman* as it has been reconceived in less modernist and more inclusive terms by women and minority writers of the twentieth century. Braendlin claims the "new *Bildungsroman* asserts an identity defined by the outsiders themselves or by their own cultures, not by the patriarchal Anglo-American power structure" (75). Citing a renewed interest in the genre by minority writers, Braendlin notes that a body of work now exists that reflects shifting or variant ideologies of subject formation and rejects rigid generic boundaries. The new *Bildungsroman*, writes Braendlin, valorizes the epistemology of experience and the role of community and self-in-relation as the primary influences on development (76–77). Significantly, Braendlin defines the genre as a "more or less autobiographical novel, reflecting an author's desire to universalize personal experience in order to valorize personal identity" (77).

Women's coming-of-age narratives are structurally and ideologically descended from the novel of development, the slave narrative, and the traditional autobiography in that, like the older forms, the coming-of-age narrative privileges the autonomous individual who feels at odds with society.[12] But instead of following the development of a coherent universal subject, the coming-of-age narrative is defiantly specific; rather than valorizing a social integration that requires the partial denial or repression of the subject's identity, these narratives avoid the teleology of a unified self by constructing subjectivity as provisional. The subjects of coming-of-age narratives, like those of the earlier genres, construct themselves as outsiders, but unlike them, they choose to remain marginalized at the end of their texts. In the traditional *Bildungsroman*, the textual end of the hero's journey also marks his reintegration into society, and in the slave narrative, the hero's tale ends with his freedom and status as a full human being. But women's coming-of-age narratives often refuse closure, preferring instead an ambiguous textual ending that affirms the provisional nature of identity. Smith and Watson note that the autobiography today is arguably *the* American master narrative, and that it has grown out of earlier forms of life narratives—most notably the *Bildungsroman*, but also diaries, letters, and oral forms used primarily by marginalized groups (14). I would amend their statement to argue it is the coming-of-age

narrative—female *and* male—that is the archetypal American narrative. If Smith and Watson are correct, then we face the startling notion that most—if not all—Americans see themselves as outsiders, an idea brought full circle by Susan Faludi's 1999 book *Stiffed*, which describes the deep sense of alienation felt by American men. Most of the men Faludi interviewed believed "the promise" as it is formulated by Bakan; they fulfilled their part of the social compact, doing everything society said they were "supposed" to do, but the implied rewards of status, income, and success never came, resulting in widespread alienation. The pattern of disillusionment and alienation from one's immediate and larger social context is a defining feature of the coming-of-age narrative; it is the quintessential outsider's genre.

The disintegration of strict genre boundaries has resulted in fewer autobiographers who position themselves and their experience as exemplary; men are as likely as women to write their narratives in terms of their private selves. Indeed, the texts that purport to tell exemplary lives today are often cynically regarded. Consider the *de rigueur* presidential candidate autobiography that is invariably ghost-written and focused solely on public achievement; personal hardship and private conflict are included only insofar as they demonstrate the would-be president's resiliency and moral fiber. Although these texts are commonly seen as rhetoric designed to make the candidate look appealing and electable, they also provide perhaps the most transparent and self-conscious example of the way in which an autobiographer (or the ghostwriter) constructs an identity that serves to portray the self in a specific light.[13] These texts come the closest to replicating the traditional autobiography in that they are intended to show an exemplary *public* life. In contrast, the most critically acclaimed autobiographies by men in recent years thematize the private drama of growing up and are often written by ordinary men. *Angela's Ashes* was written by a man who grew up to be a public school teacher, and yet Frank McCourt's memoir has been widely praised for its brutally honest portrayal of a difficult childhood. The illusory boundary of the private and public realms in personal narratives has dissolved to such a degree that a domestic, private focus in personal narrative is now not only privileged—it is essentially a requirement.

THE COMING-OF-AGE NARRATIVE

Traditionally, the grand narratives of coming of age for boys and girls differed greatly, and while it may now be acceptable, even laudable, for male authors

to construct their lives in terms of relationship, the journey to manhood is still significantly different from the journey to womanhood. A boy is still expected, for example, to separate himself emotionally from his family, especially his mother, while a girl is still expected to nurture the emotional ties to her family of origin. These varying expectations result in detectable differences in how men and women reconstruct childhood in coming-of-age narratives, just as there are detectable differences in how boys and girls are socialized.[14] The preeminent autobiography theorist, Georges Gusdorf, argued that the ideology of individualism is responsible for the cultural phenomenon of autobiography; there is no autobiographical impulse in societies where there is no "conscious awareness of the singularity of each individual life" (29). But as Susan Stanford Friedman and others have pointed out, this theoretical model exhibits a masculine bias and is flawed when applied to women and minorities. First, it ignores the fact that society imposes a group identity on marginalized individuals, and second, it does not take into account that identity is constructed differently for men and women. Drawing on Chodorow's theories, Friedman argues that women's sense of "identification, interdependence, and community" informs their construction of selfhood (38), and further, this collective identity informs the practice of autobiographical writing by women. The differences in the ways boys and girls are socialized also determines how men and women reconstruct childhood in coming-of-age narratives.

Broadly (and ahistorically) speaking, the process of growing up for a boy in the West means increased independence from others and a heightened sense of his separate individuality. For a girl, the process means initiation into the world of women, by which I mean that becoming a woman signifies the attainment of a mature understanding of her relatedness to other beings, especially other women. Manhood is associated with self-sufficiency, while womanhood is associated with continuing interdependence. In some sense, this assertion is merely a reflection of what our society accepts as natural: boys must repudiate their mothers to become men, but girls must identify with their mothers to become women. While I do not suggest that this is a *necessary* teleology, many coming-of-age narratives reflect these norms, or if they do deviate, the resulting life is either tragic or pathological, or both. The pervasiveness of this dynamic has not disappeared in recent years, but it is now much more common to find female authors thematizing a thirst for the wider world and male writers admitting a lingering attachment to home and family.[15] Significantly, instances of male authors writing about female coming of age, or vice versa, are rare. Obviously, some writers do cross this line—

Thomas Hardy's *Tess of the D'Urbervilles* comes to mind, as does William Faulkner's *The Sound and the Fury*—but these are relatively rare occurrences. Faulkner's view of his tale of Caddy as "his finest failure" is telling; he claimed that the narrative structure of the novel grew from his repeated attempt to capture Caddy's story, but it is significant that none of the four sections that constitute the text are written from her point of view.[16] Caddy is doomed because she isn't "properly" socialized into womanhood; her mother is effectively unavailable to Caddy as an agent for socialization or support. For Caddy there is no collective, connected, self-in-relation—denied a nurtured, interconnected entrance into womanhood, when she finds herself grown and without the support structure that membership in the community of women provides, she is lost.

AMERICAN GRAND NARRATIVES OF COMING OF AGE

Before turning to a closer analysis of women's coming-of-age narratives, it will be useful to examine briefly several novels that illustrate the differences between male and female constructions of childhood; each has been regarded as a grand narrative of American coming of age and at least unofficially regarded as required reading for American adolescents. *Little Women* (1868), arguably *the* grand narrative of American girlhood for generations, is an idealized version of Louisa May Alcott's own childhood that vividly illustrates how girls are socialized to be women, particularly through Alcott's fictional self, Jo March.[17] As in the traditional *Bildungsroman*, Jo is eventually integrated into the society with which she is at odds, but with the difference that Jo continues to view herself as an outsider, even after she has accepted her place in the society of women. Alcott's contemporary Mark Twain produced the boys' version of the archetypal American coming-of-age narrative in 1884: *Huckleberry Finn* holds up the ideal of the autonomous individual, morally at odds with society, who chooses solitude rather than give in to a restrictive (and feminine) society. Huck Finn's coming of age is the polar opposite of Jo March's journey; where she must relinquish her desires in order to claim womanhood, Huck claims manhood by the assertion of his free will.[18] The hero of *The Catcher in the Rye* (1951), Holden Caulfield, like Huck Finn, appears at first to be the archetypal (if profane) *Bildungsroman* hero, but he is ultimately betrayed by the path he is socialized to follow. Like Jo March, Holden is an outsider, so although his background is privileged, he sees himself as marginal. The differences in the narrative outcomes of these novels are highly suggestive of the

potential power—and destructiveness—of marginalization. These novels exemplify the coming-of-age narrative in that they invert the conventions of traditional autobiography and *Bildungsroman*, creating a conflicted, hybrid subjectivity for their heroes that implicitly critiques the liberal humanist valorization of an autonomous—and socially isolated—selfhood.

Little Women teaches female readers the value of serving others and forgetting themselves, of setting ambition aside for marriage and family, and of hiding their negative feelings. But they also learn how a community of women nurtures one another, despite women's differences, through all of life's passages. The central problem for Jo March in becoming a woman is deciding how she will reconcile her unwomanly ambitions and tendencies— that is, her claim to individualism as well as a public life—with the immutable fact of her sex. Her resolution of this conflict and her reconciliation of seemingly irreconcilable desires lies at the core of *Little Women* because Jo's ambitions have nothing to do with fulfillment in the domestic sphere. Furthermore, the resolution will require Jo to relinquish her cherished role as hero and turn herself into a heroine, which, in du Plessis's terms, is "her last act as an individual agent." According to du Plessis, quest and romance are mutually exclusive paths in the nineteenth-century novel, and furthermore, social as well as literary convention pressure females to surrender their quest for self (14). Meg characterizes Jo's "castle in the air" as full of "nothing but horses, inkstands, and novels . . ."; Jo wants to do "something heroic or wonderful that won't be forgotten after I'm dead. I don't know what, but I'm on the watch for it and mean to astonish you all someday" (172). Jo's conflicts are difficult because, of all the girls, she is the farthest from the ideal. Her journey to little womanhood is fraught with disappointments and bitter lessons, leaving Jo and her reader with the unmistakable impression that becoming a woman is a series of compromises of one's individuality—and so it is. The novel resolves neatly because even ornery Jo finally accepts the role society defines for her by story's end, although she does manage to put her own imprint on it. This struggle to find a definition of womanhood one can live with is a critical, paradigmatic rite of passage for girls in twentieth-century coming-of-age narratives. Brown and Gilligan's study of young girls coming of age in contemporary America seems to verify that the tensions and conflicts girls experience have changed only in specifics since Alcott wrote *Little Women:*

> Removing themselves from relationship, these girls struggle daily
> with the seduction of the unattainable: to be all things to all people,

to be perfect girls and model women. As their new-found capacities for abstract thought emerge, girls find it easier to disengage themselves from relational conflicts altogether (180).

Clearly, one of the central concerns of coming of age for girls continues to revolve around balancing their own desires with those of others. For all the gains of feminism in the last thirty years, girls apparently still feel they must shunt aside any needs, feelings, or desires that seem to conflict with the cultural imperative to protect their relationships and to nurture interdependence.

Jo refers to herself as "the man of the house" while her father serves in the Civil War, introduces herself to Laurie as a "businessman—girl, I mean," and generally bemoans the great injustice in her fate in being born female. She is deeply disappointed in being female, preferring instead to play all the swashbuckling, romantic male roles in the sisters' homemade melodramas, and fancying the role of breadwinner for her genteel (but poor) family. But as Joanna Russ reminds us, a woman who tries to fill a male role is untenable in our culture, because she will be considered a failure as a woman (7). The idea of Jo "providing" for her mother and sisters strikes most readers as faintly charming, but in the main, absurd. The central action of the novel serves to socialize Jo to accept and appreciate her place in a circle of women, forgoing the agency of the hero in favor of the passivity of the heroine.[19] In a culture with distinctly drawn roles for men and women, it is critical for Jo to recognize and accept her womanly attributes if she is to be integrated into society.

The first and most difficult fault Jo is asked to overcome is her wild temper. Alcott writes that "[P]oor Jo tried desperately to be good, but her bosom enemy was always ready to flare up and defeat her, and it took years of patient effort to subdue it" (90). Jo's lessons in repressing her anger come, as many others do, at her mother's knee. Having been angry for days at her youngest sister for burning a treasured manuscript, Jo fails to warn Amy about thin ice when they are skating. When Amy falls through and nearly drowns, Jo is tearfully repentant for not forgiving Amy sooner, thus connecting her anger to guilt. She calls her temper "savage," and fears she will do great harm with it someday; in other words, by feeling and voicing anger, Jo nearly kills her sister. As Judith Fetterley points out, "in the world of 'little women,' female anger is so unacceptable that there are no degrees to it"; all anger has terrible consequences (380). Furthermore, in order to maintain the nurturing function of women's culture, each member must keep the greater good of its community in mind at all times. Jo is never completely successful in repressing her feelings (and readers applaud because her expressed desire to

"paddle her own canoe" is her most appealing characteristic), but with the simple passage of time and the indoctrination she receives, she finds more socially acceptable outlets for her sometimes unmanageable feelings. The preservation of the "little sisterhood" of women is of paramount importance in the socialization of women, and Jo is carefully taught to put it above her own individual desires. Although Jo has a true vocation for writing, she is not concerned about whether her work fits standard notions of what literature is. She simply *must* write. However, the action of the plot pushes Jo to place her writing in its proper perspective—in a secondary position to her place as a woman. Although Jo does not take her writing seriously, when she does write, it consumes her. After a period of intense writing, Jo returns to the real world, cross and hungry. Her art is not romanticized; it is literary "labors," and eventually Jo concludes it is not enough to sustain her. With Meg happily married, and Amy crooning blissfully with Laurie, Jo is finally bothered by her solitude: "An old maid, that's what I'm to be. A literary spinster with a pen for a spouse, a family of stories for children, and twenty years hence a morsel of fame, perhaps" (530). This is clearly an unhappy vision, for despite Jo's mother's sermon to the contrary, it is apparently *not* all right to be an old maid under any circumstances. Jo's discomfort at the prospect of old maidhood reinforces the notion that a little woman is happily and wisely married, which will allow her to take part in the collective identity of womanhood. The advantage of a collective identity is that an individual is not isolated from others—she belongs *somewhere*, and her identity is tied to that belonging. As much as Jo relishes her solitary episodes of writing, they do not sustain her; she has been raised in the company of women, to work together with other women to ensure their common good. As Nina Auerbach writes, "[t]he communities of women which have haunted our literary imagination from the beginning are emblems of female self-sufficiency which create their own corporate reality, evoking both wishes and fears" (5). Alcott's March women are models of collaborative economic and social self-sufficiency, and *Little Women* valorizes a socially connected model for coming of age.

Huck Finn, in contrast, is almost completely alone in the world. His father is a drunk who is in jail more often than not and who kidnaps Huck in an attempt to take control of the fortune Huck has earned with Tom Sawyer. If Huck has a mother, he does not mention her. The Widow Douglas stands in as the civilizing and nurturing influence of society in Huck's life, a fact that Huck sometimes appreciates, but just as often finds oppressive. Significantly, Huck is reasonably happy being cared for by the widow, as long as he takes an occasional break from the structure of society by, say, sleeping outside, or

playing hooky from school. It is ultimately the oppression endured at his father's hand, however, that finally drives Huck away from society and down the Mississippi River. But the myth of American identity, according to Nina Baym, "holds that, as something artificial and secondary to human nature, society exerts an unmitigatedly destructive pressure on individuality. . . . There is only one way to relate it to the individual—as an adversary" (71). Thus, in order to discover his essential self, Huck instinctively knows he should seek his destiny alone. And yet, by the end of the novel, Huck is merely contemplating this move—"I reckon I got to light out for the Territory ahead of the rest, because Aunt Sally she's going to adopt me and sivilize me and I can't stand it" (245)—but he has not actually left. The text's formation of Huck's identity shows him developing morally and socially *in relation* to others, with the runaway slave, Jim, who serves as Huck's surrogate mother, father, and community for most of the novel. He knows he is expected to stand on his own in the world, yet he hesitates to leave behind the comforts offered by human society.

An even starker contrast to Alcott's mythic female path of development, *The Catcher in the Rye's* Holden Caulfield could well be a twentieth-century incarnation of Huck Finn. At age sixteen, Holden is alienated on many levels—from his peers, from his family, from society. Like *The Adventures of Huckleberry Finn, The Catcher in the Rye* is not a perfect example of the paradigm of male individualism, since Holden clearly suffers from a lack of connection to the world around him. He could use, in other words, some sense of the collective identity the March girls enjoy. But he feels he should not depend on anyone but himself because he has taken the cultural imperative for male self-sufficiency to such an extreme level—before he is mature enough to be truly independent—that he suffers a nervous breakdown.

Like Huck Finn, Holden Caulfield is clearly adrift: he is failing four classes and he is about to be expelled from the expensive prep school he attends. Instead of calling his parents for help and support, Holden decides it is time he toughed it out alone since this is not the first time he has been expelled from school. His aged teacher, Mr. Spencer, makes a half-hearted attempt to help Holden get his priorities in order, but this teacher also implicitly accepts the notion that Holden must find his own way in the world, without meaningful support. The only acceptable path to manhood involves asserting one's individuality against society, but as Holden finds, not all boys are able to successfully enact that rite of passage. He tries to enact his version of Huck Finn's paradigm by striking out for the "wilderness" of New York, on his own, and in doing so, to complete his passage to manhood. Like

Huck's, Holden's coming of age is finally unsuccessful—he ends up in a mental institution, which, as we have seen, signifies his inability to assume his assigned part in the common discourse.

Holden's enactment of male coming of age falls short of the ideal because he is unable to negotiate the terrain successfully. However, as an example of the way men are expected to negotiate their passage to manhood, it provides a telling critique. Model males are defined by solitary individualism, and *The Catcher in the Rye* does reflect the cultural expectation that boys must not create their identities in relation to others. Indeed, Salinger appears to be critiquing this paradigm, since his protagonist suffers so greatly from lack of relation to anyone or anything. The social path to manhood requires that men all but cut ties to their parents, especially their mothers. If they fail to individuate from their female parents, they are looked upon as failed men. Holden's desire for connectedness is evident in his desire to make contact with his twelve-year-old sister, Phoebe, while he plays at being grown up. Borrowing money from Phoebe, Holden claims he is going to strike out for the wilderness—the West—for real, but when Phoebe insists on going with him, his unconscious purpose is lost. He will not grow to manhood (that is, become self-sufficient) with his little sister at his side, and yet he cannot bring himself to leave her behind. Instead, he watches her ride the carousel in Central Park and weeps uncontrollably. He *knows* he is supposed to cut this tie, and yet it is the only tether he has to society. Holden's inability to sever the connection to his sister effectively prevents him from enacting the rite of passage he tacitly understands he is expected to make. In contrast, we know the March girls have made it safely to womanhood when we see the petty squabbles and rivalry that informed their adolescent relations transformed into a profound sense of interdependence with each other. This dependence is not a negative; rather, as Friedman notes, it is a significant source of support and validation. While the rest of society devalues women, women value their relations with each other. As such, they are countering with an alternative view of subjectivity from the dominant, individualistic paradigm.

Coming-of-age stories, then, depict the various degrees of success with which their protagonists negotiate the socially sanctioned paths for boys and girls to adulthood. While Americans do not mark these rites of passage with formal ritual, there is nonetheless a paradigm that each child knows that he or she must enact (having been taught it implicitly) in order to fulfill society's definition of gendered adulthood. The child who follows the path prescribed for members of the opposite sex faces social approbation or even ostracization. Thus, many coming-of-age narratives confront the ways in which the

subject, willingly or not, is gradually guided toward his or her culturally ordained role in life.

If, as I am arguing, *Little Women, Huck Finn,* and *The Catcher in the Rye* constitute grand narratives of coming of age in America, we might expect to see the same conflicts and processes, as well as similar subjectivity construction, enacted in autobiographies. Myra Jehlen argues that the novel "evolved to deal with the psychological and emotional issues of a patriarchal society" (600), a point which is borne out in these three novels. In Jehlen's view, the interior life of the novel is female, even if the character in question is male, so that Holden Caulfield's struggle to assume a comfortable identity can be seen to reflect the female side of his character. Further, she argues that there is a tragic element in the novel, "a doomed encounter between the female self and the middle-class world" (597), an apt description of Holden's—and Huck's dilemma. An androgynous identity, according to Jehlen, is the prerogative of males in the traditional novel, allowing them to act from their male side and feel from their female side (596), but Holden is unable to perform the socially sanctioned script of masculinity by enacting his male side, signifying his pathological condition in terms of the normative masculinity of middle-class society. Conversely, because she learns to deny her male side, Jo March is able to exercise the only power available to her by accepting her place in the private realm of women. As Jehlen correctly observes, the interior lives of women characters are a defining feature of the novel, and any move by female characters toward public, exterior lives and action is effectively extinguished in most novels; Jo's fate in *Little Women* is exemplary of this narrative dynamic.

On the assumption that novels are more easily molded into tidy narratives reflecting, consciously or not, various ideologies, I want to argue that the pressures Jehlen observes in the novel also appear in female coming-of-age narratives, but the binary opposition between exterior and interior, public and private, is resisted successfully in these texts. Annie Dillard, for instance, describes coming to consciousness as a dramatic event. Her narrative of growing up is nearly all interior, and based on that text alone, we cannot draw any conclusions about her later ability to act in the public realm. Of course, the fact of publishing at least one book (although she has published extensively) suggests that Dillard is able to shift between interior and exterior life as needed and, crucially, at will. Like Alcott, Dillard wants to do something important when she is grown, but unlike Alcott, who subsumed her own story of resistance and alternative subjectivity in favor of a fictional marriage plot,

Dillard's narrative is labeled autobiography, which necessarily implies that she did indeed find the power to act in the public realm.

The limits of Jehlen's formulation are immediately apparent, however, when it is applied to a text that does not originate in the middle class. Anne Moody learns to differentiate between her exterior and interior life at an early age, although this division is not necessarily gendered; in her case, the opposition clearly arises from a racial awareness that, in order to survive in a white world, her interior life must be suppressed. Moody's interior life, however, as related in her memoir, is rich with feeling and power, and indeed, contra Jehlen's assertion, she is able to harness the power of her interior life to enable action in the public realm of the civil rights movement. As Watson argues, women and other marginalized groups learn "to conceal what power they do have to protect themselves" (113), a strategy that is thematized in Moody's text.

Although the privileged American coming-of-age narrative idealizes the solitary individual at odds with a conformist society, canonical male narratives in fact reveal a subtext that demonstrate the detrimental effects of the social isolationism encouraged by the liberal humanist account of identity. In the final analysis, Huck Finn and Holden Caulfield suffer from their lack of human connection, leaving only escape or madness as narrative choices. The alternative female subjectivity described by Gilligan, Chodorow, and others in which women construct their identities in relationship is, at this historic moment, a hegemonic ideology that does not take notice of women's narratives that do not conform to the dominant construction of female subjectivity. Conversely, because the ideology of self-in-relation is ascribed solely to women, we often fail to recognize when male narratives inscribe and privilege relationship. The American woman's coming-of-age narrative is not uniform in its performance of female identity; Anne Moody constructs herself as an entirely autonomous individual with no need for relationship, perhaps in part because she is disappointed repeatedly in her relationship with her family, her community, and her nation. At the other end of the spectrum, Maxine Hong Kingston's identity originates almost completely in her relationships to the women in her life. On the whole, these narratives insist on the specificity of human identity as it is contextualized historically, socially, and culturally, and on the critical determining factor of social relationships throughout history.

4 ❖ Specifying American Girlhood

Annie Dillard and Anne Moody

> Power is the ability to take one's place in whatever dis-
> course is essential to action and the right to have one's part
> matter.
>
> —*Writing A Woman's Life*, Carolyn G. Heilbrun

Unconcerned with representing an exemplary public life, the American
woman's coming-of-age narrative dwells in the specificity of what Adri-
enne Rich has called the "politics of location," referring to the multiple sub-
ject positions held by every individual.[1] As such, these texts resist the
universalizing impulse to erase difference precisely because it is difficult to
discern any recurring patterns. But, as Clifford Geertz observes, the lack of
universality in a particular cultural text does not detract from its ability to
illuminate significant features of the human condition (44). "To be human,"
writes Geertz, "is not to be Everyman; it is to be a particular kind of man,
and of course, men differ" (53). While his use of "man" and "Everyman" is
dissonant in the context of my analysis of women's narratives, the principle
is sound—and still radical, in spite of critical theory's preoccupation with dif-
ference over the past thirty years. Becoming a subject is a complex, dynamic
process with multiple determining factors, none of which guarantees a stable
identity. For Geertz, we "complete or finish ourselves through culture—and
not through culture in general, but through highly particular forms of it"
(49). Paired with Althusser's conception of the social formations that he calls
Ideological State Apparatuses—schools, religion, family, politics, communi-
cations, and the arts (150)—Geertz's definition of culture, as a symbol
system with a historical context by which people create knowledge and

assign meaning, provides a useful framework for peeling away the layers of history to articulate the multivalent individual life. Few, if any, individuals will have equal access to all the "tools" of culture, and it is this variable that is the foundation of difference within and across groups. Thus, it is not possible to draw conclusions about what it means to come of age as a woman in America per se, given the vast diversity of its people, but it *is* possible to limn the contours of particular pockets of the culture through the study of individual accounts of coming of age, while resisting the impulse, in Geertz's words, "to take refuge in bloodless universals" (43).

Yet the impulse to universalize about experience is powerful and pervasive, as is the tendency to treat experience as an unmediated producer of truth. In Chris Weedon's view, theory needs to problematize women's experience by articulating the discursive sources and how they are implicated in material reality; for Weedon, naming the origins of conflicting subjectivities unmasks the relations of power, which in turn opens up the possibility for counterhegemonic discourses (8). In feminist discourse, essentializing practices have often been the result of well-meaning attempts to galvanize women, whose dispersion across class, race, and other divides has made feminist political solidarity such a difficult feat. At bottom, the creation of master narratives, regardless of the source, is a form of what Linda Alcoff has called "speaking for others"; it is a representation and interpretation of a life that is necessarily mediated by ideology ("Problem" 9). Furthermore, for Alcoff, "the impetus to *always* be the speaker and to speak in all situations must be seen for what it is: a desire for mastery and domination" (24). But what if the master narrative is created by an individual whose social location is on the margins?

SPECIFYING THE UNIVERSAL IN *AN AMERICAN CHILDHOOD*

Although it would be overstating the case to assert that Annie Dillard is aggressively speaking for others in an attempt to master and dominate, her 1987 memoir *An American Childhood* frequently lapses into universalizing statements, starting with a title that evokes archetypes and immediately positions her text as representing all American childhoods. And yet, the use of the indefinite article 'an' signals a *particular* childhood that is attached to a larger unified narrative of American-ness. The ambiguity of Dillard's title is reflected in the text itself as the narrative voice shifts from the particular to the universal. Dillard occupies a social location that has historically rendered

itself as normative; that is, she is white, upper-middle-class Protestant—and female. Only by virtue of her sex can she claim social marginalization, but by and large, she makes no such claim. Rather, I want to argue that Dillard is attempting to claim membership in the pantheon of the literary coming-of-age canon that has traditionally excluded women's journeys from contributing anything to the illumination of American culture. As Tillie Olsen observes, in male literary criticism, "women writers, women's experience, and literature written by women are by definition minor. (Mailer will not grant even the minor: 'the one thing a writer has to have is balls')" (47–48). The grounds for women's exclusion typically were cast in terms of the purportedly trivial and highly specified content of women's lives. The archetypal coming-of-age plot has been inscribed as male, as I discussed in the previous chapter, but here, Dillard often erases sexual and other difference through frequent lapses from first-person into second- and third-person narrative. Moving the narrative focalizer away from explicit identification with a specific narrator—Dillard—to a universal "you" or "the child" works to disrupt the narrative flow and to erase differences between Dillard and other individuals. Since most of the narrative does describe a historically contextualized, embodied, class-, sex-, ethnic-, and race-specific individual life, it is productive to ask what purpose is served by these textual departures. The first such passage occurs only eleven pages into *An American Childhood:*

> Children ten years old wake and find themselves here, discover themselves to have been here all along; is this sad? They wake like sleepwalkers, in full stride; they wake like people brought back from cardiac arrest or from drowning: *in medias res*, surrounded by familiar people and objects, equipped with a hundred skills. They know the neighborhood, they can read and write English, they are old hands at the commonplace mysteries, and yet they feel themselves to have just stepped off the boat, just converged with their bodies, just flown down from a trance, to lodge in an eerily familiar life already under way (11).

By shifting the narrative point of view, albeit briefly, to a grand narrative of childhood, Dillard suggests that her own coming of age is much like everyone else's regardless of time, place, race, sex, class, or any one of dozens of subject positions. Though this move may be read as universalizing, it is subverted by the text's pervasive suggestions of marginalization and resistance. Jill Ker Conway argues that "[m]emoirs full of abrupt transitions and shifting

narrative styles are sure signs that their authors are struggling to overcome the cultural taboos that define [them] as witnesses rather than actors in life's events" (*When* 88). While I would agree that these shifts do signal narrative tension, I read them instead as evidence that Dillard is claiming a position as definer and creator of identity. She is philosophizing rather than universalizing, and thus the textual "lapses" into an apparent third-person master narrative in *An American Childhood* are in fact Dillard's meditations on the meaning of life. Her philosophy throughout the memoir echoes Martin Heidegger's notion of being "thrown" or projected into existence, or, as Dillard puts it, *in medias res.* Thus, we are projected into a specific set of social circumstances, already in place, a constant of human existence, according to Heidegger.

The passages that depart from first-person narrative are revealing as, ironically, they can be read as pointers to textual silences, in Macherey's terms, which implicitly convey the ideological underpinnings of the narrative. Macherey argues that "[w]hat is important in the work is what it does not say," and furthermore, "what it *cannot* say is important because there the elaboration of the utterance is acted out . . ." (87). Strictly speaking, the second- and third-person narrative sections are not silences, but nonetheless they function as silences that are productive of readerly questions. What Dillard seems to be unable to say is that her narrative has value *without* referencing the universal; she has implicitly accepted the notion that a cultural narrative must be universal to be of value in illuminating the human condition. As Heilbrun points out, there are "many moving [autobiographies] of women, but they are painful, the price is high, the anxiety intense, because there is no script to follow, no story betraying how one is to act, let alone any alternative stories" (39). *An American Childhood* is an important text precisely because it does reveal the specificity of a particular cultural formation, regardless of the relative privilege of Dillard's position, and as such, it is an attempt to create an alternative way of writing the narrative of a life. But this attempt is not without its price, as Heilbrun suggests, and as Dillard's use of third-person narration attests.

Immediately following the passage quoted above, the narrative returns to a first-person narration that serves to restate the subtext of the previous passage by specifying; that is, Dillard uses her own experience as a way of testing the philosophical theory she is developing throughout the text:

> I woke in bits, like all children, piecemeal over the years. I discovered myself and the world, and forgot them, and discovered them

again. I woke at intervals until, by that September when Father went down the river, the intervals of waking tipped the scales, and I was more often awake than not. I noticed this process of waking, and predicted with terrifying logic that one of these years not far away I would be awake continuously and never slip back, and never be free of myself again (11).

The first-person narrative is deeply concerned with the meaning of *a* life, so Dillard's reconstruction of her childhood, far from generalized, is carefully located in a specific historic location where she constructs herself as an outsider due to her specific childhood interests, viewpoints, and preoccupations.

The central metaphor for coming of age in *An American Childhood* is that of a sleepwalker who gradually awakens, an image Dillard deploys most consistently in the second- and third-person narrative passages throughout the text, which serves to authorize her interpretation of her life. To write that she, Annie, awakened bit by bit does not carry as much cultural weight as to assert that "all" children come to consciousness in this way, thus further revealing a certain authorial anxiety. For Dillard, awakening means to become aware and conscious of self, the world of the senses, and most powerfully, to the contradictory, even hypocritical, moral universe of adults. In Heidegger's view, this awakening is tantamount to Da-sein, which is marked by the fact that "in its being this being is concerned *about* its very being" (10). The state of existence, for Heidegger, is characterized by an acute self-consciousness of one's place in the world (what feminists might call self-in-relation) as well as one's mortality. Arguing that the process of coming to consciousness is achieved without effort or conflict (though not without pain), Dillard writes:

> Like any child, I slipped into myself perfectly fitted, as a diver meets her reflection in a pool. Her fingertips enter the fingertips on the water, her wrists slide up her arms. The diver wraps herself in her reflection wholly, sealing it at the toes, and wears it as she climbs rising from the pool, and ever after (11).

As Sidonie Smith has argued, Dillard seems to be positing an identical "suit of skin and suit of self," which assumes an unconflicted and fixed subjectivity (*Subjectivity* 132). The possibility of a bad fit is not acknowledged here as Dillard's metaphor invokes a coherent and unified identity, which raises the question, as Seyla Benhabib writes, of "how [a] finite, embodied creature constitute[s] into a coherent narrative those episodes of choice and limitation,

agency and suffering, initiative and dependence" (161), and which is precisely the problem Dillard struggles with in her narrative. Despite her claim of a comfortable sense of identity, Dillard's memoir reveals numerous sites of contestation between herself and society. Contradictions to the image of a perfectly fitted selfhood are simply present in the text, but unacknowledged as such, again because the imperative to present a coherent self is pervasive in Western society. While this image does call upon liberal humanist notions of self by invoking a generic description of childhood, Dillard also actively challenges the separation of mind and body so central to liberal thought.

The body's tactile and sensory experiences—and the knowledge produced by those experiences—are critical to her growing self-awareness as she frequently reads the text of her life through the body, which helps to determine the meaning she assigns to her experience. Of course, the body's response is not the only mediator of meaning, as the discursive signifying practices of her specific historical location contribute to her interpretation of her own experience as well, a point I will develop shortly. Implicitly, Dillard recognizes that the body is capable of transmitting and receiving knowledge, and she attends carefully to the clues it gives. Slipping into second-person narration, Dillard describes how she "knows" her neighborhood: "It was your whole body that knew those sidewalks and streets" (104), thus suggesting that her knowledge of the city extends beyond the cognitive recognition of street names and embeds itself in her very body, which she suggests is true for "you" too. Dillard is positing a body capable of *knowing* the streets and the landscape, in the same way our bodies *know* our signatures without cognitive assistance. And because our bodies know certain things, so we, as beings made up of body *and* mind, know things. Dillard sees her body working in concert with her mind as a means to know and understand, and thus makes a profoundly antihumanist argument. "Knowledge," she writes, "wasn't a body, or a tree, but instead air, or space, or *being*—whatever pervaded, whatever never ended and fitted into the smallest cracks and the widest space between stars" (107; emphasis added).

The body is also capable of showing and using its knowledge in Dillard's text. Feeling the "inexpressible joy" and "the gratitude of the ten-year-old who wakes to her own energy" (107–108), Dillard begins to run down a sidewalk in Pittsburgh as fast as she can: "I knew well that people could not fly— as well as anyone knows it—but I also knew the kicker: that, as the books put it, with faith all things are possible" (107). Having noticed a physical dissipation and calming of this "inexpressible joy" as each day wore on, she decides that for once she wants "to let it rip" (108). Running, then, down the side-

walk, for blocks and blocks, arms flapping, heart pounding, lungs burning, Dillard is 'flying' at last, though her feet never leave the ground. From this extremely physical moment, she comes to know her own capacity to "let it rip" in every sense without fearing looking foolish in others' eyes. She has tested her own capacity for boldness through a bodily act, and in doing so, she acknowledges that her body is inextricable from her mind in the process of knowing.

The materiality of life is foregrounded early in *An American Childhood*, when Dillard asserts in the first chapter that the foundation of her identity is in part determined by the topography of her geographical location. To tell the story of her childhood, she "anthropologizes" her self by means of a distancing, third-person narrative "thick description" whose purpose is to make sense of a elliptical, contradictory social context.[2] Her physical exploration and experience of her home, her neighborhood, and Pittsburgh at large, as well the ideologies contained in those sites, is explicitly acknowledged in the text as significant determinants of Dillard's subjectivity, and these details mitigate any universalizing by grounding the narrative in place. Throughout *An American Childhood*, the history and geography of Pittsburgh are tied to the development of her subjectivity:[3]

> A child is asleep. Her private life unwinds inside her skin and skull; only as she sheds childhood, first one decade and then another, can she locate the actual, historical stream, see the setting of her dreaming private life—the nation, the city, the neighborhood, the house where the family lives—as an actual project underway, a project living people willed, and made well or failed, and are still making, herself among them (74).

If coming of age is an intensive period during which an individual begins to make sense of the cultural "webs of significance" that contextualize subjectivity, and the individual strands of that web exert their ever more powerful pressure on the formation of subjectivity, then the influence of the "historical stream" can be distinguished as one of many determining factors of subjectivity. Here again, echoes of Heidegger's notion that we are "thrown" into history can help us situate Dillard's philosophical musings as radically *antiliberal humanist*, for although she is again using the universal third-person narrator, she is arguing that humans are contextual beings whose identity and consciousness *as* beings arises in recognition of the social context into which life projects them. Following Heidegger, Hans-Georg Gadamer

claims that before we consciously come to know ourselves, we first "understand ourselves in a self-evident way in the family, society, and state in which we live" (276), and it is this claim that we see Dillard making in the passage above. Moreover, for Gadamer, we are owned by tradition long before we own it ourselves. While Gadamer defines authority (which I read as "hegemony") as "that which has been sanctioned by tradition and custom" (280), I understand it to be the discursive formations, social practices—the "historical stream" in Dillard's words—and the particular history that has been handed down. No discourse or practice emerges fully formed from thin air; rather, it is a constantly evolving formation, influenced by other discourses and practices that are also constantly shifting. For Geertz, the web is composed of words, gestures, visual information, sounds, and objects, which are used to make sense of lived experience. Broadly defined, these "significant symbols" are the discursive practices in circulation at a given moment in a specific culture when individuals are born, which they will use throughout their lives "to put a construction upon the events through which [they live]" (45). But the meaning attached to these symbols is variable across and within cultures, their meanings continually revised and adapted. Consequently, the meaning of experience cannot be fixed, but rather is fluid and provisional.

In the growth of children into adulthood, the lack of fixed meaning is most clearly evident in the changing interpretation given to various constants of life[4]—parents, religion, or education—as we grow older, and although Western culture, after Hegel, tends to view adult identity (or essence) as fixed, the evolution of meanings assigned to these constants continues throughout life. At one level, Annie Dillard provides evidence for this claim through a detailed explication of her childhood view of adult skin, which she saw as a "defect" and viewed, at least in retrospect, as evidence of adults' ongoing physical degeneration in contrast to the "wholeness" and "absence of decrepitude" in children's bodies (24). But the evolution of her viewpoint brings her to the realization that adult beauty, when it had been displayed, was earned, and constitutes evidence of adult power. Echoing Gadamer's notion that we belong to history before it belongs to us, Dillard realizes that "[w]e could not, finally, discount the fact that in some sense *they owned us*, and they owned the world" (24; emphasis added). Despite this overwhelming evidence of adult power, Dillard takes pride in the specific instances of power wielded by her parents: her mother's beauty, her father's tallness, their wit and splendor. She hopes other adults are as awed by their superiority as she is. But of course this view changes as Dillard enters adolescence, when she will scrutinize her parents for any hint of weakness or hypocrisy.

Deconstructing wholeness is key in the process of coming of age. From a psychological perspective, wholeness or coherence comes under scrutiny in adolescence as the assumptions of childhood are questioned; according to Kagan, "the resulting incompatibility [of old assumptions and new perspectives] is resolved by delegitimizing the earlier assumption" (96). A common example of this evolution in thought is that a child's unquestioning belief in the goodness of God is challenged in early adolescence by the realization that there is great pain and suffering in the world. Instead of rationalizing ways in which a benevolent deity might coexist with a suffering world, the adolescent is just as likely to reject *any* belief in God. Faced with a paradoxical world, the adolescent has no choice but to leave behind the simpler perceptions of childhood and find ways to reconcile earlier assumptions with new perceptions. Ideologies of childhood in the latter part of the twentieth century holds that childhood is a time of innocence, precisely because a child's worldview is believed to be coherent. As Weedon writes, the practice of seeing ourselves as coherent subjects begins in early childhood; "[w]e learn that, as rational individuals, we should be non-contradictory and in control of the meaning of our lives" (76). The loss of a unified worldview—and by implication, a unified self—is constructed as a negative, so coming of age is widely viewed as bittersweet; indeed, a cornerstone of psychological theory holds that the healthy individual possesses a unified personality (Erikson 92). Furthermore, as Norman Holland argues, the reader "will have different ways of making the text into an experience with a coherence and significance that satisfies" (816), but when the text thwarts that desire for narrative coherence—as these coming-of-age narratives so often do—the reader also experiences the alienation of a fragmented identification. And yet it is precisely this identification with the fragmented sense of self common in women's coming-of-age narratives that have made them so powerful in shifting dominant ideologies of womanhood. That which was a "problem with no name" was gradually named and articulated in complex detail, and while new ideologies can be as restrictive as the old ones, it has become difficult in this postmodern age to accept uncritically the notion of a unitary subjectivity.

Annie Dillard describes paradigmatic shifts in understanding that occur throughout her adolescence, which are part of the process of self-examination that Gadamer claims is necessary to attain self-knowledge; indeed, these shifts are a distinguishing feature of coming of age in America. No longer accepting the received tradition unproblematically, the adolescent is on a quest to understand the world through her own eyes. As a child, Dillard loves going to church and believes passionately in God; as an adolescent, she notices that her parents never attend church—they drop her off and pick her

up, signaling to Dillard their unforgivable hypocrisy. Contrasting the materialism of the wealthy Presbyterian Church and its fur-clad congregation with the simplicity of Christ's radically antimaterialist life and message, Dillard rejects religion entirely, even writing a formal letter of resignation to her pastor, noting that she "knew enough Bible to damn these people to hell, citing chapter and verse" (196). Church is also the site that finally codifies class and gender difference for Dillard. Realizing that a random event of birth is the ticket of admission to her church—and to life—Dillard defines birthright as the families and institutions that constitute the individual. She realizes that she cannot escape the ideology that gives her a privileged position while others are unfairly excluded, although she tries to distance herself from her own privilege by aligning herself with those who are excluded. Her pastor's radio ministry brings in letters of admiration from "Alaskan lumberjacks and fishermen. The poor saps. What if one of them, a lumberjack, showed up in Pittsburgh wearing a lumberjack shirt and actually tried to enter the church building? Maybe the ushers were really bouncers" (195).

By virtue of her birth, Dillard is called into being by a specific set of what Althusser would clearly see as Ideological State Apparatuses—here, an upper-class Presbyterian Church and all its related organizations and institutions. Though Dillard is socialized to accept her privilege, she recognizes the absence of fairness or rightness in her unearned inheritance of privilege. Her insight that others are excluded from those sites by virtue of their *different* social locations results in a deep disillusionment, which the adult Dillard reads as a loss of innocence. The loss is signified most clearly by her anger and her rejection of her family's values. Of course, the rejection is without teeth as she is powerless to remove herself from her church, family, school, neighborhood, or city. She can only wait, restlessly, until she can leave home. It is unlikely she will, in the end, completely reject the values with which she was raised, but she is undergoing a fairly classic process of moral development, leading presumably to some reconciliation between her radical rejection of those values with those she is trying on for size. As Kagan writes, events and thoughts that do not mesh with one's assumptions "provoke the mind to resolve the uncertainty and, through that work, premises are changed" (96).

Though Dillard does not explicitly claim a marginal status, and indeed, seems rather to claim the center through her title and her use of a narrative voice that unproblematically assigns mythic meaning to highly specific experience, the coherent surface is frequently shattered in moments that hint at outsider status despite her relatively privileged position. The most sustained

evidence of the lack of complete narrative coherence are the passages that deal with Dillard's growing awareness of boys. Through the new lenses puberty provides for her, a previously known quantity, boys, become mysteriously powerful.[5] At ten, Dillard is sent to dancing school where both boys and girls wear white cotton gloves: "Only with the greatest of effort could I sometimes feel, or fancy I felt, the warmth of a boy's hand—through his glove and my glove—on my right palm" (89). The warmth, imagined or real, of the boys' hands is related to her burgeoning interest in the opposite sex and her attempts to understand how they are different from girls. Inexplicably, the boys have changed, as has the girls' attitude toward them. Later, Dillard realizes that "the boys had been in the process of becoming responsible members of an actual and moral world we small-minded and fast-talking girls had never heard of" (91). While it is unlikely that Dillard, at fifteen, articulated her interpretation of the boys' social position in quite this way, in the process of constructing her coming-of-age narrative she realizes that while she had been exploring, dreaming, and attending to her interior life, her male peers were preparing to ascend to their rightful position of power and authority.

Dillard notes that she had assumed the boys shared both her dreams and values. A romantic, she dreamed of playing professional baseball, or exploring the Himalayas and she believed all children, including boys, had the same kinds of dreams. Not only did Dillard fail to realize that few girls were likely to fulfill many of the dreams she had, but the boys of her peer group were not dreaming these sorts of dreams either. Instead, "[t]hey must have known, those little boys, that they would inherit corporate Pittsburgh, as indeed they have. They must have known that it was theirs by rights as boys, a real world, about which they had best start becoming informed" (92). The temporal aspect of Dillard's observation suggests that this insight is something constructed in the process of writing the memoir rather than something the child subject understood explicitly. Unlike Dillard, her male peers apparently recognized themselves as they were hailed as subjects by the ideologies of Pittsburgh's ruling class. By contrast, the girls were "vigilantes of the trivial" who never thought twice about the world outside school, family, and country clubs (91), a description that profoundly echoes Friedan's definition of the "feminine mystique." According to Friedan, American signifying practices in the late 1940s and 1950s consistently and persistently placed women and girls in the domestic sphere while simultaneously discouraging feminine interest in the world beyond. In her 1997 memoir *Wait Till Next Year*, historian Doris Kearns Goodwin writes that in the years after World War II the president of Mills College (a school for women) was arguing that higher

education was irrelevant to their certain future of marriage and motherhood, and further, might actually make them unhappy with their domestic roles (73). Surrounded by messages that told them that marriage and motherhood were all they needed to be content, middle-class white housewives were often unable to even name the source of their discontent.[6] Though Dillard comes to recognize the terms of her interpellation, she does not recognize herself as the subject being hailed, and thus is able to turn away.

The passage in which Dillard compares the future of boys with that of girls, quoted above, is another instance of third-person narration in which Dillard distances her own voice again, but this time to soften the anger that is actually hers. She is not speaking for all girls everywhere here, nor is she even speaking for all the girls in her own 1950s Pittsburgh peer group; she is speaking for herself. Elsewhere, she explicitly acknowledges this move.[7] Moreover, the narrative time is cloudy in this section, making it difficult to discern exactly when Dillard consciously recognizes the disparity of choices available to males and females in her world. Again, it seems unlikely that she could articulate the outlines of ideology quite so clearly at fifteen, but elsewhere in the text she refers to the blinding rage that marks her adolescence (158). At some level, she understood that her options were limited by her sex, whereas the boys were somehow being prepared for important roles involving the exercise of agency and power. She also realizes that she (but here too she writes in the third-person "we" and "the girls") is being prepared for something, and looks to what her parents count as important for clues about exactly what sort of life she is expected to assume when she reaches adulthood. "It was something, however, that ballroom dancing obliquely prepared us for, just as, we were told, the study of Latin would obliquely prepare us for something else, also unspecified" (91). Realizing that she was being prepared for an unwanted and unspecified future with Latin class and ballroom dancing, Dillard rebels to such a degree that her parents decide to send her younger sister away to boarding school when she reaches age thirteen, rather than cope with two adolescents in one house. She has recognized that she is not an autonomous agent, that there are invisible forces constructing her life against her will. In Althusserian terms, Dillard is being interpellated by the specific ideologies in circulation while she is coming of age. However, Dillard does not entirely recognize herself as she is being called into being; the material reality of her existence is, of course, familiar to her, but she is caught off-guard when she realizes that these material practices are prodding her into a highly structured subjectivity. As Belsey points out, the ideologies in circulation at any given historical moment are

always contradictory, but again, that very inconsistency provides the window of opportunity for change (45).

Turning her gaze on the adults that surround her, Dillard is confronted with men who, in her view, were bewildered by their families and who "seemed to be looking around to the entrance to some other life" (194). She sees the women coping, raising their children alone, and wasting little time; they are the volunteers that keep the Ideological State Apparatuses afloat. But occasionally, some of these women went "carefully wild," and Dillard reads this behavior as the overflow of suffering that could no longer be contained. Everywhere confronted with evidence of women's constricted lives, Dillard identifies with males; in church, she assumes the boys are as outraged as she is by what she sees as blatant hypocrisy. She is bewildered to discover that the boys are indeed praying earnestly in church, and that they are not at all disdainful of their surroundings. Still, the alternative—identifying with females—is even less attractive. Since books are Dillard's primary source of information about the wider world, she takes her cues from them, and they, almost without exception, valorize the activity of males. "No page of any book described housework, and no one mentioned it; it didn't exist" (216). Implicitly, women do not exist either.

Often, girls who love to play baseball and football or who want to cure cancer, as Dillard did, are told by at least one significant adult that these are inappropriate pursuits for girls. But this scene was apparently not played out in Dillard's childhood; her parents left her to her own pursuits and did not dampen her many enthusiasms by steering her toward play that would also, ostensibly, prepare her for the same future that requires a background in ballroom dancing and Latin. Perhaps this accounts for the fury with which Dillard hurls herself through adolescence; she disapproves of "most things in North America" (222), which are, of course, the moral ideologies of adults who are imperceptibly but surely pressing and molding their children into highly specific roles. Dillard's anger gives rise to a volatility that even she realizes makes people flinch; "[b]lack hatred clogged my very blood. I couldn't peep, I couldn't wiggle or blink; my blood was too mad to flow" (224).

Furious with her parents and her entire culture because of their hidden agenda for her life, Dillard feels the grief that accompanies crushed dreams. No one had told her that her horizons were limited, and she had dreamed freely and unselfconsciously throughout her childhood, unaware of the limitations she faced. As Williams writes, contra Althusser, determining limits must be overcome in the imagination before social change takes place, and imagination is, in fact, the key to agency (86). Grief constitutes the meaning

of adolescence for Dillard, which is predictably determined by the discourses surrounding coming of age:

> So this was adolescence. Is this how the people around me had died on their feet—inevitably, helplessly? Perhaps their own selves eclipsed the sun for so many years the world shriveled around them, and when at last their inescapable orbits passed through these dark egoistic years it was too late, they had adjusted (224).

For Dillard, adulthood, and particularly womanhood, means a shrunken horizon and fixed borders, even a living death. As Heilbrun notes, the ideals of "safety and closure" for women "are not places of adventure, or experience, or life" (20). Dillard constructs childhood as a time when selfhood is unfettered by adult limitations, but because the child self is still focused on her own image of wholeness she does not notice when the world begins to shrink around her. By the time her ego shifts the self away from center stage, she has already passed through grief and accepted what she cannot change. Loss of world is a defining feature of Dillard's adolescence, and although she enjoys a high degree of material privilege and social acceptance, she feels entirely alienated from her social surroundings. Perhaps it could be argued that Dillard fails to read the signs of ideology while she is growing up and thus suffers great disillusionment when she realizes she is being groomed to *marry* someone who will inherit Pittsburgh, rather than becoming an agent in her own right. Perhaps she suspects her story will end, as du Plessis has it, as soon as she accepts a man in the standard romance plot, and she is reluctant take a step that, conventionally, requires her to relinquish her agency (8). Certainly, she perceives discursive practices as conspiring to limit her, depriving her of the exercise of the free will guaranteed by humanist discourse. But, after Foucault, I would argue that the notion of free will is at least partly illusory, given the power of language and discursive practices to fix the individual socially, and furthermore, it is Dillard's *perception* that her subjectivity is being limited by outside forces that enables her to resist. That is, if ideology must be invisible to work effectively, its failure to incorporate Dillard's interests explains her ability to question the dominant narrative of white American womanhood.

On closer inspection, it is clear that Dillard has been exposed to oppositional or counterhegemonic discourses all along. Indeed, the late 1950s and early 1960s of Dillard's adolescence constitute a transitional moment in the social roles of American women, especially those who were white and middle

class. In 1963, during Dillard's last year of high school, Betty Friedan published *The Feminine Mystique*, which articulated the discontent of women who otherwise seemed quite privileged. Dillard's memoir does not mention the then-nascent women's movement, but as a discourse beginning to enter the mainstream, it constitutes one of Gramsci's "traces of history" that fail to leave an inventory on individuals. Nonetheless, as Said argues, it is critical to take such an inventory in order to adequately articulate subjectivity (25). Thus, as a historical subject, Dillard cannot avoid being affected, perhaps unconsciously, by the discourse of feminism. Although the words "feminism" and "women's movement" appear nowhere in *An American Childhood*, there is substantial evidence of the oppositional discourses available to Dillard as she was growing up. Her mother introduces surprising, even radical ideas to counter the dominant ideology of womanhood. For instance, she teaches her daughters how to curtsy, an indispensable sign of good breeding—and she teaches them how to play poker. A small enough gesture, but powerful in its contradiction of the discourses of girlhood in that social location. More critically, her mother's "energy and intelligence suited her for a greater role in a larger arena . . . than the one she had. . . . She saw how things should be run, but she had nothing to run but our household. . . . She was Samson in chains" (115). Confined to a socially sanctioned womanhood, Dillard's mother has a classic case of "the problem with no name," Friedan's ironic definition of the discontent of educated white housewives, but the example of her intelligence and unusable abilities is not lost on her daughter. *An American Childhood* tacitly recognizes the sexism that keeps Dillard's mother from operating on a larger stage than her own home. While the nineteenth-century options of marriage or death for a heroine were losing their grip on the American imagination, what was left at that historical moment was either marriage—or not. The marriage option is knowable and clear, but its opposite is rather murky. The assumption that marriage *will* occur in Dillard's white, upper-middle-class, Protestant milieu is so strong, even for Dillard's mother, that it seems unnecessary to even mention it. Marriage is a transparent fact of life here, as is the right of males to inherit social power. The transitional moment is signaled variously however; marriage is not so sacred or serious, for instance, that Dillard's mother feels constrained from engaging in playful hazing of her daughters' suitors. Nonetheless, the same mother who teaches by example that "[t]orpid conformity was a kind of sin" is part of the conspiracy to channel her daughter into a way of life that Dillard objects to on moral grounds as an adolescent.

In du Plessis's terms, the source of Dillard's angst lies in the conflict that results when the female hero faces the incompatibility of romance (marriage)

and quest in women's fiction and lives. Nineteenth-century women's fiction concluded with the termination of quest, either through marriage or death, but du Plessis argues that, in the twentieth century, women writers developed an "array of narrative strategies . . . explicitly to delegitimate romance plots" (3). In Dillard's memoir, which is profoundly concerned with quest for self and vocation, the narrative ends before a choice between romance and quest must be made. And yet, the act of textually "authoring" her life symbolically reveals Dillard's rejection of the heroine's sacrifice of quest, as well as her resolve to reinvent womanhood for herself. The final pages reinscribe Dillard's social and geographic milieu, and invoke the cultural myths that contextualize her implicit decision to pursue quest—American culture, she learns from her father, is "Dixieland pure and simple" (252). It is a stock market crash, a World's Fair, Harlem, the Dust Bowl, P.T. Barnum, and Jim Thorpe, but "[a]bove all, it was the man who wandered unencumbered by family ties"—Johnny Appleseed, Daniel Boone, whalerman, the gandy dancer, "Huck Finn lighting out for the territories; and Jack Kerouac on the road" (253). As Morwenna Griffiths points out, "imagining you are anyone who counts in history tends to mean imagining you are a boy" (25). The mythic models Dillard invokes are exclusively male, but Dillard rejects the one-to-one correspondence; at the end of *An American Childhood*, she makes it clear that her intention is to light out for the territories too. Having situated and grounded herself geographically, the territory she seeks is, of course, not only a geographical one, but one that will allow her to continue the quest begun in childhood, which she understands she is expected give up as she matures. Unwilling to do so, Dillard recalls her father's own quest: quitting the family business to follow a long-held dream, then buying a boat and sailing for New Orleans to seek the Dixieland music he loved. He never arrived, too lonesome and too fearful of what people at home were saying to complete his journey. But as she prepares to leave home for college, Dillard wonders if her father still thinks of himself in the way she did, "as the man who had cut out of town and headed . . . down the river toward New Orleans" (254). Her father's apparent loss of quest, symbolized by his love of loud Dixieland jazz, is signified by Dillard's speculation that "[i]f it had ever been at all, it had been been a long time since Father had heard the music played loud enough," and finally she wonders if the "music" will be loud enough in her own life to suit her passionate quest (254–55).

While implying that she will not subsume self in romance, Dillard makes no parallel suggestion that quest and romance are incompatible. In the same breath with which she contemplates becoming a medical missionary to

the Amazon, Dillard thinks she will marry the current love of her life, and in this way suggests that she is writing her own life beyond the either/or dichotomy of quest and romance. Taking a both/and view, she resists the female social trajectory prescribed in the 1950s and 60s for women of her race and class, and thus challenges the social and cultural construction of gender. As I have already said, Dillard's social marginalization is strictly gender based, but for her, the oppression of self occasioned by that factor alone is enough to create resistance. As a child, her resistance takes the form of unfocused, powerless anger which in turn leads her to push the cultural limits through such behaviors as drag racing and quitting church. As Heilbrun has observed, "[t]he expression of anger has always been a terrible hurdle in women's personal progress" (25). Rarely taken seriously, female anger is shrugged off as evidence of woman's irrational nature. In Dillard's case, this problem is compounded by her age: as an adolescent, she is taken seriously by no one except herself. Dillard's rebellion against social limitations is thus diffused, while discourses on adolescence simultaneously offer her parents the explanation that she is "just being a teenager" so there is nothing permanent or valuable in her desires. No one, not even Dillard herself, apparently understands the source of her rage. The traditional *Bildungsroman* is also characterized by the protagonist's rage and alienation from society, but unlike the earlier genre, *An American Childhood* ends without the conventional social reconciliation. Indeed, a defining characteristic of the American woman's coming-of-age narrative is the *in medias res* ending, which suggests that identity and subjectivity are not achieved once and for all when maturity is reached. The journey is never finished.

HEGEMONIC INSCRIPTION OF THE BODY IN *COMING OF AGE IN MISSISSIPPI*

Annie Dillard imagines that coming of age is like "slipping into your skin perfectly fitted," which suggests that adolescence is a time for coalescing selfhood and identity into a comfortably unified whole, though her text belies that assertion. The choice of metaphor is telling in that Dillard enjoys a degree of social acceptance and integration not shared by all, so although she deploys the image as a universal theory of identity, closer analysis reveals it is a highly specific construct. As I have argued, Dillard's universalizing move seems to erase difference in coming-of-age experiences and fails to account for alternate discursive patterns that constitute subjectivities along a range of

practices. But the flaw in Dillard's metaphor of perfectly fitted skin is immediately apparent when the discourse of race is added, and indeed, the metaphor is not particularly apt for Dillard either. Nonetheless, the "skin" of society is constructed to the specificity of white experience, so clearly, Dillard will experience whiteness as a transparent, ground-zero norm against which the other is measured, but she rarely recognizes race as a critical aspect of her own subject position.[8] In contrast, Anne Moody did not have the luxury of forgetting race. In her 1969 autobiography *Coming of Age in Mississippi*, she enacts a reversal of Dillard's erasure of race, instead privileging racial discourse and practices as the primary origin of her identity. Where Dillard can delight in her ability as a child to shift from conscious awareness to oblivion, Moody can only recall being painfully aware from a very early age, with no respite from the harsh realities of the external world.

It is almost a cliché in the scholarship on women's lives that women's contributions have been overlooked, undervalued, and systematically suppressed by the dominant culture. The time and place seem to make no difference—it is simply a given that in almost every era, arena, and culture, the significance of women's contributions has been systematically erased. The American civil rights movement of the 50s and 60s is no exception; the drive for equality for African Americans was apparently led by Martins, Malcolms, Stokelys, Hueys, and Bobbys. The only woman many Americans associate with the civil rights movement is Rosa Parks, but the mythology surrounding her actions claims an almost accidental quality to her activism—Parks was just too tired the day she refused to yield her bus seat to a white passenger. The myth erases the reality of Parks's political activism long before that day in 1955, and further, the fact that plans for a massive boycott of Montgomery's segregated public transportation system were already in place. Parks was no political innocent, but received notions of women as apolitical carry far more cultural weight than the reality of women's lives, and as a result, the significance of Rosa Parks's contributions have been largely undervalued.

Indeed, the contributions of African American women to the struggle for civil rights have only been seriously studied in mainstream scholarship in the last fifteen to twenty years. Crucially, this body of scholarship has established the long and proud tradition of black women's activism, which has taken many creative and powerful forms, and further demonstrates that, far from being peripheral to the movement of racial uplift, black women have been at the very center of activism since the nineteenth century. Charles Payne puts it plainly: "Men Led, But Women Organized." Payne notes that "historically,

black women have always fulfilled social roles not commonly played by women in white society" (2). Combined with the widely held stereotypes of black womanhood, the dominant narrative of African American activism historically has erased black women's presence. But recent history and cultural investigations demonstrate repeatedly that African American women have been organizers and activists for as long as they have been in America.[9] It may have been men who got the media attention, but it was women, like Ella Baker who was instrumental in founding SNCC, setting policy and establishing a notably antibureaucratic and antihierarchical organization that attracted volunteers regardless of their status (Payne 3). And it was women like Anne Moody, who might have remained an anonymous foot soldier in the civil rights movement had she not written *Coming of Age in Mississippi*, in which the most critical stance is that of resistance to external definitions.

Moody both accepts and rejects the subjectivity imposed on her by whites as well as blacks, and, as Gramsci argues, that conflicted stance helps maintain hegemony's dominance. But as we know, in the era when Anne Moody comes of age, American blacks began to successfully shift the hegemony. For a time, American whites were able to maintain their dominant position through a paternalistic discourse that constructed blacks as childlike, ignorant, and unable to provide for their own well-being. As a result, white ideology reasoned, black interests would be best served through the fulfillment of subservient roles—in this way, black material needs would be provided for, and, not incidentally, white material desire for economic and social dominance would be maintained. White hegemony, in the final analysis, failed to maintain itself because it failed to adequately incorporate black interests. It failed because its view of black material and bodily *needs* (jobs with adequate pay, decent clothes, shelter, food, and so on) did not mesh well with blacks' material and bodily *desires*. The contradiction that confronted blacks was the disparity between white society's claim that it was looking out for and taking care of blacks' needs, and the actual lived reality which showed blacks quite clearly that their interests were of trifling concern to white people. With the recognition of those contradictions came the impetus for creating a powerful counterhegemonic force which ultimately forced a reconfiguration of American hegemony. Further, the discourse of resistance gained hold because people like Anne Moody recognized the contradictions of the white definition of black subjectivity, and did so in large measure due to the pressures placed upon their bodies. Few would argue that hegemony in this country is still overwhelmingly white. But by successfully forging alliances with members of other groups devalued by mainstream society because of

their association with the body—the youth, whose bodies were associated with sex, the soldiers and conscientious objectors, whose bodies were exploited as cannon fodder, and women, whose bodies were associated primarily with reproduction—blacks were able to significantly shift white hegemony by forming a coherent historic bloc which forged a major change, in part by publicly challenging the hegemonic valuation of its members as bodies.

Moody does not foreground gender as constitutive of identity, in part because liberal discourse allows for only one defining feature of subjectivity. Thus, her text most often valorizes the category of race, but gender may be the central origin of the text. Indeed, given the prominent role played by black men and the mostly unseen work performed by women in the civil rights movement, I would argue that the text exists in part to counter the unspoken assumption that a civil rights worker is always a black man. As bell hooks notes, radical black males involved in the movement, such as Martin Luther King, Malcolm X, Stokely Carmichael, and Amira Baraka, "all argued that is it is absolutely necessary for black men to relegate black women to a subordinate position both in the political sphere and in home life," thus reproducing the model of white patriarchy (94–95). And Michele Wallace remembers that "[i]t took me three years to fully understand that Stokely was serious when he said my position in the movement was 'prone,' three years to understand that the countless speeches that all began 'the Black man . . .' did not include me" ("Black Feminist" 6).

As an African American female coming of age during the heyday of the civil rights movement, Moody attempts to draw on discourses other than those of race as she moves to claim agency in constructing her own identity, and though she actively resists the ideology that constructs her primarily as a body, she is inexorably drawn to the discourses she is explicitly rejecting. *Coming of Age in Mississippi* fits squarely in the African American slave narrative tradition, a genre that found new utility during the civil rights movement for reasons remarkably similar to those that gave rise to the tradition in the eighteenth century: a continuing need to demonstrate the structural inequalities in American society by means of detailing the sometimes horrific and usually degrading personal experiences gave rise to such texts as Claude Brown's *Manchild in the Promised Land* (1965), and Alex Haley's 1964 rendering of *The Autobiography of Malcolm X*. Much as the slave narratives did more than a century before, these new narratives worked to convince the nation that the horrors of racism were untenable, particularly in a society that proclaimed its dedication to the ideal that "all men are created equal." The civil

rights-era memoir, of which Moody's is exemplar, dispenses with the peripheral documentation used to authenticate the testimony of the slave narrative itself, but retains the literary conventions specific to the rhetorical purpose of effecting social change.[10] In particular, the latter-day narrative—like the slave narrative—details the material deprivations experienced in childhood; the lure of crime or promiscuity; accounts of maltreatment—physical and emotional—by whites; the barriers to higher education, which is seen as the best hope of escaping poverty and oppression; a description of how the author "escaped" the bonds placed upon him or her by the dominant white society. The closing pages of civil rights-era memoirs contain reflections by authors on the narrow "escape" made from the debased existence that dooms African Americans to unending poverty, crime, and ignorance, accompanied by dire predictions for the future if racism is not conquered. Sometimes the memoirist owes his redemption to an outside force—Elijah Muhammed for Malcolm X—but frequently the texts suggest that the authors "made it out" of the ghetto or the sharecropper's shack through the exercise of their independent free will. For Anne Moody there was no Elijah Muhammed; only a rare teacher offering quiet encouragement to resist white hegemony. In most instances, Moody writes that she was actively discouraged from resistance by both family and community members.

Portraying herself thus as a solitary individual at odds with both black and white society, Moody constructs an identity of protest that serves as the lens by which she attempts to articulate a coherent subjectivity. The civil rights movement provided an outlet for Moody's anger over social injustices, but ultimately, the movement could not address the underlying issues of dominant discourses of black womanhood. Like the slave narrators of the nineteenth century, Moody escaped the conditions she was born into, but, unlike them, she sees little hope for change by the end of her memoir. Published when Moody was just twenty-nine years old, *Coming of Age in Mississippi* affirms the courage and centrality of women in the movement, but also raises several critical issues. Specifically, Moody's representation of her life begs the question: How does an individual find the personal courage and power to resist a dominant culture that systemically devalues and denigrates her existence? Although she is unable to completely rid herself of the constitutive power of racial discourses, Moody's text illustrates Foucault's assertion that power is never just a function of a repressive state apparatus. Foucault argues that individuals assent to power because it "doesn't only weigh on us as a force that says no, but it traverses and produces things, it induces pleasure, forms knowledge, produces discourse" ("Truth" 61). In the historical

context of segregated Mississippi in the era of Jim Crow law, Foucault's argument can help us to understand how Anne Moody (and many thousands more) stopped assenting to white power. Quite simply, white hegemony functioned primarily as a repressive force in relation to African Americans that failed to reproduce itself by adequately incorporating black interests.

Born to a family of poor sharecroppers, Moody begins to question her assigned place in life at an early age, despite the often overt hostility of whites and despite her family's attempts to force her to accept her place. In an environment that valued black women primarily as domestic workers and sexual objects, Anne Moody pushed herself to scholastic achievement, economic self-sufficiency, and a sense of self-worth with little support or encouragement. In a milieu that produced fear and hatred of any black who did not know her place as the white community defined it, Moody found extraordinary courage in the face of great personal danger to devote her considerable intelligence and energy to the civil rights movement. Rewarded neither by appreciation from her own community, nor even by a measure of the fame won by black male leaders, Moody's passionate dedication to the cause of civil rights might seem to defy expectation. Autobiography presents an opportunity for the subject to construct herself, consciously and unconsciously, so in order to understand how Moody finds the power to resist external self-definition, we need to examine how she constructs her identity. As Sidonie Smith has argued, the self created by the autobiographer isn't "an a priori essence, a spontaneous and therefore 'true' presence, but rather a cultural and linguistic 'fiction' constituted through historical ideologies of selfhood and the processes of [our] storytelling. . . . As a result, autobiography becomes both the process and the product of assigning meaning to a series of experiences, after they have taken place, by means of emphasis, juxtaposition, commentary, and omission" (*Poetics* 45). Thus, to answer my central question about how Moody is able to resist her powerful social "hailing" as a black female, it will be helpful to examine the way in which Moody implicitly theorizes subjectivity in relation to the workings of power and hegemony, which, in order to reproduce themselves, must necessarily create spaces of resistance.

Gramsci's theory of hegemony rewrites the simple opposition of dominant and subordinate classes, making the workings of coercion and consent operative in subtle but important ways. For Gramsci, the concept of hegemony needs to be paired with that of domination. Consent and force are nearly always employed in concert, although usually one or the other is the primary means for achieving dominance. But in practice, most dominant

groups do not simply achieve that status by creating and perpetuating what would be for them a desirable symbolic order; they must also convince subordinate groups to subject themselves to the hegemonic social order by incorporating the interests of the nonhegemonic. Consent to that order *might* mean that subordinate groups are fervent adherents to the hegemonic, even if their best interests are not necessarily being served by that order. But that individuals might agree to an order that does not have their best interests in mind is evidence of the power of ideology and the conflicted nature of human subjectivity.[11] On a conscious level, individuals might recognize that their desires are invalidated by the dominant discourse, but they are still capable of social practices that implicitly reinforce the hegemonic. Furthermore, this conflicted subjectivity helps hegemony to maintain its status, because if a historic bloc is able to articulate the contradictions of its existence, it is then in a position to mount a serious challenge to the form and content of the hegemonic (Gramsci 167). Thus, it is in the interest of the dominant order to smooth over social contradictions, although it is a delicate balance; if the contradictions become too obvious, then historical blocs can become counter-hegemonic forces which might then become revolutionary forces.

While most theorizing about the workings of hegemony focuses on ways that consent is gained by the promulgation of a worldview passed off as truths, I am arguing, after Foucault, that hegemonic discourse does not merely work on people's *minds*—it exerts pressures on their *bodies* as well. After the abolition of slavery, whites shifted from the use of force as the sole means of maintaining dominance to a more subtle emphasis on securing the consent of American blacks to remain in their subordinate social position. In Althusserian terms, abolition necessitated a move from Repressive State Apparatuses to the ideological ones already in position. This is not to ignore the historical fact of widespread lynching, which clearly has no consensual component. Describing the years when Anne Moody was coming of age, C. Vann Woodward writes that Mississippi had stubbornly resisted implementing *Brown v. Board of Education* as well as other efforts to dismantle segregation, and that resistance became increasingly violent as the 1960s began (173–75). Violent coercion continued to play a significant role in the domination of American blacks after the end of slavery, but with the advent of legal protections it became necessary for whites to secure the implicit consent of blacks to white social hierarchies.[12] The discourse of dominant whites in the American south remained essentially the same as it had been in slavery: blacks are best suited for manual labor,[13] are lazy, are oversexed, are ignorant, are dangerous, are, in a word, inferior.

Against this public backdrop, however, are the invisible social structures that either support or reject individual members of a group. Patricia Hill Collins and others have described the strong network of support that a community of black women often provides, which usually nurtures various strategies of survival, resistance, and activism (141–22). And yet Anne Moody seems to have enjoyed no such network of support. She describes her mother as beaten down by too many children, inconstant men, and the need to work long hours in white people's homes; Moody views her mother as unsupportive and thereby implicitly challenges the narrative of womanhood proposed by Chodorow, Gilligan, and others, which argues that women create their identities in relationship with others. While it is absurd to suggest that Moody's subjectivity is created autonomously and in isolation, I want to argue that, by highlighting her social and cultural alienation, Moody is adapting the grand narrative of the autonomous individual in an attempt to align herself with "universal" American values. This move has its origin in the slave narrative tradition, but produces a paradoxical effect: in the process of persuading others that she is worthy of full citizenship and the right to define herself as human, she must detach herself from relationships with others in order to prove her worthiness. Indeed, Moody alienates, or is alienated by, nearly every individual she comes into contact with, white or black. In her representation of self, Moody's construction of her identity of protest is similar to Richard Wright's in his 1944 memoir *Black Boy*. Both Wright and Moody position themselves in opposition to *everyone*—whites, of course, but also family members and the larger black community. While Wright and Moody are deeply angry with whites, both reserve their deepest scorn for blacks who, in Wright's words, "make subservience an automatic part of [their] behavior" (196). Knowing that the culture expects them to act subserviently or to go without work, neither Moody nor Wright can bring themselves to play the game of dissembling. Here too, Moody (and Wright) adapts the discourse of rugged individualism, which does not admit a need for ongoing relationships with other human beings or a need for assistance as the individual climbs to success.

Coming of Age in Mississippi recounts numerous scenes depicting the life of African Americans under Jim Crow, including one that gave Moody her allotted fifteen minutes of fame, as a press photo of her was prominently featured in the national media. As part of a CORE (Congress On Racial Equality) protest, Moody and several others sat down at a segregated Woolworth's lunch counter in Jackson, Mississippi, and asked to be served. The white waitresses refused, then fled when the press descended on the store and

began to ask the protesters what they hoped to gain. White high school students surrounded Moody and the others, chanting "anti-Negro" slogans and attempting to place nooses around their necks. For hours, the three protesters were beaten and smeared with ketchup, mustard, sugar, and pies. When, after enduring hours of abuse, the president of Tougaloo College (where Moody was a student) arrived to personally escort the protesters to safety, Moody writes that although ninety police protected them from the mob, they did not stop the white hecklers from throwing things at them as they left (263–67). There are many such anecdotes throughout Moody's text, as she articulates in minute detail the indignities and abuses suffered by blacks under the Jim Crow system, as well as the threats to their personal safety as they tried to dismantle the oppressive social order. While I do not wish to suggest that Moody is exaggerating her experiences, I do want to draw an analogy between the litany of abuses she recounts in her text and similar scenes in the nineteenth-century slave narratives: in both cases, the rhetorical strategy of overwhelming the reader with numerous heartrending and horrific examples of white mistreatment of blacks works to enlist reader empathy for the cause of racial uplift.[14] Moody's text, like the slave narratives, is meant to sway readers to accept the premises of the civil rights movement's call for equality.

There are other instances that recall not only the slave narrative, but the African American literary tradition generally. Moody recounts an early experience, classically paradigmatic of African American narratives, of the moment when she realizes that her skin color places severe limitations on the life options available to her. When she is seven, Moody, her mother, and siblings walk to town for a Saturday matinee, where the children unknowingly enter the white lobby with their friends. Moody's mother explodes in anger and drags her children out of the theater as she tells Anne "um gonna try my best to kill you when I get home. I told you 'bout running up in these stores and things like you own 'em!" (38). Moody is thus socialized by her mother (and many others) to know her place, illustrating the powerful role of the family Ideological State Apparatus in socialization. As Williams contends, "[t]he true condition of hegemony is effective *self-identification* with the hegemonic forms: a specific and internalized 'socialization' which is expected to be positive but which, if that is not possible, will rest on a (resigned) recognition of the inevitable and the necessary" (118). For Moody, however, the socialization is not positive and she rarely concedes that her assigned place in society is "inevitable" or "necessary." Incident after incident shows her mother (and nearly everyone else in the narrative) taking sides against young

Anne, most notably by frequent and various reminders that she has none of the rights she believes are her due. As Collins notes, black "[m]others may have ensured their daughters' physical survival, but at the high cost of their emotional destruction" (123). In Moody's case, what is destroyed is a sense of connection to her family and her community; she reads no one as trustworthy once she has a clear picture of her social milieu. Throughout her narrative, Moody represents her mother as a repressive force on a roughly equal level as that of whites, but she never explicitly recognizes the likely reasons for her mother's behavior. It has been necessary for black parents since slavery to train their children how to survive in the white world.[15] This training sometimes looks cruel and spirit crushing from the outside, but there can be little doubt that it was done in love, with the goal of helping children survive in a world hostile to their presence. As Patricia Hill Collins argues, "survival is a form of resistance," and without successful survival strategies, "struggles to transform American educational, economic, and political institutions could not have been sustained" (140). Moody may have been too young when she wrote her story to fully appreciate and understand her mother's motives in teaching a set of survival strategies that seemed only to limit the child's inclination to believe the world is hers for the asking.

The incident at the movie house spurs a desire in Moody to discover white people's secret. Deciding that there must be a better explanation of the widely differing material lives lead by whites and blacks, Moody is determined to uncover the secret of white power. Since she sees the source of that power as "secret," it is perhaps logical that she looks for answers in places that are normally covered—namely, white people's "privates." Moody contrives a game of "playing doctor" with her siblings and white children in her neighborhood so she can discover the reason white people had better lives than she and other blacks. Disappointed by her findings, Moody asks her mother and her white employers to tell her the secret, but no one will explain the difference to her satisfaction. Although Moody the author does not directly theorize about the effect of her investigations on her own identity, these memories contain implicit suggestions about her eventual ability to resist. That she found no physical differences between herself and white people may have suggested to her that there is no basis for believing she is inferior. Seeing no significant differences, except perhaps that white people were lazy, which explained to her why they had blacks do all their work for them, Moody accepts herself as inherently equal, perhaps even superior because she is not prone to the preposterously contradictory logic of segregation and Jim Crow. Her friendship with white children is thus altered by the sudden realization that she is different from them:

> I had never really thought of them as white before. Now all of a
> sudden they were white, and their whiteness made them better
> than me. I now realized that not only were they better than me
> because they were white, but everything they owned and every-
> thing connected to them was better than what was available to me
> (38).

This classic epiphany is conventional in the African American literary tradi-
tion beginning with the slave narratives and continuing to the present day.
Harriet Jacobs writes that until the age of twelve, she had no conscious aware-
ness of her difference from whites:

> No toilsome or disagreeable duties were imposed upon me. My
> mistress was so kind to me that I was always glad to do her bidding,
> and proud to labor for her as much as my young years would permit.
> I would sit by her side for hours, sewing diligently, with a heart as
> free from care as that of any free-born white child. . . . Those were
> happy days—too happy to last. The slave child had no thought for
> the morrow; but there came that blight, which too surely waits on
> every human born to be a chattel (7).

For Jacobs, the idyll's end comes with the death of her first mistress, who
bequeaths Jacobs to her five-year-old niece, Dr. Flint's daughter. Jacobs ties
this change in circumstances directly to the the loss of innocence that
inevitably accompanies the adolescent slave girl's coming of age. Likewise,
the narrator of James Weldon Johnson's 1912 novel *The Autobiography of an Ex-
Coloured Man* experiences a similarly dramatic shift in perception at age nine
when he is astonished to find himself counted among the black students by
his school principal (16–19). Some writers have implicitly resisted the neces-
sity of depicting this moment in their writing; Zora Neale Hurston, in keep-
ing with her "I am not tragically colored" worldview, pointedly avoids this
master narrative of blackness in *Their Eyes Were Watching God,* in which Janie
Starks experiences many conflicts on the road to self-fulfillment, but ulti-
mately betrays no loss of self due to her skin color.[16] Janie does have her
moment of recognition, however, when as a small girl she is shown a photo-
graph of herself and the white children her grandmother works for and fails to
recognize herself. As she tells the story of her life, Janie says that until that
moment she believed she was "just like de rest." (9). To counteract the nega-
tive effects of that recognition, Janie's grandmother leaves her job to provide
a normatively black context in which to raise Janie. The trope of difference

appears frequently in civil rights-era literature as well, but with less emotional restraint than in earlier periods. No longer politically confined to portraying sadness in response to being oppressed, Amira Baraka, Lorraine Hansberry, and others of the Black Arts movement gave free creative rein to the anger they felt by being Othered in American culture. More recently, Toni Morrison invokes the trope of difference in her 1970 novel *The Bluest Eye* through the figure of Pecola Breedlove, who is drawn to representations of whiteness because she believes that beauty and love adhere only to white objects.

Moody's quest to understand the implications of color reflects Robert Coles's assertion in his 1964 study *Children of Crisis* that the "'usual' problems of growing up find an additional dimension in the racial context. In a very real sense, being Negro serves to organize and render coherent many of the experiences, warnings, punishments, and prohibitions that Negro children face" (336–37). Moody's material surroundings, and the difference between what she has and what others have, make sense to her through the prism of color. Color determines everything about her existence, and it is this fact that she implicitly recognizes as the primary origin of her marginalized social position.

At ten, Moody begins working a series of domestic jobs to earn money to help support her family, buy herself school clothes, a used piano, and to pay for college. She recounts a familiar litany of misuse at the hands of many of these employers, but she also reports a time-honored strategy of resistance used by black women domestic workers. One employer, Mrs. Burke, actively tries to force Moody to maintain a submissive position by such means as tricking her into using the back door. In response to this stratagem—and many others—Moody honors Mrs. Burke's request once, but the next time she knocks at the front door again. Resistance to white employers' demands, although not always emphasized, can be found throughout African American history and appears frequently in protest literature as well. Collins writes of a more subtle practice used by black domestic workers (demonstrating the Foucauldian circulation of power) in which they feign gratitude for handouts of old clothing, for instance, but immediately throw the items away as soon as they leave their jobs (142). Moody persists in her own determined resistance to many such incidents until Mrs. Burke finally concedes victory and lets Moody do things in her own way. Moody writes that had she not, she would have quit her job. That position, in retrospect, may have been cavalier, because most domestic workers did not have the luxury of quitting their jobs if they did not like the conditions of their employment. However, the necessity of being finely attuned to one's employer's limits probably suggested which methods of resistance would be the most successful and which meth-

ods would result in being fired. Collins writes that black women's acts of resistance are historically masked by behavior that seems, outwardly, to conform to white demands on black women, allowing them to feel a greater sense of self-worth than seems possible (91). Citing the example of Fannie Barrier Williams, who in 1905 called the black woman "irrepressible," Collins argues that resistance would not have been possible had black women not rejected their historic interpellation as mammies, tragic mulattas, and other images that serve to control and repress the expression of black difference (92). Moody's battles of will with Mrs. Burke and others include little sense of fear or anxiety; in fact, throughout the book, it seems that Moody rarely hesitates to speak her mind or act on her political beliefs at a time when it was extremely dangerous to do so. Her memory of herself as fearless and alone is suggestive of how she chooses to create her identity for this book and posterity, a point to which I will return shortly.

The job with Mrs. Burke plays a significant role in Moody's awakening political sensibility. Emmet Till's 1955 murder and the lynchings of local blacks heighten racial tensions in Centreville, Mississippi, and in response, Mrs. Burke begins to have secret meetings at her house. Moody is never quite able to discover the specific purpose of these meetings, but she overhears the words "nigger" and "NAACP" in the women's discussions, after which Mrs. Burke is careful to give Anne the afternoon off when the meetings are held. She hears enough to know that the NAACP has something to do with black people, and wonders what had white people so worried and angry. When she asks her mother about the NAACP, Mrs. Moody angrily tells her that she must never mention that word around any white person, but does not define the term. Finally Moody asks her homeroom teacher, who explains the NAACP's purpose and its goal of getting a conviction in the murder of Emmett Till. Over dinner, Mrs. Rice tells Moody about lynchings and less extreme forms of terrorism enacted against blacks all over the South, resulting in Moody's new understanding of her social position, which she defines as "the lowest animal on earth" (128). That description is, of course, more than coincidental. As Henry Louis Gates has pointed out, blacks have been constructed as more similar to animals than human in philosophical, political, and other discourses beginning at least as far back as the Enlightenment.[17] Historically, blackness has been defined primarily in terms of the body, whereas whiteness has been seen as occupying the realm of the mind, reinforcing the Cartesian privileging of mind over body. Given Western bias against all things corporeal as debased, it served white hegemony well to fix the meaning of blackness in terms of the body.[18]

Exactly the same age as Emmet Till, Moody finally concedes feeling fearful as she observes the reactions of whites—and blacks—in Centreville after his death. Admonished by her mother to act as if she knows nothing of Till's death when she goes to work, Moody shakes uncontrollably once there, breaking dishes and avoiding the Burke family as much as possible. Still, Mrs. Burke cannot let the opportunity to remind her of her place slip by:

> [Emmet Till] was killed because he got out of place with a white woman. A boy from Mississippi would have known better than that. This boy was from Chicago. Negroes up North have no respect for people. They think they can get away with anything. . . . That boy was just fourteen too. It's a shame he had to die so soon (125).

For the first time that Moody explicitly recognizes, Mrs. Burke's attempts to subdue her and instill fear worked:

> [W]hen she talked about Emmett Till there was something in her voice that sent chills and fear all over me. Before Emmett Till's murder, I had known fear of hunger, hell, and the Devil. But now there was a new fear known to me—the fear of being killed just because I was black (125).

Deeply affected by the racial tensions in her town, and unable to imagine what to do with her anger, she buries herself in schoolwork, jobs, and extracurricular activities. She keeps herself busy, apparently so she will not have time to think. As a black female, Moody is contending with signifying practices that construct her as intellectually inferior, lazy, and unambitious. Her anger propels her toward high achievement as a means of proving the stereotype wrong, and in a very real sense she has accepted the liberal notion that if she can demonstrate her worthiness, she will be accorded a full measure of respect and respectability by white society. In contrast, Dillard's response is an exact reversal; ideology has already constructed her as a high achiever with a particular destiny. In rebelling against her interpellation, Dillard reconstructs her image by breaking rules and resisting everything that conspires to channel her into a particular life. Instead of filling every free moment with activity, as Moody does, Dillard becomes studiously bored, filling her time with petty "infractions" such as drag racing and sexual play. Both Moody and Dillard refuse to accept the "hail" of their cultures, but with highly contradictory results. Though she refuses the highly sexualized, intel-

lectually inferior image assigned to her, Moody is unable to change the ideology at large. Had she chosen, say, to be sexually promiscuous and drop out of school early, society would have had its image of black females confirmed, but the stereotype remains unchanged despite evidence that Moody herself embodies to the contrary. By the same token, although Dillard noisily rejects the subjectivity offered by her milieu, her behavior does nothing to tarnish the image that is her birthright as an upper-middle-class white female. Neither woman is able to entirely shake off the stereotypical expectations despite their strenuous efforts to do so, nor do their efforts create a significant shift in paradigms.

Moody's busy life may explain in part why she comes across as friendless and fearless, but there is certainly more to it. Coles notes that "growing up as a Negro child had its special coherence and orderliness as well as its chaos." These children were "lonely, isolated and afraid . . . but they also knew exactly what they feared, and exactly how to be as safe as possible in the face of what they feared" (339). The need to make herself safe also explains why Moody threw herself so fanatically into staying busy during every waking moment, as well as why she would not see herself as primarily fearful. She kept herself too busy to notice the fear that was almost certainly lurking in her subconscious. Giving her life the coherence and orderliness she craved allowed her to survive, which, as we have already seen, is the basic requirement for resistance. Although it might appear that such a period of heavy involvement with school, jobs, and activities is apolitical in nature, I would argue that in fact, Moody was actively resisting external definitions of self during this period that precedes her involvement in organized activist groups. Through high achievement in scholastics, sports, and music, Moody is demonstrating that she rejects social definitions of herself as a black female who is best suited for domestic work. Significantly, Moody almost completely leaves out discussion of her own sexuality, creating a highly charged textual gap that is perhaps best understood in light of what Collins calls the "controlling images" of black womanhood (67). These images—mammy, matriarch, welfare mother, tragic mulatta—share a common concern with the sexuality of black women, according to Collins, who argues that the purported asexuality of the mammy figure creates a mythic mother figure while the other images represent uncontrolled sexuality (78). In the African American literary tradition, women writers have consistently resisted these stereotypes, often by appropriating the liberal rhetoric that valorizes mind over body.[19] Frances E. W. Harper, for instance, creates a protagonist who might have been read as a tragic mulatta in her 1892 novel *Iola Leroy*, but whose

moral compass is so strong, she is able to reject the fence-sitting that is the ostensible origin of the biracial woman's tragedy. In choosing to publicly identify herself as black and to devote her life to racial uplift, Iola Leroy resists the teleology of tragedy, finding instead a noble mission and personal fulfillment in her work with the former slaves.

Similarly, Moody implicitly rejects her interpellation by white *and* black society through a consistent reversal of expectations of her embodiment. In other words, Moody inscribes the body as a sign of hegemony, and by extension a site of counterhegemonic practices. But *Coming of Age in Mississippi* cannot acknowledge Moody's sexuality because to do so would be to reinscribe the codes of black womanhood. While Moody labors to distance herself from any hint of promiscuous sexuality, claiming no interest in boys until she is in college, Dillard is relatively free to subtly allude to her awakening sexual desire. There are gaps, however, even in this silence about sexuality in *Coming of Age in Mississippi:* Moody recounts how she started a fashion trend by wearing tight jeans to school, but she acknowledges neither the sexual nature of her classmates' responses nor her own enjoyment of displaying her sexuality. As a domestic worker, she must certainly have encountered the sexual double jeopardy that she describes as entirely commonplace in her town—"Just about every young white man in Centreville had a Negro lover" (130)—and yet, she makes no mention of so much as a close call. If in fact she did manage to avoid unwelcome advances, perhaps it can be explained by her written manifestation of herself. Though signs of the body are prominent in her text, Moody frequently attempts to distance her *self* from her body in the narrative, with the notable exception of chronic hunger, and headaches which seem to flare in response to stress too great for her to handle. These headaches allow for occasional retreat from the chronic but nevertheless acute tensions associated with the mask of double-consciousness that Moody cannot escape. The hunger and headaches work subtly to remind her of her own embodiedness—a fact that she is desperately trying to deny. The imperatives of white society with respect to black bodies require acceptance of oneself as valuable for labor and, in the case of women, sex, and little else. If Moody is to successfully resist that definition, she has few options except to prove she is more than a working, sexual body.[20] And yet sometimes she gives in to that very definition, as she does by wearing a risque costume for her tumbling performances and by noting her coach's appreciation of her body.

Moody's text suggests that the body is inscribed by hegemony, in that physical activity such as sports and domestic labor, skin color, and representations of sexuality serve as cultural signs that signify social position.[21] In con-

trast to the ideology of white female purity signified by innocence and inactivity, feminine blackness is signified through labor and wanton lust. These are the ideologies Moody tries to resist, and yet paradoxically, she seems almost drawn to bodily discourses. The early curiosity about genitalia, the decision to wear tight pants in high school (and set a new fashion trend), the close observation of her mother's frequently changing body in pregnancy, the interest in transvestism, and many other examples serve to focus on the body in *Coming of Age in Mississippi*, but Moody continually slides between the body and the intellect, the "real" and the ideological, brute force and hegemony. She realizes early, however, that signs are unstable: her cousins *look* white, and yet they are defined as Negro. The "logic" of the color line eludes her as Moody repeatedly demonstrates her inability to read signs correctly, but this is also the ultimate source of her resistance. Overtly, Moody strives to live the life of the mind, but her cultural milieu repeatedly works to return her to the body. After performing her tumbling act for her college, Moody is approached by the dean and asked if she is a physical education major. Although she explains she is planning to major in biology, the dean sends the physical education instructor to try to change her mind (245).

Moody's resistance to work as a site of hegemony is evident in her realization that field work is a death sentence, as well as in her refusal to accept Mrs. Burke's mastery over her. Less overtly, Moody accepts some expressions of her embodiment, such as tumbling, but very clearly refuses to embody hegemonic interpellations of black female sexuality; there is no direct expression of sexual desire on Moody's part, although she circles the issue in representing her mother's too frequently unwanted pregnancies, in her reaction to her stepfather's sexual advances, and in seeming not to notice the sexual nature of her schoolmates' response to her tight jeans. Moody writes that her college boyfriend tried repeatedly to kiss her, but she steadfastly refuses for a long time before she finally allows it. Dreaming one night of having intercourse with her boyfriend, Moody becomes afraid that if she does kiss him it will inevitably lead to intercourse (230–31). She makes up her mind to "quit him" so she will not have to give in, and although she does finally kiss him, her emphasis on kissing and her eventual loss of interest in settling into a sexual relationship are a pointed counterhegemonic representation of black womanhood. Clearly, Moody is refusing to accept the externally imposed definition of herself as highly sexualized (230–32). Arlyn Diamond suggests that Moody's referencing of Margaret Mead's classic *Coming of Age in Samoa* signals her desire to anthropologize her culture as well as her own life (221), but I see Moody as more interested in articulating the

contradictions in black identity discourses during the civil rights era. Initially establishing an identity of protest and marginality to distance herself from her uncomprehending family, she next aligns herself with the critique of white hegemony. Moody eventually protests the identity imposed on her by the black leaders of the civil rights movement, and finally wonders if African Americans ever will overcome (384). Her quest for self, like Dillard's, is unfinished, but in Moody's case there is little evidence that her quest resulted in agency, with the significant exception of her book, which signifies her agency in defining herself. But after her memoir was published, Moody effectively vanished from public life, refusing to be interviewed or to answer the mail addressed to her that continues to pour in to her publisher.[22] *Coming of Age in Mississippi* ends without resolution; for Anne Moody, quest continues in other, unspecified, spheres.

5 ❖ "Lying Contests"

Fictional Autobiography and
Autobiographical Fiction

People are prone to build a statue of the kind of person that
it pleases them to be. And few people want to be forced to
ask themselves, "What if there is no me like my statue?"
—Zora Neale Hurston, *Dust Tracks on a Road*

A thing may happen and be a total lie; another thing may
not happen and be truer than the truth. . . . story-truth is
truer sometimes than happening-truth.
—Tim O'Brien, *The Things They Carried*

As a consequence of poststructuralist and postmodernist theories that call
into question the notions of stable identity and transcendent Truth, the
boundary between autobiography and fiction has become increasingly
blurred. If truth is contingent and subjectivity is constructed, and both are
the products of language and discourse, it follows that there is no difference
between fact and fiction. And yet, readers continue to read autobiography
quite differently from the way they read fiction. As Phillipe Lejeune has writ-
ten, there is an implied contract between the autobiographer and the reader
which "[guarantees] 'identity' sealed by the name of its signer" (209). More-
over, since autobiography is a referential genre, Lejeune argues that it also
promises to convey the "image of reality"—that is, the autobiographer
implicitly swears that "the evidence I shall give shall be the truth, the whole
truth, and nothing but the truth" (211–12). But in recent years, some fiction
writers have subverted the autobiographical "contract" by conflating the

author's identity with that of the protagonist while some autobiographers explicitly fictionalize their life stories, effectively nullifying the contract. Tim O'Brien's 1990 novel, *The Things They Carried*, for example, chronicles the Vietnam war experiences and coming of age of a protagonist/narrator named Tim; since O'Brien, a former GI himself, is a well-known literary chronicler of the Vietnam soldier, it is difficult to avoid conflating Tim the narrator with Tim O'Brien, the writer. But the text itself frequently erases the resemblance and undermines the realistic style by allowing the author's voice to intrude upon the narrative. A recurring narrative involving a Vietnamese soldier killed by Tim is variously told from first- and third-person points of view, but finally, O'Brien writes:

> [T]wenty years ago, I watched a man die on a trail near the village of My Khe. I did not kill him. But I was present, you see, and my presence was guilt enough. I remember his face, which was not a pretty face, because his jaw was in his throat, and I remember feeling the burden of responsibility and grief. I blamed myself. And rightly so, because I was present.
> But listen. Even *that* story is made up.
> I want you to feel what I felt. I want you to know why story-truth is truer sometimes than happening-truth (203).

O'Brien problematizes the referentiality of the text by giving the narrator his own name while simultaneously destabilizing the correspondence between himself and the literary character through a meditation on the nature of truth. Theorizing through a subversion of narrative desire, O'Brien suggests that fictional truth can be as reliable as factual truth, and, conversely, that facts provide no guarantee of truthfulness. The desire for stable truth and a unified subjectivity is refused, because, as *The Things They Carried* suggests, reality can be truthfully conveyed from a multitude of angles.

Similarly, in her 1957 memoir, *Memories of a Catholic Girlhood*, Mary McCarthy subverts the illusion of truth by interspersing the straightforward chapters of her text with italicized interchapters which serve several purposes: first, McCarthy deconstructs her own memories by adding the "testimony" of other family members that sometimes corroborate, but just as frequently question her version of events. Second, the interchapters work to bridge the gaps between the vignette-like chapters. There is no attempt at constructing a comprehensive past in *Memories*, which McCarthy argues is impossible because the early death of her parents ruptured the continuity of

family mythology, but the commentary of the interchapters functions as a bridge from the preceding story and the one that follows. Finally, and most significantly, McCarthy uses the italicized passages to "confess" to inventing parts of her story. She does not define these fictional touches as lying, but rather claims that "if you are in the habit of writing fiction" (as McCarthy was) there is a great temptation to "[arrange] actual events so as to make 'a good story' out of them" (164–65). In a lengthy "To the Reader" introduction, McCarthy writes that her readers often assumed that she had invented these recollections of her coming of age, and she wonders, "Can it be that the public takes for granted that anything written by a professional writer is *eo ipso* untrue?" (3).[1] Anticipating Monique Wittig's 1969 plea to women to "[m]ake an effort to remember. Or, failing that, invent" (89), McCarthy notes that she is most tempted to fictionalize when her memory fails her: "the story is true in substance, but the details have been invented or guessed at" (97).[2] In her willingness to explicitly confront the provisional nature of truth and the extent to which memory and narrative work to construct truth, McCarthy anticipates the poststructuralist critique of liberal humanist notions of subjectivity. *Memories of a Catholic Girlhood* subverts the reader's desire for a seamless, coherent narrative by means of the author's metanarrative on the autobiography she has written and, in the process, McCarthy rewrites the autobiographical contract to allow for fictionalizing truth and subjectivity.

Both O'Brien and McCarthy are adapting a technique pioneered in the twentieth century by the German dramatist Bertolt Brecht, known as the "alienation-effect" (*verfremsdungseffekt*), which works to destroy the illusion of reality often created in theatrical productions. In Brecht's view, drama could be a vehicle of social change if, instead of identifying with the dramatic narrative, the spectator is alienated and detached from the action by means of devices designed to unveil the workings of the theater. A typical Brechtian device has an actor addressing the audience in the midst of an otherwise "realistic" play, thus ignoring the invisible "fourth wall" which encourages a suspension of disbelief on the part of the audience.[3] The effect of this technique, in Brecht's view, is to "free socially-conditioned phenomena from that stamp of familiarity which protects them against our grasp today."[4] Familiarity—and realism—can function to hide the ideological underpinnings of social behavior, so disrupting the familiar encourages resistance to the status quo. By addressing the reader directly in their texts, and subverting desire for narrative coherence, McCarthy and O'Brien break the code of realistic fiction and traditional autobiography, both of which call for readers to suspend disbelief and accept the narrative's ideology uncritically.[5] Readers are thus

"alienated" as the anticipated narrative is defamiliarized, resulting in a rupture of generic requirements and the grand narratives that accompany them. O'Brien deconstructs the image of the soldier by revealing the fears lurking behind the façade, effectively feminizing a male narrative, while McCarthy provides a variety of narrative threads, some admittedly fictional, as equally valid renderings of her story. Fiction, quite as much as autobiography, has traditionally valued a coherent, uncontradictory narrative that adheres to generic conventions of plot and characterization, but O'Brien and McCarthy problematize these notions, creating the hybrid of autobiography and fiction that marks the American woman's coming-of-age narrative.

McCarthy's observation that her readers tend to assume she is "making up" her stories contradicts Molly Hite's assertion that women writers are nearly always assumed to be writing autobiographically, regardless of the putative genre of their work. Noting that readers commonly conflate first-person narrators with their authors, Hite sees this assumption as inevitable in the case of women fiction writers, who "find it difficult to evade the imputation that they are 'writing themselves,' in the sense of transcribing in narrative form their own experiences, emotions, attitudes, and ideas" (Foreword xiii). The unspoken critical assumption, according to Hite, is that the female author's experience is often regarded as unmediated by language, discursive practices, or power relations, which in turn provides the basis for dismissing women's literature. In contrast, I argue that the coming-of-age narrative problematizes the notion of a unitary self as a transcendental source of meaning, and that the act of writing is itself implicated in the construction of self. As Hite points out, women's autobiographies historically have been written partly in response to a growing awareness of the discourses and ideologies that construct their identities; culturally marginalized individuals, by definition, "have had little or no say in the construction of [their] own socially acknowledged identity," and thus they are unlikely to see the act of writing the self as a simple matter of transcribing an essential self (xv). The coming-of-age narrative inscribes the competing discourses that construct subjectivity and resists erasing their contradictions.

The response of early poststructuralists to the contingent and constructed nature of subjectivity was, initially, to pronounce the "death of the author" (Barthes), and by extension the "death of the subject" (Foucault). Reasoning that the coherent subject is an artifice of discourse, poststructuralism argues that the subject is meaningless and that the concern of criticism should properly focus on the text's discursive practices and the relations of power therein. As Janice Morgan points out, this pose differs little from

that of New Criticism, whose focus was on the "work" rather than the author or the historical context of the text (3). In both systems, autobiography's necessary invocation of historical context and other matters beyond the text/work defines it as inferior (for New Critics) or hopelessly compromised (for poststructuralists).

Yet, as Morgan notes, it is in the context of these contemporary theoretical developments that autobiography has enjoyed a newfound critical respect, with prominent theorists such as James Olney and Georges Gusdorf arguing that all literature is, at bottom, autobiographical (5). This last argument has served to valorize what is commonly called "autobiographical fiction" as well as to destigmatize critical focus on the correspondences between authors and their texts. Instrumental in this critical revision has been the critique of feminist theorists such as Nancy K. Miller, who points out the irony inherent in pronouncements of the death of the subject at the precise historical moment when women and other marginalized people were finally becoming successful in claiming their subjectivity. In this view, it is no coincidence that as society's Others claim subjectivity and agency, privileged white male theorists argue that both concepts are illusory. But significantly, the distinguishing features of a postmodern selfhood closely resemble the definitions of identity constructed by authors from socially marginalized groups. In other words, W. E. B. DuBois's assertion that black identity is characterized by a "mask of double-consciousness,"[6] as well as the idea of identity as a construction resulting from human relationships[7] (once solely the province of women writers), are now canonical markers of subjectivity.

According to Liz Stanley, early literary blending of autobiography and fiction allowed women writers greater freedom in claiming a specifically female selfhood since the category of fiction made denial of the "real" more plausible (59). Ironically, however, that same alchemy of fact and fiction has also been the basis of women's exclusion from the autobiographical canon when, as we have seen with Lejeune, autobiography is defined as a presentation of the "whole truth." But, as Mary McCarthy suggests, memory is unreliable, fictionalizing inevitable, and thus the self constructed by the autobiographer is by definition contingent. The act of writing, then, serves to connect fragmentary memories in order to impose meaning on events that might otherwise be seen as meaningless or unrelated. Stanley argues further that, since memory is limited and fictionalizing necessary, "all selves invoked in spoken and written autobiographies are by definition non-referential even though the ideology of the genre is a realist one" (62). Echoing both McCarthy and O'Brien, Stanley argues that "fictions often enable more of 'truth' about a life to be written than

a strictly factual account" (67). It is this assertion I wish to test through a discussion of two Zora Neale Hurston texts: the first, *Dust Tracks on a Road*, is categorized as Hurston's autobiography, whereas the second, *Their Eyes Were Watching God*, is considered fiction but is often described as a fictionalized account of Hurston's life. In reading both, I focus on what—if any—difference genre makes in the coming-of-age narrative.

"LYING CONTESTS": SIGNIFYING COMING OF AGE

As I argued in chapter 3, the American woman's coming-of-age narrative is a hybrid of the traditional *Bildungsroman*, the slave narrative, and the canonical autobiography, archetypally male genres reconstituted into a form more congenial to the social and cultural locations of women. As a genre that breaks with established forms, the coming-of-age narrative reflects the liminal location of its practitioners. In other words, the referential claims of the traditional autobiographical subject and the unitary subjectivity of the *Bildungsroman* hero is of no use in the coming-of-age narrative, which, by my definition, ruptures grand narratives of American selfhood by narrating an alternative identity formation marked by the marginal status of the subject. Here, however, I want to reestablish the older generic boundaries in order to theorize ideological differences between *Dust Tracks on a Road* and *Their Eyes Were Watching God*. Ultimately, I argue that the traditional autobiography is inadequate to the task of narrating private identity formation for Hurston, whose treatment of the process in *Dust Tracks* suggests she views the autobiographical act as a public one that properly foregrounds the larger social context inhabited by the individual. In contrast, however, *Their Eyes Were Watching God* provides a coherent, fully realized account of its protagonist's inner life with the larger culture serving as a backdrop. The freedom to "signify" on her life through a fictional narrative affords Hurston the necessary breathing room to theorize subjectivity. Before turning to *Their Eyes Were Watching God*, however, it will be helpful to consider Hurston's conscious construction of a "public" self in her autobiography, because while many critics consider *Dust Tracks* a failure on several counts, I argue that Hurston was not in fact writing her "autobiography" according to standard formulas. Instead, she radically revises the definition and subverts liberal humanist ideologies of the autonomous self.

Alice Walker, who is largely responsible for the recovery of Hurston's literary reputation, considers *Dust Tracks on a Road* the "most unfortunate thing Zora ever wrote" ("Zora" 91), and Robert Hemenway, in his introduction to

the second edition of *Dust Tracks*, details the deceptions and inconsistencies in Hurston's text and wonders why she would choose to dissemble in a text that, by convention, promises to tell the whole truth. Hurston was evasive about her birth date; her age at certain critical moments is unclear, resulting in, as Hemenway notes, a ten-year gap in her narrative. Hurston was actually twenty-six when she enrolled in high school, but her text suggests she was sixteen. She reduces her first husband to his initials, completely neglects to mention her second marriage, devotes a scant eight pages to a writing career that was then still considered prolific and admirable, and generally avoids specifying her individual experience of life. Clearly, Hurston's view of the autobiographical contract differed from received wisdom about its conventions, and the resulting text profoundly resists the requirement of veracity.

Of what value then is *Dust Tracks on a Road*, if it is so widely regarded as unreliable? Hemenway argues that its value lies in its "representative" nature, as the narrative of a woman whose career defied all odds and because it provides an enlightening glimpse of how a major artist sees herself (Introduction xiv). More bluntly, I want to argue that Hurston's "lying" reflects her understanding of the function of lying contests in the context of black culture, and furthermore, that the "lies" she tells suggest that Hurston is, in fact, telling the whole truth, *as she sees it*. She is, as Gates points out, specifying according to her own definition in *Dust Tracks*, where she defines it as "giving a reading" (*Signifying* 198). As Art Spiegelman has argued, "the categories of fiction and nonfiction have become useless. . . . All art making is a kind of lying because willfully or unwillfully you select and that selection sets a whole stream of assumptions in motion" (*Complete Maus*). Hurston's narrative choices reflect her understanding of the individual's right to "spin" the truth as she sees fit, although she sorely tests the reader's ability to accept her version of truth by extending the boundaries of what constructions are "allowable" to include even such apparently straightforward truths as dates.

Writing of her girlhood, Hurston devotes an entire chapter of *Dust Tracks* to the storytelling she heard on the store porch in Eatonville and how those "lying" sessions inspired her own fanciful stories. Here she defines lying contests as "straining against each other in telling folks tales" (63) through such stock characters as Brer Fox and Brer Rabbit, but expands the meaning to include signifying stories in *Their Eyes Were Watching God*. The practice of signifying in African American culture encompasses a variety of forms, including loud-talking, testifying, rapping, and playing the dozens. Henry Louis Gates, Jr. argues that signifying is "a rhetorical act that is not engaged in information giving. Signifying turns on the play and chain of signifiers, and

not on some supposedly transcendent signified" (*Figures* 238).[8] Elsewhere, Gates claims that Hurston is apparently the first scholar to define and analyze the trope of signifying, as well as the first writer to represent it in print.[9] For Hurston, the "lies" of signifying practices, which she defines as "showing off" (*Of Mules* 161), represent more durable truths than an ostensibly straight-forward account ever could. Thus, the purpose of storytelling is not to impart information, but rather to engage in a free play of signifiers that invoke a range of meanings and truths having multiple sources and origins. The lack of a transcendental signifier enables Hurston to signify freely on her own life story in *Dust Tracks on a Road*, as well as in *Their Eyes*, such that both narratives can be equally valorized as vehicles of truths.

To return to the negative assessments of *Dust Tracks on a Road*, it is true that Hurston's text lacks many of the traditional markers of autobiography, particularly its exclusive focus on the life path of the writer. Walker's point that *Dust Tracks* rings false after the first few chapters may stem from the fact that Hurston frequently turns away from self-revelatory narrative toward what could be described as an ethnographic "thick description" in which her cultural milieu stands as a trope for her self. Even in the chapter on the importance of storytelling in Hurston's youth, her inclination is to let the stories speak to her own inner life and public geography. That is, through much of *Dust Tracks*, Hurston articulates her selfhood by means of free indirect discourse, a description that is often applied to *Their Eyes Were Watching God* but which I argue is equally apt for the autobiography. Gates writes that the indirect discourse of the "speakerly" text in African American literature "privilege[s] the speaking black voice" (*Figures* 249), but in *Dust Tracks* Hurston has radically revised this notion away from the individual speaking voice toward privileging the collective voice. Françoise Lionnet proposes redefining *Dust Tracks* as an "autoethnography," which she defines as "the defining of one's subjective ethnicity as mediated through language, history, and ethnographical analysis . . . a kind of 'figural anthropology' of the self" (383). Noting that *Dust Tracks* "does not gesture toward a coherent tradition of introspective self-examination with soul-baring displays of emotion" (385), Lionnet argues correctly that Hurston's text refuses to invoke a transcendent purpose—or signifier—to drive the narrative. Rather, her vocation of collecting the folk tales of the rural south, coupled with her understanding that these stories are unfixable, changing according to the rhetorical situation, infuses *Dust Tracks* with a collective sense of self. As Will Brantley contends, Hurston seems more inclined to articulate the "emotional sources" of her life, which are situated in black folk culture (191). In other words, Hurston's story is embed-

ded in the larger narrative of her culture, which implicitly tells her own story. This is precisely the problem with the text for many critics: Hurston frequently erases self in favor of telling stories about others or philosophizing about the state of the world: the paradigm of traditional autobiography finds too many gaps and silences here. In Hemenway's words,

> *Dust Tracks* fails as an autobiography because it is a text deliberately less than its author's talents, a text diminished by her refusal to provide a second or third dimension to the flat surfaces of her adult image. Hurston avoided any exploration of the private motives that led her to public success. Where is the author of *Their Eyes Were Watching God*? (Introduction xxxix).

Clearly searching for the paradigmatic conventions of autobiography, Hemenway pronounces the text a failure. Behind this condemnation lies the expectation that autobiography will be coherent, linear, comprehensive and, most critically, will explicitly articulate the private self. But these expectations belie the hegemonic ideology associated with autobiography, that the autobiographical imperative to focus on an individual journey reflects the liberal humanist ideology that values the autonomous individual whose free will is the primary source of identity. Hurston actively resists the traditional text by making the relevant social discourses an integral part of the text. In refusing to portray her inner life to any great extent, Hurston subverts the master narrative of self-writing and denies the reader's desire to see that particular narrative unfold.

But while I suggest that Hurston is redefining a genre with *Dust Tracks*, I do not mean to ignore extenuating circumstances in her life that might also account for some of her narrative choices. In particular, Hurston's dependence on the patronage of wealthy whites such as Fannie Hurst and Annie Nathan Meyer throughout her adult life creates a potential conflict for her, even if she wanted to "tell the whole truth." In this sense, the construction of *Dust Tracks* may reflect Hurston's need to maintain the "stories" she had originally told to secure the patronage she relied on. For instance, as I mentioned above, Hurston gave conflicting birth dates throughout her life, but in general seems to have "lost" approximately ten years in her text. When she returns to high school, she passes for sixteen, although she is in fact, twenty-six. And, as Hemenway writes, when she matriculates at Barnard College at age thirty-four, the people responsible for her admission believed her to be a typical college freshman (Introduction xii). More seriously, Hurston's

commentary on race in *Dust Tracks* is often contradictory and is frequently read as accomodationist. As Brantley writes, readers and critics alike have been able "to accept all of Hurston's eccentricities, save those regarding race. In the nexus of gender, family, region, nation, and race, it is race that remains the most problematic issue *for Hurston's readers, if not for Hurston herself*" (212, emphasis added). That readers find Hurston's positions on race implausible says more about readerly desire than the relative truth value of Hurston's apparent attitude, and yet there are unquestionably contradictory assertions made in her text. Following an eyewitness account of a black man who nearly causes a riot because he insists he has a right to a haircut and shave in a shop that serves only whites, Hurston reflects that perhaps she should have defended the man's rights: after all, "he was one of us." But she quickly turns away from this possibility, noting that the livelihood of fifteen other blacks (including herself) would have been lost if they had taken his side, and concludes that "self-interest rides over all sorts of lines" (164), a statement that becomes highly significant when considered in the context of Hurston's adult life. Claiming she has "no lurid tales to tell of race discrimination at Barnard," she also notes that she quickly became its "sacred black cow" (169). And, according to Hemenway, Hurston's private letters reveal that her benefactor forbade her to attend the Barnard Prom (Introduction xiii), which makes her claim that she experienced no discrimination seem disingenuous. So while she mocks the "Race" men and women for their over-eager readiness to defend blacks from all hints of inferiority, in the next breath she dryly notes that "no Negro in America is apt to forget his race" (*Dust Tracks* 218).

In Hurston's autobiographical rendering, coming of age entails resisting the ideology of the autonomous individual through the invocation of a black collective identity, admitting the exigencies of dependence on other people (including whites) for a variety of reasons, but paradoxically dissenting with contemporary identity politics. In other words, Hurston ironically refuses the notion that race is the primary basis of black identity, while at the same time she seeks to celebrate the specificities of black folk culture. *Dust Tracks* argues further that quotidian needs drive and construct identity as surely as racial and gender discourses. A continuing need to secure financial support for her research and writing necessarily formed Hurston's autobiographical construction of a self, an assertion that Hemenway and other critics continue to see as less than truthful because it seems to accept an accomodationist view of race issues. In this sense, *Dust Tracks* is a pragmatic text not unlike Booker T. Washington's 1899 autobiography *Up From Slavery*, which has been similarly faulted for its muted representation of the realities of racial

oppression in the United States. But Washington was under constant pressure to raise funds for Tuskegee Institute and, like Hurston, could ill afford to alienate potential contributors.[10] Both texts resist the unspoken expectation that African American texts must thematize social protest; instead they construct identities that speak to the truths arising from their particular goals and aspirations. Because Hurston wished to continue her work collecting folk tales, for instance, the foregrounding of those stories in her text serves to advertise her ethnographic work. Furthermore, Alice Walker argues that Hurston was "more like an uncolonized African than she was like her contemporary American blacks, most of whom believed, at least during their formative years, that their blackness was something wrong with them" ("Zora" 86). Walker speculates further that Hurston's relatively rare experience of coming of age in the all-black community of Eatonville was responsible for creating an individual with an unusually confident sense of racial pride, so the resulting comfort with black racial identity was inconceivable to her many critics ("Looking" 100).

For Hurston, the autobiographical act is conceived as a public statement that contextualizes the individual life in relation to community identity, and she expects the reader to bridge the interpretive gap between general descriptions of her milieu and the discrete incidents from her own life. As she writes in the opening chapter of *Dust Tracks*, "I have memories within that came out of the material that went to make me. Time and place have had their say. So you will have to know something about the time and place where I came from, in order that you may interpret the incidents and directions of my life" (3). The text, accordingly, situates Hurston in a particular social context, emphasizing the "material that went to make me" and suggesting that these factors are more salient that Hurston's specific acts. The specific feelings and individual events related to coming of age are thus less important and less telling than the cultural backdrop. But as I noted earlier, this approach to autobiographical writing is antithetical to the traditional form, which valorizes the autonomous individual. More specifically, Hurston's text also posits an identity in opposition to the traditional self of African American autobiography, which Stephen Butterfield defines as

> a member of an oppressed social group, with ties and responsibilities to the other members. It is a conscious political identity, drawing sustenance from the past experiences of the group, giving back the iron of its endurance fashioned into armor and weapons for the use of the next generation of fighters (2–3).

While Butterfield's definition invokes the notion of group identity, the basis of that identity is primarily related to shared oppression. Butterfield's model, based on a tradition established in male slave narratives and entrenched as tradition by the Harlem Renaissance, valorizes the statement of individual oppression and personal triumph over adverse circumstances.[11] But the autobiographical model of black women has always differed from the black male paradigm. Joanne M. Braxton sees black women's autobiography as "an attempt to define a life work retrospectively and as a form of symbolic memory that evokes the black woman's deepest consciousness . . . [and] an occasion for viewing the individual in relation to those others with whom she shares emotional, philosophical, and spiritual affinities, as well as political realities" (9). The critical difference between Braxton's definition and that of the traditional male text is found in the focus on relationships as a determinant of identity, and this may explain the manifestation of selfhood Hurston creates in *Dust Tracks on a Road*; if the genre demands the performance of rugged individuality apart from any cultural context, there is little space for Hurston to articulate the feminine narrative of connectedness and relationship. In other words, although *Dust Tracks* expressly details and celebrates black community and culture, it does so at the expense of human connectedness, for Hurston is at pains to distance herself in her autobiography from her peers in the black community, as well as from her benefactors. But, seen another way, it could be said that she had already, five years earlier, narrated the inner life that she neglected to mention in *Dust Tracks on a Road*. The fictional story of Janie Crawford, widely acknowledged to be based on Hurston's experiences, apparently provides a more felicitous vehicle for explicating the inner self. As I have argued, fiction has long provided women with a "safe" place to develop specifically female selfhoods, in that a writer may paradoxically feel greater freedom to bluntly state her perspective under the protective cover of fiction. While I make no claim here that *Their Eyes Were Watching God* is factually Hurston's own story, I do argue that the novel develops Hurston's philosophy of selfhood more deeply than *Dust Tracks* and shows identity to be a journey that unfolds through an evolving process of learning and knowing the self.

JANIE'S WAYS OF KNOWING

After its publication in 1937, *Their Eyes Were Watching God* was met with nearly universal condemnation by the black male literary establishment for break-

ing with the tradition of black protest fiction. Richard Wright was perhaps Hurston's harshest critic, bitterly attacking her novel for perpetuating an image of the Negro as minstrel. Alain Locke wondered when Hurston would "come to grips with motive fiction and social document fiction."[12] Mainstream black male writers and intellectuals demanded that Hurston conform to their vision of black art, something she consistently refused to do. In 1928, Hurston wrote:

> I am not tragically colored. There is no great sorrow damned up in my soul, nor lurking behind my eyes. I do not mind at all. I do not belong to the sobbing school of Negrohood who hold that nature somehow has given them a lowdown dirty deal and whose feelings are all hurt about it. . . . No, I do not weep at the world—I am too busy sharpening my oyster knife ("How" 153).

Hurston's view here does not differ significantly from that of another African American woman of letters, Frances Harper, who in 1861 wrote that "[w]e are blessed with hearts and brains that compass more than ourselves in our present plight."[13] Harper seems to be looking forward to the day when blacks might look up to the horizon and recognize that their lives are much richer than the relentless focus on oppression admits. Out of this worldview, Hurston created a new type of black woman character; neither black mammy, conjure woman, loose black woman, nor even a tragic mulatta, Janie Crawford is, according to Barbara Christian, the first instance in African American literature of the story of a black girl's development, "not from without, but from within" (57). While such a narrative might seem commonplace today, it is important to recognize what a radical departure Hurston's novel was from contemporary norms for black fiction in the 1930s. In marked contrast to Wright's 1940 novel *Native Son*, which depicts Bigger Thomas as repressed and defined by white constructions of his identity, Hurston shows Janie in the process of constructing *herself*. The movement of the narrative takes Janie from being defined by others to defining herself through the meaning she assigns to her experiences.

Geta LeSeur terms *Their Eyes* a black *Bildungsroman* to differentiate between narratives of the European tradition and the particular patterns of the African American version of the genre (19). In general, LeSeur argues that the black *Bildungsroman* must be defined separately due to differing sociological and historical contexts, which result in a divergence in the growth of black and white children—black children simply do not flourish as well as

white children (21). These texts, writes LeSeur, differ from autobiography in that they are "novels of initiation, childhood, youth, education, and the various other definitions used for the Bildungsroman, with autobiographical components" (26), an argument that strikes me as tautological. LeSeur claims that the protagonists of black *Bildungsroman* are "not concerned with what is specific to them as artists, but with something more generally shared in the human experience" (26), but there is a telling conflation of the "hero or heroine" and the "artist" in this argument. Nonetheless, LeSeur makes a crucial point when she notes that the black female *Bildungsroman* does not limit its purview to the protagonist's youth, but instead sees *Bildung* as a lifelong process, an observation that accurately captures the major thematic concern in *Their Eyes Were Watching God* (101).

Since the novel first regained widespread recognition in the early 1970s, the question of whether Janie succeeds in creating her own identity has been the primary focus of critical debate. Specifically, critics have examined the problematic question of Janie's achievement of voice (and hence, agency) in the novel, given that, although Janie is ostensibly telling Pheoby her own story, the bulk of the novel is written in the third person. This charge seems ironic in light of Annie Dillard's choice to use third-person narration as a means to authorize and philosophize about the meaning of her experiences. Robert B. Stepto was among the first critics to question whether Janie truly achieves her voice in *Their Eyes*, since most of her story is told by an omniscient third-person narrator rather than Janie herself. Stepto argues that this fact implies that "Janie has not really won her voice and self at all" (166), and yet, Stepto seems not to recognize that women's narratives historically have been seen as inferior precisely because they relied too much on a feminine 'I'. Thus, women writers have sometimes removed the subjective narrator in order to lend greater authority to their narratives. Gates addresses this dilemma by describing the text as the first example of a speakerly text in the African American tradition, a text with "rhetorical structures [which] seem to exist primarily as representations of oral narration, rather than as integral aspects of plot or character development. These verbal rituals signify the sheer play of black language which *Their Eyes* seems to celebrate" (*Signifying* 181, 194). Therefore, the representation of Janie's voice is depicted primarily in what Gates terms as "free indirect discourse," which is neither the voice of a character nor a narrator, nor the two combined; "rather, it is a bivocal utterance, containing elements of both direct and indirect speech. It is an utterance that no one could have spoken, yet which we recognize because of its characteristic 'speakerliness,' its paradoxically written manifestation of the

aspiration to the oral" (*Signifying* 208). For Gates, the problem of Janie's achievement of voice is overcome by recognition of Hurston's stylistic variation of traditional depictions of voice. John F. Callahan argues that "the two major voices in *Their Eyes Were Watching God* do not contend; rather, they cooperate and collaborate" (118). "Author and character work together; each shares authorship and authority—collaboratively" (119).

In her foreword to the 1990 edition of Hurston's novel, Mary Helen Washington recounts the debate about Janie's voice at a well-attended MLA session in 1979, during which Alice Walker "found her own voice" and rose to defend Hurston's choice to allow Janie silence at strategic points in the novel, arguing that women do not necessarily have to speak when men think they should and affirming women's right to choose where and when to speak (xi–xii). The question of Janie's voice is a crucial one in determining the success of her quest for self, but it is not the only way in which her blooming selfhood is manifested. Even during the long periods of Janie's public silence, her identity is in process, growing inexorably as she comes to know and understand her self on her own terms. Janie's eventual ability to name her own experiences is demonstrated not simply in her voice but in her actions and in the evolution in her ways of knowing herself. Conflating the achievement of voice with the achievement of self ignores other concrete demonstrations of Janie's act of self-creation, which diverges from the male pattern of selfhood in significant ways. Moreover, Janie's absence of voice in the narrative is sometimes an unreliable indicator of her self-concept.

It is axiomatic by now that women tend to define themselves within the context of their relationships; Janie's story affirms this argument, as others impose their texts on her and she tries them on for size, either accepting or rejecting their definitions of her. Chris Weedon notes that "subjectivity . . . is precarious, contradictory, and in process, constantly being reconstituted in discourse every time we think or speak" (33), or, I would add, act. It is productive to view Janie's tale in these terms, as it helps to justify the sometimes contradictory assertions the narrative makes about Janie's self-expression. Instead of requiring Janie to exhibit a unified self through a full rendering of her own story told in the first person, her identity is more productively seen as still in process, even at the end of the novel, by which time she is in her forties, well past adolescence. We can then look beyond Janie's verbal expression to determine the success of her quest for selfhood.

Research in the developmental psychology of women over the past twenty years or so has illuminated different epistemological paradigms for women, describing alternative paths to selfhood from those attached to male

developmental patterns and providing a useful framework from which to evaluate Janie's growth from object to subject. In *Women's Ways of Knowing*, Belenky et al. trace five distinct ways of knowing in which women may develop the self, voice, and mind. While I find these categories of knowing useful in understanding how Janie is able to pursue quest when she is discouraged at every turn from doing so, it is important to note that the categories described by Belenky et al. may overlap, and that not every woman will pass through each of the stages described. In other words, these ways of knowing might represent stages of growth for some women, while others will only experience some of the stages, which represent an epistemological continuum from simple, passive silence to complex, constructed knowing. In the bumpy process of coming of age, Janie moves from being a passive recipient of others' knowledge to a complex constructor of the meaning of her own experience who recognizes the authority inherent in her hard-won knowledge of self.

At the age of six, Janie is confronted with a picture of herself with the white children with whom she is being raised, but fails to recognize her own image: "Ah don't see me" (9). Others must point her out in the picture because has no clear sense of self; she does not even realize she is black. The source of self-definition resides in others here, and Janie relies on them to construct her subjectivity. She is called "Alphabet" during this period in her life "cause so many people had done named me different names" (9). As Sigrid King points out, naming has special significance in the African American tradition: "Afro-Americans have been made aware that those who name also control, and those who are named are subjugated" (683), an assertion which explains the widespread rejection of slave names after abolition, and indeed into the twentieth century.[14] Kimberley W. Bentson notes that the namer objectifies the named, forever marking her as other. Arguably, few six year-olds would be able to name themselves effectively or to wrest power from others to fully assert their own identities, but Janie's case is unusual by virtue of the name bestowed upon her—Alphabet. A sign without a concrete signification, Janie is defined as all *and* as nothing. By dubbing Janie Alphabet, her namers fix her as an object not worthy of fixing, and thus exercise control over her subjectivity. For Gates, Janie's early identity as a "nameless child" underscores the great degree to which her journey enables her to claim a voice (185), and consequently to assume a complex subjectivity.

In her adolescence, removed from the white gaze that defines her as other, Janie's quest for self begins in earnest. At sixteen she finds herself under a pear tree "stretched on her back listening to the alto chant of the vis-

iting bees" and watching them pollinate the blooms. Enchanted, Janie transforms the narrative of the bees and the pear tree into one that illuminates her sexuality: "So this was a marriage!" (10). This image informs her knowledge of the meaning of love, and she trusts that knowledge to such an extent that it becomes the litmus test by which she will test the validity of her three marriages. Her grandmother, however, reads Janie's awakening sexuality as dangerous, and moves quickly to safeguard her granddaughter against reenacting her own life/narrative.[15] The pollination experience represents Janie's first genuine attempt to claim her own subjectivity and agency, but Nanny subjugates her by forcing her own text of subjectivity on Janie. Nanny had once hoped to "preach a great sermon about colored women sittin' on high, but they wasn't no pulpit for me" (15), so she concludes that black women are "de mule uh de world" (14). Unable to transcend her own status as a mule, Nanny has made it her life work to protect Janie from assuming that same identity. Equating "sittin' on high" with material wealth, Nanny sees the middle-aged Logan Killicks with his "often-mentioned sixty acres" (20) as Janie's best hope of escaping the negative definitions of black female subjectivity. For Janie, though, Nanny's vision desecrates the promise of the pear tree and silences her attempt to name her own reality.

In Belenky et al.'s terms, she is positioned as a silenced knower, which is marked by "unquestioned submission to the commands of authorities, not to the directives of their own inner voices" (28). Knowing that marriage to Killicks contradicts her own vision, Janie submits because she has not yet learned to privilege the knowledge she has, a common enough dynamic among children and adolescents who, by cultural agreement, are not as wise as their elders. A closely related epistemological position is that of received knowing, defined as a reliance on others' knowledge, which Janie assumes after her marriage as she tries to understand others' definitions of marriage: "Janie had no chance to know things, so she had to ask" (20). Doubting the validity of her own vision, Janie asks for advice from others and is told that she will learn to love Logan within the context of their marriage. Janie has little confidence in her own knowledge, believing that others' knowledge is more reliable, so she assumes her position as wife and "wait[s] for love to begin" (21). But when the marriage fails to transform her feelings toward Logan, Janie once again turns inward to listen to her own "still small voice."[16] In Belenky et al.'s formulation, "newly acquired subjectivism leads the woman into a new world, which she insist[s] on shaping and directing on her own" (76). But this altered subjectivity comes at a heavy price, for Hurston writes that "Janie's first dream was dead, so she became a woman" (24).

Equating the loss of dreams with the advent of womanhood, Hurston seems to give credence to James Weldon Johnson's assertion that what a girl feels on the threshold of womanhood is negative. Yet Janie Crawford does not give up her quest for self because she was disappointed with womanhood; indeed, the quest becomes more important because she does not accept that womanhood should be negative. Moreover, although *Their Eyes Were Watching God* can be read as a search for romance, for Janie, romance and quest are inextricably related. Romance does not prove to be an end for Janie, but rather a means of achieving subjectivity. Hurston's text argues that identity is created and quest carried out in the context of relationships.

Janie's quest for selfhood seems to be aided by the appearance of Joe Starks, who speaks to her "for far horizon" (28). As an increasingly subjective knower, Janie is able to walk away from the past because she is learning to assert her own autonomy. She can act because, in Williams's terms, she has *imagined* a new way of being in which her own authority is privileged. During her courtship with Joe, Janie learns to listen to what one of Belenky et al.'s subjects called her "infallible gut." Janie believes that the answers she is searching for can be found within herself, which allows her to leave with Joe, reflecting the argument that, in order to assert and define themselves, women must learn to rely on their intuition and authority (Belenky 54). But for Janie, intuition proves fallible as Joe's promises play out in unexpected ways. Promising to place her on a pedestal, Joe provides Janie with a means of escaping Logan's definition of her as a mule, but Joe ends up interpellating her more successfully than either Nanny or Logan. As mayor of Eatonville, Joe will not permit Janie to speak in public, and she endures twenty years of silence because Joe expects her to "class off" from the rest of the folk. He gives her social position and material wealth, but he does not allow her to join in community life. Silencing Janie, he positions himself as the authority on who Janie is and should be.

While Joe denies authority to everyone in Eatonville, it is through Janie that this travesty is most deeply felt. The bigger Joe's voice gets, the smaller Janie's exterior becomes. But because she privileges her inner knowledge of self, her identity never disappears completely; instead, it continues to evolve. Matt Bonner's mistreated mule and Janie's reading of it demonstrate the growth in her identity as she compares her own lot in life to that of the mule, which underscores Nanny's equation of the black woman with a mule—both are domesticated beasts of burden in the hegemonic economy of the novel. As Matt seeks to assert his authority over the mule by mistreating it, the townspeople bait the creature into misbehavior in order to signify on Matt.

Janie is appalled, however, and mutters to herself that the mule has "had his disposition ruint wid mistreatment" (53). Then a "little war of defense for helpless things was going on inside her. People ought to have some regard for helpless things. She wanted to fight about it" (54). Realizing that she is similarly helpless, Janie clearly identifies with the mule's situation and longs for someone else to notice that she is as mistreated as the mule.

Hurston writes that Joe's silencing of Janie results in a self-protective division of her inside and outside selves that deepens as the bloom dies on their marriage. Rather than being psychologically debilitating, this compartmentalization of inner and outer lives allows Janie to protect the part she cherishes—her interior knowledge—which is still alive and in process while externally coping with and surviving her marriage. This division of self radically revises the liberal humanist conception of the unity of identity without the normative accompanying suggestion of inferiority. Hurston reverses the privilege accorded to the monolithic self and applies it instead to the multidimensional self. When Joe slaps Janie for ruining his dinner, she realizes she must never again show Joe her inner self. I quote from the text at length here because this moment is pivotal in Janie's eventual ability to resurrect her own voice:

> Janie stood where he left her for unmeasured time and thought. She stood there until something fell off the shelf inside her. Then she went inside there to see what it was. It was her image of Jody tumbled down and shattered. But looking at it she saw that it never was the flesh and blood figure of her dreams. Just something she had grabbed up to drape her dreams over. In a way she turned her back upon the image where it lay and glistening young fruit where the petals used to be. She found she had a whole host of thoughts she had never expressed to him and numerous emotions she had never let Jody know about. Things packed up and put away parts of her heart where he could never find them. She was saving up feelings for some man she had never seen. She had an inside and an outside now and suddenly she knew how not to mix them (67–68).

Although Janie will remain silent on the outside for many years, her thoughts demonstrate the dynamic nature of her creation of identity, which is largely the result of interpellation by others' discourses, but also the tenacious integrity of her private vision.

When Janie learns to separate her inner and outer selves, she simultaneously resurrects the image of the pear tree, allowing herself to revive her

romantic vision of love while living a mundane, loveless life on the outside: "one day she sat and watched the shadow of herself going about tending the store and prostrating itself before Jody, while all the time she herself sat under a shady tree with the wind blowing through her hair and clothes" (73). In this way, Janie is able to cope with what is otherwise an intolerable existence. But though this coping mechanism allows her to resist Joe's definition inwardly, it does not empower her to act. Awkward argues that it is only when Janie sees evidence of Joe's deteriorating health that she gains the courage to deflect his text. Joe's "big voice" no longer corresponds to his physical self, which Janie reads as the reason for his increasingly disparaging insults of her. Attempting to shift public attention from his own aging, Joe repeatedly calls attention to Janie's signs of age and she recognizes that his death is imminent. Quietly, Janie realizes she will soon be freed from Joe's tyranny, and so she sees no need to assert her voice.

The dissonance of Joe's abuse grows because, despite his assertions to the contrary, Janie does not look old—Joe does. "For the first time in their relationship," notes Awkward, "Starks is unable to create a sense of harmony between words and reality" (77). Joe's diminishing power gives Janie the courage to fight back in a moment when, as Gates points out, she signifies on Joe's manhood: "When you pull down yo' britches you look lak the change uh life" (75). Reversing their relationship, it is Janie who uses voice to name Joe and, consequently, herself. As Gates writes, "Janie writes herself into being by naming, by speaking herself free" (*Signifying* 207). The truth of her signifying is verified as Joe's health deteriorates immediately; Janie's signifying leads directly to his death, suggesting the power of her knowledge. Joe's death and Janie's ascendancy as a reliable knower signals the critical importance of an accurate vision of self. In Gates's view, this moment signals Janie's achievement of voice, and thus authority, although "not a sign of a newly found unified identity. Janie's speaking voice, rather, is an outcome of her consciousness of division" (203), which Hurston does not represent as problematic. Rejecting previous discourses that, in her view, defined her erroneously, Janie sets about to create an alternative subjectivity that privileges her own vision of life and love. Realizing she is a "motherless child," Janie finally acts to create self according to her own design. Still, in some senses, she continues to wait passively for an opportunity to remake her identity.

Having established by now that Janie defines herself within relationships, it is not surprising that the next stage in her growth is precipitated by her relationship with Tea Cake. The difference now is that she is far clearer about the nature of relationship she is willing to accept. While it might be

problematic for contemporary readers that Janie is unable to define herself outside of her relationships with men, Janie has established a reasonably effective mode of self-realization within the contexts of her relationships, although it is difficult to avoid the conclusion that, had she chosen better, her coming of age would not have been delayed for so long. But as du Plessis reminds us, quest for self and romance are not usually compatible in women's fiction, so Hurston's narrative can be seen as a transitional text in that Janie's quest for self takes place in the context of romance and continues beyond the traditional marriage ending. Between her marriages to Joe and Tea Cake, Janie is adding to the arsenal of identity an important element of identity and relishing the "freedom feeling" (86) that she is no longer willing to subsume in exchange for relationship.

Janie's reinvention of self is dynamic and radical in the context of her relationship with Tea Cake Woods. Nellie McKay points out that Hurston scholars are divided about how much credit Tea Cake should be given for the eventual full emergence of Janie's identity. But McKay sees much of Janie's marriage to Joe as the vehicle for Janie's quest for self, so she is in fact primed to make that quest active by the time Tea Cake appears (61). Awkward disagrees though, seeing Tea Cake as yet another text seeking to impose its ideology on Janie, although he concedes that Tea Cake's view of marriage is relatively liberating for Janie. Still, as Awkward correctly notes, many interpretations of *Their Eyes* gloss over numerous narrative moments when Tea Cake acts as an archetypal domineering male (83). Maria Tai Wolff sees the difference between Tea Cake's text and those of Janie's earlier relationships in that Tea Cake *invites* Janie "to live a text, to formulate a role. In the narrative of Janie's life, knowledge accepted from a prepared text—one that is told—is opposed by knowledge gleaned from experience" (31).

Belenky et al. argue that a woman in the subjectivist position of knowing goes through a period in which her self-concept is unstable. Separated from her most recent and long-standing definer, Joe, Janie observes and considers a whole range of possible self-definitions. She is in no particular hurry to fix her identity. Because she defined herself internally for so many years, her inner voice has grown in stature as she gradually learns to privilege her intuitive knowledge over the truth imposed by Joe. In her relationship with Tea Cake, Janie remains in a subjectivist position, but her quest for self moves tentatively into external manifestations. "[W]omen in this position develop "strategies for knowing [that] grow out of their very embeddedness in human relationships" (Belenky 85). Thus I argue that Janie's dependence on Tea Cake's text for the creation of her own identity is a legitimate and

productive strategy. Some contemporary readings of *Their Eyes Were Watching God* express disappointment in Janie's continuing reliance on her relationships as the source of her identity, but such a view ignores the fact that many women (and men) do in fact define themselves in the context of their relationships.[17] It has been a highly productive means of self-creation for women throughout history, and indeed, it is arguably impossible to define oneself in isolation from human interaction. Through her characterization of Janie, Hurston challenges the liberal humanist notion of a unified, autonomous self.

Janie and Tea Cake's courtship is marked by her exploration of the uncharted territory of her subjectivity. She challenges many of the texts that have been imposed on her as black, woman, and mayor's wife. Tea Cake invites her to actively share his life and to enjoy herself, but in the final analysis, Janie's text is largely dictated by him; she wears clothes *he* likes to see her in and eventually leaves Eatonville to marry Tea Cake and "start all over *in Tea Cake's way*" (108, emphasis added). Although she claims to have lived Nanny's way and now means "tuh live mine," Janie accepts Tea Cake's way as her own. In order to live out this new text, Janie must define herself in opposition to the old one, necessitating a move away from the place where the old identity is embedded. Tea Cake's apparently egalitarian view of his relationship with Janie is undermined by his frequent retreat into sexist domination of her. These episodes periodically force Janie to retreat into her former mode of protective self-division. Despite Tea Cake's domination, the alternative text he offers Janie provides her with choices for the first time in her life.

The journey for Janie and Tea Cake is far from smooth, however, and their relationship undergoes more than a few serious crises in trust. The greatest test of the integrity of Janie's newly created self-concept comes when Tea Cake, transformed by rabies, threatens to kill her. Were Janie truly defined by his text alone, she might have found herself transformed by his altered perception of her. But, signaling her investment in her own definition of self, Janie rejects Tea Cake's rabid definition of her and kills him before he can kill her. Even her murder trial fails to dissuade her from the truth of why she had to kill him; the strength of her vision convinces first the white court, and finally, more grudgingly, Tea Cake's friends.

As she comes of age, and through her three marriages, Janie employs distinct ways of gaining self-knowledge. Throughout her life, she allows herself to be externally defined, although she does not recognize the subjectivity she is called to assume. Marriage to Joe is marked by Janie's inner growth, which occurs as a result of her careful observation of the dissonance between her

own text and that of others. Finally, in her marriage to Tea Cake, Janie creates knowledge through direct experience with the larger world, and she signifies on it by freely assigning meaning to that experience. Janie has become what Belenky et al. define as a "constructed knower." Women in this position listen to a "voice of integration," which the psychologists describe as a "fusion of reason and intuition and the expertise of others" (133). Janie's journey has taught her the necessity of employing all of these strategies in constructing her self, privileging none above the others. Additionally, constructed knowers feel compelled to confront life in all its complexity, both externally and internally, "[a]nd they want to develop a voice of their own to communicate to others their understanding of life's complexity" (137). After Tea Cake's death, Janie's primary need seems to be to voice her complex understanding of her experience; she privileges her inner voice, and is finally confident enough to listen to others and learn from them too.

Hurston's representation of coming of age extends its boundaries to suggest that the process of attaining subjectivity does not end with adolescence. Indeed, Tea Cake tells Janie that "God made it so you spent yo' ole age first wid somebody else, and saved up yo' young girl days to spend wid me" (172), an observation borne out by the activities Janie and Tea Cake engage in during their courtship, coded as adolescent behaviors: fishing all night long, going to the movies, learning to drive, playing checkers (105). And there is no suggestion that Janie is finished with the process of constructing her subjectivity at the end of *Their Eyes Were Watching God*. Furthermore, Janie's subjectivity is decidedly constructed in and through relationship, not only to her grandmother and her three husbands, but through the community of Eatonville as well. As with the protagonists of other coming-of-age narratives, Janie does not accept the ideology that requires women to relinquish quest in favor of romance. Steadfastly clinging to agency regardless of her marital status, Janie simply leaves her husbands (either physically or emotionally) when it is clear that they will not permit the continuation of her quest. The shifting point of view may suggest that Janie's authority is undercut by the third-person narration, but Janie herself refutes that assertion in the final moments of the novel by suggesting that talk not backed up by experience is meaningless: "talkin' don't amount tuh a hill uh beans when yuh can't do nothin' else. . . . you got tuh go there tuh know there. Yo' papa and yo' mama can't tell yuh and show yuh. Two things everybody's got tuh do fuh theyselves. They got tuh go to God, and they got tuh find out fuh theyselves" (183). Janie has done precisely that. The act of narrating her own story is the most important indicator that she has indeed found out for herself.

6 ❖ "Room for Paradoxes"

Creating a Hybrid Identity

> I learned to make my mind large, as the universe is large, so
> that there is room for paradoxes.
> —Maxine Hong Kingston, *The Woman Warrior*

Clearly, some individuals find it possible to repress difference in order to construct a unified identity. But for the American-born child of immigrants, the clash of cultural identity is necessarily foregrounded as living parents stand in clear contrast, if not outright opposition, to the new American culture.[1] Caught between two cultures, children of immigrants struggle with self-definition: Am I an American? A Pole? A Polish-American? If the latter, what exactly is that? Homi K. Bhabha might define that subject position as the "third space"—neither one nor the other, but forever in between.[2] Occupying this third space allows the individual to escape fixed identity, according to Bhabha, but in my view also places her in a position of permanent uncertainty in a culture that values certainty, even if it is chimerical. In Bhabha's view, positioning ourselves in that in-between place will free us of the repressive apparatuses of nationalism, allowing us to assume a subject position that is neither/nor, one that thus enables individual agency. While that position sounds plausible in theory, I argue that maintaining an "in-between" position is impossible in practice. It is a fine ideal to sit "perched on a hyphen," in Richard Rodriguez's words, but many immigrant narratives suggest that one is, at any given moment, identified as one or the other.[3] A first-generation American will find it difficult if not impossible to stand comfortably between two or more cultures and feel she is occupying both spaces at once. More likely, she will feel outside both cultures; the immigrant texts

I discuss in this chapter explicitly confront the deep alienation and confusion that result from a hybrid subject position. But as I have already suggested, it is a *productive* conflict that creates a space for alternative forms of identity. When a choice is forced between the binary opposition of "American" and "foreign"—and American discourses tend to encourage the denial of foreignness—immigrants invariably feel that a significant element of their identity has been devalued or even lost, just as the sexual identity of intersexed individuals who were "assigned" a sex at birth argue that they lose an integral part of their identities when their sexual ambiguity is surgically altered. The intersexed individual's bodily knowledge of his/her sexually ambiguous identity is a physical manifestation of the subjectivity of the immigrant.[4]

Although fraught with emotional pain and conflict, a hybrid or ambiguous social location is ultimately liberating for the subject of the coming-of-age narrative, allowing her to choose elements of identity that originate in the different discourses that interpellate her. In my view, the Venn diagram, in which the overlapping space of two (or more) circles creates a new and distinctive identity that draws on some aspects of the separate spheres, provides a better graphic model of hybrid identity construction than Bhabha's amorphous third space.[5] Kathy E. Ferguson argues for a "mobile," rather than multiple, subjectivity to "avoid the implication of movement from one to another stable resting place, and instead to problematize the contours of the resting one does" (158), a move that would prevent Bhabha's "third space" from becoming yet another fixed identity. Ferguson calls mobile subjectivities "relational, produced through shifting yet enduring encounters and connections, never fully captured by them" (154), a description that could be applied to many individuals and which I find particularly productive in reading immigrant narratives. Unlike "native" Americans whose families have lived in the United States for generations, and whose culture shock is but a distant memory, recent immigrants cannot avoid the recognition that they occupy a dual identity, at the very least, shifting from one position to another depending on the social context. But Shirley Geok-Lin Lim argues that the ambivalent identity of immigrants is a dialectic, "as in an optical illusion, their identities encompass[ing] more than one figure simultaneously. . . . Though we know both figures exist, we can only see one at a time" (22). Furthermore, Lim claims that immigrants themselves can be conscious of only one identity at a time, suggesting the difficulty of occupying an "in between" place for more than a passing moment.

As I have been arguing, identity is produced by multiple discourses, acknowledged or not, but clearly, many individuals are able to deny contradictory selfhood by employing what Kenneth Burke has called "terministic

screens." According to Burke, when attention is focused on one view of reality, attention is necessarily deflected from other views.[6] Thus, because Anne Moody focuses primarily on race as a determinant of identity in her memoir, she does not explicitly acknowledge other, equally salient, elements of her subjectivity, specifically gender and class. Similarly, Annie Dillard's conscious awareness of herself as female deflects her attention somewhat from other discursive constructions of her identity. This move is overdetermined in the liberal humanist tradition and authorized in academic and scientific discourse that has long claimed that a unified identity is a marker of healthy personality. There is, in other words, great cultural pressure on the autobiographer to present a coherent textual identity and to deflect attention from contradictory aspects of selfhood. But for many American-born immigrants, racial and ethnic difference foregrounds duality, and thus forces a conscious confrontation with identity.

Furthermore, the specificities of social construction of gender are variable across cultures, so for some women immigrants, American culture has provided greater opportunity for education and better material circumstances, but when American ideologies of womanhood conflict with those of the country of origin, a girl coming of age is forced to confront—and explicitly define—her identity as a woman. The process of constructing an identity is further complicated for American-born immigrants as the discourses of at least two cultures become entwined at the site of individual consciousness, often requiring a more explicit consideration of self than what is usually necessary for people who come of age in their native lands. For instance, according to Sau-Ling Cynthia Wong, Chinese immigrant literature frequently explores adult sexuality, especially in the context of heterosexual relationships, whereas American-born Chinese writers are conspicuously vague about sexuality. Wong speculates that American-born Chinese, struggling with racism and a sense of homelessness, may feel a special urgency to create a Chinese American identity: "The effort may be so all-consuming . . . that it forecloses further imaginative venturing; formulation of a serviceable identity then constitutes the culminating achievement of which subsequent experiences are but applications or variations" (124). American ideologies of sexuality may also explain the reluctance of American-born Chinese to treat sexuality in their literature; at various times in U.S. history, for example, Asian women have been considered at one extreme sexually repugnant or at the other, highly desirable "exotic" sex objects. A desire to avoid being stereotyped in these ways, then, may explain the absence of sexualized characters in the literature of American-born Asians, who, with their clearer grasp of American norms (compared to their foreign-born parents) would

likely be aware of signifying practices that serve to Other them. In this subtle but insidious manner, dominant views of Chinese by Americans work to shape the identities of immigrants and their textual representations of self in much the same way that stereotypes of black women have (partially) determined their subjectivity.[7]

Twentieth-century strategies for creating an immigrant identity in the United States have ranged from assimilationism to accommodationism to cultural separatism, so the American-born children of immigrants have shaped their subjectivity in response to the specific discourses in circulation as they come of age. In addition, the dominant views of nonimmigrant Americans toward those of foreign parentage have shifted in response to historical changes that affected the degree of acceptance felt by immigrants at any given historical moment. In general, the less an immigrant looks like she is of European descent, the more Othered she tends to feel in American society. Her response to being Othered culturally, in addition to the widespread cultural Othering of females generally, will then shape her identity in myriad ways. I turn now to two quite different coming-of-age narratives written in the context of female immigrant identity formation: Kate Simon's 1982 memoir *Bronx Primitive* and Maxine Hong Kingston's 1975 autobiography *The Woman Warrior*. Simon's family is willingly trying to assimilate, so Kate's mother explicitly constructs a radical view of womanhood for her daughter while implicitly enforcing Old World gender codes. In contrast, Kingston's family actively seeks to instill a "pure" Chinese womanhood in young Maxine, and while she initially rejects this construction, eventually she achieves an uneasy hybrid of Chinese and "American" identity. In reconstructing their coming of age, both writers thematize the special difficulties of the American-born child of immigrant parents in creating identity. Neither woman is able to unproblematically reject the old culture *or* embrace the new. Thus, while the circumstances of their lives in the United States differ a good deal, and while they were born a generation apart, Kingston and Simon faced a similar dilemma of negotiating identity amidst competing cultural claims.

A "WORLD OF PAPER STRENGTHS": THE EDUCATION OF KATE SIMON

Spying on her brother and his friends playing "King of the Hill" in a vacant lot, Kate Simon feels a distinct letdown when she realizes that the game that

had seemed so mysterious to her was only the boys' ritual of urinating into a bonfire in an empty lot. The game with the powerful name merely demonstrates to her "a feeble power that was an accident of birth," and thus Simon's view of the masculine world is demystified. She knows that it was supposed to be a "man's world," but she begins to realize that this is not such a remarkable or mysterious thing, and that she can hold her own in that "world of paper strengths" (134). This moment of truth in Simon's 1982 memoir *Bronx Primitive: Portraits in a Childhood* is one of many from which she constructs an identity. The first volume in what would be become three volumes of autobiography, *Bronx Primitive* focuses on the experiences that transform a child from a "primitive" being into a "civilized" and conforming member of society. In Simon's telling, the transformation is sometimes violent, sometimes disappointing, and often traumatic. More particularly, *Bronx Primitive* illustrates the forces, influences, and experiences that press and mold a girl into assuming her proper place in American society: of how a woman is made, not born. But Simon's autobiography is also a memoir of resistance, as the "King of the Hill" episode demonstrates. A complex web of social and cultural forces are at work on Simon, but at the distance of later years, she remembers questioning them.

Education, in the broadest sense of the word, is key to Simon's growing understanding of the world, but in a different sense than had held true for immigrants of a slightly earlier period. Fictional and autobiographical narratives such as Anzia Yezierska's 1925 novel *Bread Givers* and Mary Antin's 1912 autobiography *The Promised Land* tell of young immigrant girls who yearn for the education that America promises, even to girls. Learning has long been valued by Jewish tradition, but until the mid- to late nineteenth-century, it was largely reserved for boys and men. Education meant religious study of the Torah and Talmud, and secular training held little value. By the time of mass emigration to America, an education was within a girl's reach. Book learning and formal education were finally available to girls who had only been able to dream of the chance to go to school in the old country. An education signified the promise of economic freedom and social acceptance, but for Simon, just a generation removed from Antin and Yezierska, becoming educated comes to mean much more than formal schooling. In addition to the usual subjects in school, Simon gets an education out in the world. Crowded living conditions and lack of privacy drove her and other children out into the Bronx neighborhood to observe and learn. Such a situation would have been less likely for earlier women, since tradition would have bound them to their mothers' sides to learn domestic arts.

As if to dispel any notion that hers is a timeless, universal story, and to situate it geographically and ethnically, Simon opens her memoir with a chapter titled "Lafontaine Near Tremont," detailing the precise topographical location of her childhood. Beginning with the larger view of the Bronx neighborhood, Simon gradually narrows her vision to focus on the building, and then on the apartment in which she came of age, implying, as the coming-of-age narrative convention demands, that her experience and subjectivity are marked by a particular time and place. She is who she is because of where she came from, and the specificities of that time. The experience of coming of age, then, is profoundly affected by a complex web of factors and experiences—geographic and historic location, gender, ethnicity, sexuality, class—that are far from universal. As Lois McNay argues in her feminist gloss of Foucault's later work, subjectivity is never overdetermined, but rather, "against [a] background of multiple determinants, individuals act upon themselves and order their lives in numerous and variable ways" (65). The autobiographical act accomplishes exactly this ordering of experience to articulate the discourses of identity. Still, it may be possible to suggest some strands of commonality in the journey of growing up that, while they vary in specifics, do carry across time and place to some degree.[8] Awakening sexuality, the body's metamorphosis in puberty, consciousness of difference from males, and the socialization into feminine gender roles are thematized in American women's coming-of-age narratives, which suggests the significance of the body in the creation of knowledge.[9] But there are variations even in these themes, because if it can be said that all females experience these life passages, they do not occur at a conscious level for all young girls, and even if they do, it is the articulation of the passage into an autobiography that imposes meaning in hindsight. The past can never be duplicated precisely as it was experienced, so while the grown writer may look back and construct a narrative from a series of events that make sense of her sexual awakening, for instance, she likely did not understand the events *as* a sexual-awakening narrative while she was experiencing them. Nonetheless, as I have argued, the act of writing autobiography is an interpretation of memories, a construction of meanings that make sense to the individual herself in the historical, political, ideological, and discursive context of her life. Consequently, it matters little how the writer interpreted an event at the moment it occurred; interpretations are endlessly revisable as understanding is filtered through new experiences. Without doubt, discursive practices contemporaneous to an event shape the initial interpretation, but all retellings will be revised in light of constantly shifting discourses. Thus, the autobiographer is unable to access

any original or transcendent meaning; rather, her autobiographical text constitutes an interpretation that is situated in a particular temporal space and which can never be duplicated.

Writing after the sexual revolution of the 1960s, as well as the heyday of second-wave feminism, Kate Simon inscribes a self that she could not have created before those particular movements shifted public discourse by authorizing open discussion of sexuality. As I mention above, Simon is only a generation older than Mary Antin, but because she wrote her memoir in 1982, she—unlike Antin—can explicitly articulate the sexual aspect of her coming of age. The crowded living conditions that sent lovers to rooftops were likely much the same for Antin as for Yezierska, but because Simon is writing in the 1980s, she is able to represent what her predecessor could not. Simon's memoir is dotted with small moments that contribute to her growing understanding of sex, although she is given no concrete knowledge by her parents or others with direct experience. She must therefore add each experience, each hint, to her storehouse of knowledge and come to her own conclusions as she seeks to know and understand the body's role in subjectivity. Unfortunately, the understanding she comes to about sex is troublesome and problematic. The silence that surrounds sex in her youth is emblematic of the arguments made later by feminists in regard to women's sexuality; silence, for Simon, leads to a great deal of fear and ignorance, something that the women's movement has sought to dispel by speaking what was formerly unspeakable. And her story suggests what psychologists have been arguing since Freud: children are sexual beings who understand a great deal without being told anything by adults. Thus, when Kate sees two dogs mating and runs to her pregnant mother to go "help" them because she believes someone glued them together, her mother's response is a flat "No. I'm staying here and so are you. Mind your own business" (61). An awkward silence ensues, and Kate believes she has done something wrong. "I shouldn't have told her about the dogs. I didn't ask her why. She didn't tell me" (61).

Further into her mother's pregnancy, Kate wanders to the rooftop, and sees a pair of lovers having sex. Laughing, she runs back to her apartment to tell her mother, but as soon as she sees her, she remembers "the face that had turned to stone when I asked her to help the dogs. I looked at her belly; maybe the people on the roof were making a belly" (66). Simon also begins to equate overheard bits of conversation about childbirth with sex, and wonders why anyone would do anything that might cause her to endure the horrors of birthing. Grown women did not include young girls in open discussions of childbirth, but the few things Kate overhears frighten her.

Presumably, mothers were protecting their daughters from the realities of the pain of childbirth, but the fragmented information only heightens fears for Simon. When her mother goes into labor, nothing is explained to the children. They are sent outside and told to wait until their father gets home. They only know that something is happening to their mother, and that it has something to do with a baby. Kate hears screams as her mother labors through the night, but nothing is said, and no one reassures her. Her interpretation of these fragments of knowledge causes her to reject the new baby who has caused her mother such pain. She believes that the reason her mother often becomes angry with her for no apparent reason is that Kate too had been a source of great pain when she was born, clearly a harmful assumption. By revealing her dismal education in sex, Simon tacitly serves the political agenda of feminism by showing the impact such silences had on her. As Adrienne Rich writes, "We have had the truth of our bodies withheld from us or distorted; we have been keep in ignorance of our most intimate places" ("Women" 189). This is a rallying cry of the feminist movement, and Simon's text bears witness to the destructive meanings ascribed to women's bodies and experience by patriarchal signifying practices.

Bronx Primitive, like *The Woman Warrior*, is an immigrant narrative, and although Simon was born in Poland, her family emigrated to the United States in the 1910s when she was only four years old. Earlier immigrant narratives thematize the great pressure on immigrants to prove that they were willing to work hard to become good citizens and to leave behind their Old World ways. Antin's *The Promised Land*, for instance, is dominated by scenes that demonstrate her parents' and her own struggles to become Americans. She waves the flag incessantly and believes the American dream wholeheartedly, even in the face of evidence that the dream is not fulfilled for everyone. Her father is never able to make a successful business in the United States, but she blames his personal shortcomings for his economic failure, rather than questioning the dream itself. By contrast, even though her parents are also immigrants seeking a new and better life in America, Kate Simon's recollection of her childhood hints at no tension about the need to assimilate, except in an early chapter when she notes that the adults in her multiethnic Bronx neighborhood are instantly on guard when they hear "unaccented English." Some of this can be explained by Simon's age when she arrived, whereas for Antin, who was closer to ten, coming to America meant the opportunity to go to school, something that was unthinkable before. Simon was so young when she arrived that she had not yet had a chance to understand that her life was far less circumscribed in the United

States than it would have been had she grown up in Poland. Simon wrote her story in the context of a different rhetorical situation from Antin, but nonetheless she displays a similarly wide-eyed, uncritical acceptance of Anglo-American culture. What is different about Simon's account is her apparent assumption that she belongs in that culture; in contrast, Antin's account is riddled with a narrative anxiety that suggests she believes she must prove *to Americans* that she too deserves to be an American.

The conflict between a daughter who wants to shed the Old World traditions and the Orthodox rabbi father who tries to control her in Anzia Yezierska's *Bread Givers* exemplifies the prototypical immigrant story, which thematizes generational and cultural tensions. Generally, these narratives oppose parents bound by tradition to their children who often want to live the much freer life of an "American." One of the more interesting aspects of Kate Simon's story is that her parents *wanted* to assimilate, and so she was raised in an atmosphere that was dynamic and fluid in the sense that traditions were actively being altered as she grew up. Her mother, retaining her fluency in Polish, Yiddish, and Italian, took English-language classes as soon as she could after arriving in New York. Unlike some immigrant mothers, Simon's did not fear the strange new place she had come to—she wanted to see everything, right away, and was accommodated by aunts and uncles who watched Kate and her brother while she went exploring. Simon's father had arrived some two years before she and her mother arrived, and he was distinctly displeased to be tied down to a family again. Although he was anxious to shed his Old World self, he had very Old World ideas about the place of children, and especially about the place of girls. He did not like his daughter running the streets like a "wild beast," and he expected ladylike decorum out of her long before she had left childhood behind.

A crucial aspect of anyone's education are the lessons in gender roles, and Simon's memoir is rich in recognizing the process of engendering femininity. These forces are often contradictory, but the subtlety of those paradoxes allows ideology to reproduce itself, unquestioned. In Simon's case, however, ideological contradictions are often blatantly obvious to her, making resistance to a stereotypical gendered identity that much easier, since the existence (and acceptance) of alternative narratives allow for a more complex subjectivity. Emigrating from Poland as a toddler allowed Simon to avoid the inevitable teleology of marriage, children, and death. Horizons expanded for girls who emigrated to the United States, and the younger they were on arrival, the looser the grip of Old World values on their futures. Beyond that, Simon's mother was already carving out a progressive identity in Poland.

There she had owned a business and fallen deeply in love with a Gentile before she met Simon's father. Not so progressive that she could overcome the difficulties of an exogamous marriage, she was still able to construct an alternative identity in a marriage more acceptable to contemporary values. But Kate was sent to school, just like her brother, and she reaped the benefits of having a mother who held modern ideas about being female. Instructing her daughter with the knowledge she has gained through marriage and motherhood, Simon's mother advises her daughter:

> Study. Learn. Go to college. Be a schoolteacher and don't get married until you have a profession. With a profession you can have men friends and even children if you want. You're free. But don't get married, at least not until you can support yourself and make a careful choice. Or don't get married at all, better still (48).

But Simon senses that this would be seen as beyond eccentric among her friends; it was understood that girls would marry young, so Simon kept her mother's unusual views on the importance of an education to herself.

In addition to her mother, Simon has other models of womanhood to examine: Fannie Herman, a neighbor who is terrified of the outside world and who relies on Kate's mother to help her negotiate foreign territory such as the butcher shop; Mrs. Haskell, whose preparations for the end of the world look remarkably like Yom Kippur preparations; fashionable Mrs. Silverberg, who is carted off to the insane asylum one night. Simon inscribes her fascination with these various manifestations of womanhood, but does not emulate any of them; each model parades before her consciousness as an option—here is one way of being a woman. And yet they are problematic models, for collectively they suggest to Simon that womanhood is fraught with emotional danger and suppressed desire. With the exception of her mother, Simon is surrounded by women for whom femininity (and marriage in most cases) means enclosure, madness, and restriction. As Susan Bordo argues, agoraphobia can be read as a parody of domesticity, and hysteria (or madness) as a heightened version of normative femininity (16–17); Simon receives an object lesson in the pitfalls of feminine ideologies simply by observing her female neighbors' unhappy responses to their own lives.

In *Bronx Primitive*, Simon demonstrates that gender is defined for her by what it is not, and what she cannot do. Feminism's critique of gender has long included the view that man is viewed as the norm, while woman is the Other. Thus, females must often contend with a world that materially and psycho-

logically restricts their movement. Only eighteen months older than her brother, Simon is given the responsibility of watching him from a very early age. As they grow older, the disparity in their freedom gives rise to Kate's bitterness and perhaps a nascent feminism:

> His opportunities were much greater than mine. His role with the baby was to kootchy-koo her as he dashed in from school and down to the street while I thumped the carriage down the five flights, up and down again with pillows and blankets, up and down again with the baby. While he, the grasshopper, sang and danced, I, the ant, sat demurely rocking the carriage. He was in the full sun, I in the shade; he was young, I was old (137).

This clear-eyed understanding of the limits placed on girls is surely the articulation of the adult writer, and echoes Nancy Chodorow's thesis on how mothering is reproduced, although here the reproduction is not willing. The passage illustrates the process by which girls are trained for motherhood, which is marked by confinement, and simultaneously we see how a boy learns to be a father. Simon's brother is already performing the identical version of masculinity seen in their father, by which neither male is bound by domesticity but is instead free to roam at will. Simon's memoir turns on the theme of feminine responsibility for others and on a view of herself as old when she was still a child. Furthermore, coming of age often carries with it an imperative to put aside the androgyny of childhood and begin to take on the social norms of womanhood, as we have already seen in Dillard and Moody's texts. The imperative is tacit and the underlying ideologies are unspoken, as when Kate's father threatens to keep her inside when, at age eleven, she is caught wrestling with a boy. It is made clear to her that wrestling is an unacceptable behavior for a girl of her age, just as it is clear that babysitting duties are appropriate for girls, but Simon's father does not make plain to her the sexual dangers he fears, or why babysitting is an acceptably safe expression of female sexuality. Like Maxine Hong Kingston, Simon learns many vivid lessons through "mistakes" which are then corrected by her parents or other members of her community. These mistakes are mystifying to both Simon and Kingston, because, until they are slapped, cursed, punished, and silenced, they are unaware of the ideological laws they have broken. Further confusing the issue, parents are often silent about the very existence of the cultural laws of female behavior, even after they punish their daughters. Simon does not suffer these restrictions gladly, but neither does

she verbalize her objections. She learns instead how to wage silent battles and enjoy private victories over the oppressive restrictions imposed on her.

Education in the strictest sense is certainly influential in shaping Simon—as countless theorists on the left have argued, the school is profoundly influential in shaping and molding children into obedient, productive citizens—but as an adult writer, Simon sees formal schooling as of secondary importance in relation to the education she receives outside of school: at the movies, at the library, and in the streets. In a chapter entitled "The Movies and Other Schools," she reveals that the movies were a far more tantalizing source of knowledge than school, for on the screen she is exposed to ways of being far removed from her own circumstances. The movies articulate for Simon an uncontradictory, neatly ordered world of gender roles where fathers come home from work at the end of the day to perfectly coiffed wives, pretty, docile daughters, and polite sons. Mothers speak gently and lovingly to their children in the movies, a stark contrast to the shouting, coarse interchanges Simon hears in her Bronx neighborhood. The mothers Simon knows limit their maternal duties to feeding, clothing, and seeking medical advice for their children, but beyond that they want their children out of their way. The fantasy movie world of rolling green lawns, tennis, and carefully controlled emotions is significant for Simon because the contrast to her own world feeds her imagination, and allows her to question—if only to herself—the social order she knows. In particular, Simon observes that there are different ways of being married: "From what I could see, and I searched, there was no Love on the block, nor even its fairy tale end, Marriage. We had only Being Married, and that included the kids, a big crowded barrel with a family name stamped on it" (45). Movies, then, serve as a point of contrast as well as a source of interpretation. While love in the movies was "a very foreign country . . . smooth and slinky" (45), at home in the Bronx it appears that romantic love is nonexistent. Simon's parents seem to move in separate spheres and fight over money and how to discipline the children. But in a moment that signals an increasingly complex understanding of multiple ways of being, Kate sees her father cutting her mother's toenails, and makes a cognitive leap in interpreting the scene as a sign of her parents' intimacy and affection: "Something, another branch in the twisted tree that shaded our lives, was going to keep us safe for a while" (54). Having found "love on the block" after all, Simon's movie-inspired definition of love finds alternative means of expression in her parents' mundane gestures.

Becoming educated, for Simon, also involves learning what it means to be a Jew. Simon's family is secular—they go to temple on the High Holy

days, only so as not to give the *goyim* something to wag about. Her brother has a pretty singing voice, so he sometimes sings at the synagogue, but otherwise they are not observant. They have only one set of dishes, meaning that theirs is not a kosher house, unlike Kate's friend Helen Roth's family which boasts four sets of dishes, one being reserved for Passover only. A crucial shift occurs one Sabbath Friday as Kate's mother is saying the traditional prayer while lighting the candles. Mid-prayer, she blows the candles out and says she will never perform the ritual again. She says she does not believe in it, never did, and there is no one around whom she must please by continuing the ritual. Thus, religious Judaism slides away, but Simon notes that the rhythm of the week remains exactly the same as before, with the characteristic smells of Friday preparations, and the quiet of the Sabbath. Simon's Jewish identity is not articulated or understood through any incidents of anti-Semitism, nor through religious practice. Rather, it is a thread that is woven into the fabric of identity, neither more nor less important than other threads. Furthermore, as with other parts she tries on for size, Simon articulates the experimental nature of her identity as a Jew in her text. Just as she weighs different ways of being female, so she performs various versions of Jewishness in the process of finding one that suits her. In addition to her mother's rejection of religious ritual as a mode of being Jewish, the mystic Judaism practiced by her friend Helen Roth's father serves as an example. For a time, Simon entertains the idea that Mr. Roth might be training her to become a "miracle *rebbitsin*" (115) so that she might be the one to discover the secrets of the earth by breaking the numeric code of the sacred texts. She gives up after countless hours of drawing geometric shapes and combining letters and numbers, but this small drama contributes to her construction of identity. She does not directly articulate what sort of Jew she is, or how being Jewish affects who she is, but the childhood game of trying on identities serves her well as she comes of age. She also understands that identity can be arbitrary: after becoming close to a number of Italian families in her neighborhood, Simon concludes that "Italians were really sort of Jewish anyway" (94). As a result, there is no assertion of an essential Jewish or female self in *Bronx Primitive*; indeed, there is no successful model of unified subjectivity for Simon to use. Instead, a plethora of possibilities is arrayed before her watchful gaze, subverting any suggestion that a unitary self is possible.

Although Simon does generalize about the behavior of other ethnic groups in her neighborhood, the sheer presence of ethnic and gender alternatives suggests that she is not locked into a particular trajectory. Here, the subject is created—partly consciously, partly not—through trial and error by

means of performing various identities imaginatively. As her neighborhood comprises many ethnic groups, and since many of her close friends are Italian, Simon has a chance to evaluate non-Jewish identities too. She observes that the Gentile families she knows celebrate Christmas by getting drunk, playing cards, and pinching women; only women, children, and the old men go to church to celebrate the birth of Jesus. Simon's knowledge of other ethnic traditions, however, only brings criticism from her Jewish peers. Because her knowledge of the "wider world" stigmatizes her, Simon decides to keep her observations to herself. She learns to be on "one side of the street, sort of Jewish, on the other sort of Italian, yet always trying to arrange a comfortable melding" (94). The result is a sort of hybrid Jewishness, one that Simon feels she must hide from peers whose sense of identity appears less conflicted than her own.

As she comes of age, Simon is presented with various subject positions that seem to require a choice, but in many cases she chooses to meld subjectivity rather than make an either/or decision about how she will identify herself. Along with the obvious issues of sexuality and gender difference, coming of age is also concerned with fulfilling the norms of class. Simon's mother participates in a mandolin orchestra, which was privileged and supported by Yiddish socialists because it was a communal activity (Dobroszycki 202), and yet Kate's father insists that she play the piano, a sign of American individuality and upward mobility (Howe 261). Andrew R. Heinze notes that Jewish immigrants widely inscribed the piano as an instrument of social mobility as well as of music. Creating a refined home was said to inculcate a taste for high culture in children, and piano lessons became a common element in girls' upbringing. Furthermore, writes Heinze, it was widely believed that piano skills made a girl a more valuable commodity in the Jewish marriage market (142). As a solitary activity that valorizes individual achievement, piano playing was seen as antithetical to the socialist ideal of collectivity, but Kate's father dreams of producing a prodigy, a child who is better than other children. The clash in parental ideologies ultimately results in Simon taking her mother's side, since her mother's more accepting attitude is less stressful than her father's high expectations that play should be sacrificed for piano practice. The war between mandolins and pianos in Simon's family is emblematic of a greater ideological struggle between the parents: the father urges his children to think of themselves as special and superior to others (a clearly liberal humanist notion), whereas the mother's philosophy of class consciousness can be summed up in her response to her husband's bigotry toward a black man—"*Es is doch a mench*"—"and yet he is a man" (52).

Interestingly, while Kate admires her mother's clear morality, she is ultimately persuaded by her father's desire to see her rise above the immigrant class—to achieve autonomous individuality. She resists his efforts to turn her into a prodigy, but nonetheless chooses to continue her schooling through college.

While traditional autobiographical practices posited a universal subject and invited readers to identification, Kate Simon's memoir is marked by the focus on specificity, which I have suggested is the hallmark of the coming-of-age narrative. The highly detailed specificity of time and place discourages over-identification on the part of the reader, since relatively few readers—if indeed any—will share the writer's exact circumstances. Implicitly, however, this narrative feature suggests to the reader that different social, temporal, political and geographic locations construct different forms of subjectivity, and thus open the possibility of resistance to dominant ideologies of identity. Like Dillard, Simon begins her memoir with a geographic and ethnographic description of her childhood that, by implication, is a key determinant of who she is. She claims neither an essential, a priori subjectivity, nor does she claim that her experiences are universal. They are simply hers. But her experiences bear witness to how much was unspoken in earlier days, and the destructiveness of certain kinds of silence. Tillie Olsen reminds us that for every woman like herself there are countless others "born to the wrong circumstances—diminished, excluded, foundered, silenced" (448). Kate Simon's memoir narrates a very different immigrant childhood than the kind that were sanctioned in the narratives of the early part of the century, and as a result, she pursues the feminist project of speaking the forbidden. Adrienne Rich argues that "until we can understand the assumptions in which we are drenched we cannot know ourselves. And this drive to self-knowledge, for women is more than a search for identity; it is part of our refusal of the self-destructiveness of male-dominated society" ("Women" 39). This is the cultural work of the woman's coming-of-age narrative—to define experience and subjectivity in female terms without sacrificing specificity. *Bronx Primitive* represents coming of age as a series of choices to be weighed and decided, showing the reader a conflicted, contradictory individual who continually reconstitutes herself in light of new knowledge and information. Simon's text tacitly suggests that an essentialist identity has no more than "paper strength," and against that, the individual can create her own identities.

David Biale et al. argue that Jews "constitute a liminal border case, neither inside nor outside—or, better, both inside and outside" (8), and as such are in a unique position to challenge the notion of a hybrid identity; Biale

argues that hybridity lingers as a synonym for the melting pot, and prefers instead the term "multiplicity" as a way to articulate the simultaneous performance of several identities while suppressing none ("Melting" 32). Noting that Jewish identity has always been a blend of religious, ethnic, gender, and national locations, Biale et al. claim that being Jewish in modern America is by definition "to lack a single essence" (9). But lacking an essence does not necessarily mean that one is comfortable in that "in-between" space, in Bhabha's terms. While it is true that Jews have occupied multiple subject positions throughout the diaspora, living in a culture that valorizes the simple and single identity may produce a conflicted stance in relation to the multiple self. The assertion of Simon's memoir is that it is unnecessary to choose between distinct identities; it is possible to consciously choose how to identify oneself without being caught in between. The liminal space becomes a newly constituted full subjectivity in its own right, though it remains contingent and in process. The ability to choose among available identities also implies the ability to shift those choices at will. Biale argues that American Jews are a "kind of intermediary ethnic group, one of the most quickly and thoroughly acculturated, yet, among European immigrant ethnicities, equally one of the most resistant to complete assimilation" (31), and as such, may provide a usable model of multiple subjectivity. As Biale points out, Jews were once considered "colored" in American racial discourse, and became "white" only when the issue of civil rights took precedence over the earlier social urgency associated with immigration (26), a factor that may account for the relative ease with which Kate Simon's family found a place in America. But at this point, I want to consider how identity formation is affected when acculturation is impeded by more visible signs of racial difference.

MYTHOLOGY AND NARRATIVE IN THE CREATION OF IDENTITY: *THE WOMAN WARRIOR*

"You must not tell anyone," my mother said, "what I am about to tell you" (3). With these words, Maxine Hong Kingston opens *The Woman Warrior: Memoirs of a Girlhood Among Ghosts*, signaling her intent to end the silencing that marked her socialization and coming of age. In a radical departure from the familiar linear narrative of autobiography, Kingston uses five separate narratives, only one of which focuses directly on her own experiences, to define the contours of her identity. Each narrative is a story unto itself, and yet they are unified by their impact on Kingston's subjectivity. More noticeably mul-

tivocal than many coming-of-age narratives, *The Woman Warrior* draws on a host of myths, narratives, and voices to articulate the discourses that constitute Kingston's subjectivity, creating what Lyotard would call "narrative knowledge." The text, then, valorizes the power of narrative—"talk-story" in Kingston's words—to articulate a theory of subjectivity. Like the other coming-of-age narratives discussed here, Kingston posits a subject constantly under revision, refusing to suggest that she has arrived at a "finished" self. Toward the end of *The Woman Warrior*, she writes: "I continue to sort out what's just my childhood, just my imagination, just my family, just the village, just movies, just living" (239), thereby naming the major discourses by which she continues to constitute her identity. These discourses are constantly shifting as well, but having passed out of the "storm" of adolescence, Kingston suggests that she is no longer buffeted by the winds; she has learned instead to accept a provisional identity.

The primary task of identity formation is deeply complicated for the female child of immigrants, and while I do not wish to universalize across cultures, it is difficult to imagine an easy passage for any immigrant child, regardless of national origin. Autobiographies, literature, oral histories, and even theory testify repeatedly to the delicate and often painful negotiation of identity that is experienced by immigrants. Inscribed with the culture of her parents while trying to negotiate a place in mainstream American culture, the immigrant child must decide how to *be*, at the most basic level. American-born Chinese solutions to this dilemma have varied historically: some, like sociologist Rose Hum Lee, advocate for complete assimilation into American society.[11] Others like Jade Snow Wong choose to serve as "cultural bridges" or interpreters between traditional Chinese and American cultures.[12] In the 1960s, Chinese Americans took a cue from the civil rights movement, and rejected mainstream white American norms in favor of recovering their ancestral heritage. In the last twenty years, according to Gloria Heyung Chun, Chinese Americans have felt the need to move beyond the "pan-Asian American" identity established out of political necessity in the 1960s toward a multivalent identity that includes not only ethnicity but also gender, economic status, sexuality, and political affiliation.[13] These solutions, however, are the conscious discursive constructions of adults, and as Kingston repeatedly shows, they are not necessarily intelligible to the girl who is coming of age, who must make sense of the discourses before she can choose among— or be chosen by—them. The attempt to understand possible ways of being is severely hampered for Kingston, who is silenced from all directions: by her parents because she is female; by Chinese American society because it fears

deportation and violence; by white American society because she is female *and* foreign; by her own confusion and guilt. Paradoxically, loud speech is normative and expected in Chinese culture.

Silencing is continually reinforced for Kingston throughout her childhood and adolescence, first and foremost by her mother, Brave Orchid. *The Woman Warrior*'s first narrative, "No Name Woman," begins, as I have noted, with Brave Orchid's admonition to keep secret the story of Kingston's aunt, who disgraced the family by bearing an illegitimate child and then committing suicide in the family well. There is no ambiguity in Brave Orchid's message to her daughter: "Now that you have started to menstruate, what happened to her could happen to you. Don't humiliate us. You wouldn't like to be forgotten as if you had never been born" (5). With one story, Kingston's mother constructs her daughter's sexuality in terms of the dangers that accompany it. Her aunt has no name because the family has repudiated her for transgressing village norms and for failing to "maintain the real" for them (14). Although Kingston's family is by now far from the ancestral village, her mother enforces its structural realities through the explicit analogy drawn for Maxine. The warning serves to police the hegemonic order of the old country, but it is simultaneously undermined by counterhegemonic discourses that allow Kingston to name the contradictions, which in turn frees her to imagine her aunt into being. The discourses that empower Maxine to create alternative narratives of womanhood come from several sources, but the most influential source is, interestingly, her mother. "She said I would grow up a wife and slave," writes Kingston, "but she taught me the song of the warrior woman, Fa Mu Lan" (24).

The traditional Chinese myth of Fa Mu Lan dominates "White Tigers," the second section of *The Woman Warrior*, which Kingston inhabits in a first-person narrative. The imaginative fusion of the real girl and the mythic one is framed by the remembrance of her mother's teaching her the chant of Fa Mu Lan along with the fact of her debased status as a female. Although this narrative is often deeply unsettling to Western readers socialized to seek non-contradictory selfhood, both in themselves and in narrative, "White Tigers" allows Kingston to construct herself as valuable *as* a female. The text describes a fifteen-year period in which Fa Mu Lan is separated from her family while being trained in warrior ways so that she might avenge her people. For seven years, an old couple teaches the young girl how to tune her body to nature and to strengthen her for battle. After returning from a survival test, she undergoes another eight years of training in "dragon" ways, and learns that "[y]ou have to infer the whole dragon from the parts you can

see and touch" (34) because dragons are too large to see all at once. Significantly, Kingston was born in a dragon year herself, and she even takes pride in the fact that both she and her mother are dragons. According to tradition, people born in dragon years are known for their majestic spirits, fearlessness, strength, and fierce protectiveness of those they love.[14] By having her Fa Mu Lan alter ego become expert in dragon ways, Kingston imagines her identity taking on the strength associated with the dragon totem.

Detaching Fa Mu Lan's identity from the negative connotations of womanhood, Kingston transforms the impediments associated with femininity into more neutral facts of life. In contrast to the meaning Brave Orchid confers on menstruation in "No Name Woman," for Fa Mu Lan/Maxine, menstruation is no impediment to power. The old couple demystify and demythologize the onset of menarche simply by defining her as a sexually mature adult. But instead of worrying that she will humiliate them, the old people ask her to wait before bearing children. Fa Mu Lan is valued, in other words, for the contribution she will make to her people, which allows Maxine to imagine herself an agent of history. Unable to completely shed the traditional discourse of femininity however, Fa Mu Lan/Maxine wants to "use the control you taught me and stop this bleeding," signaling her desire to be free of feminine bonds. The old woman, however, equates menstrual blood with "shitting and pissing" (37), and thus underscores the impossibility of escaping an embodied womanhood. But by making this analogy, the old woman effectively neutralizes the sexual dangers that Brave Orchid invokes as the assumed result of menarche.

Throughout "White Tigers," the narrative shifts between reinforcing traditional gender codes and Kingston's attempts to subvert them. Maxine's version of Fa Mu Lan is married, in absentia, to a man to whom she was promised when they were both babies, but instead of being a stranger, he is her best friend and loves her enough to be a "spirit bridegroom" (37). When she returns to her family in preparation for taking her father's place in battle, her mother and father are so proud of her that they kill a chicken for dinner, "as if they were welcoming home a son" (40), but painfully tattoo her back with their "revenge" and thus inscribe and appropriate her body in service to the clan (40–41). The use of the female body to renew and preserve the patrilineage finally sounds a false note, when, after vanquishing all enemies, Fa Mu Lan abruptly ends her warrior life and is silenced once more. Kneeling before her parents-in-law, she says "Now my public duties are finished. . . . I will stay with you, doing farmwork and housework, and giving you more sons" (53–54). Fa Mu Lan/Maxine is celebrated and fed well in exchange for

her "perfect filiality." Having no village to save, however, the "real" Maxine struggles to discern something she *can* do to make her parents proud so they will not sell her when they return to China.

Sidonie Smith calls the woman warrior a "privileged female avenger," but argues that the truly radical story of feminine power lies with the "witch amazons" that Fa Mu Lan frees after she has liberated her people. Inscribed as archetypal women with bound feet and small voices, these "ghosts" are transformed into genuine women warriors:

> Later, it would be said, they turned into the band of swordswomen who were a mercenary army. They did not wear men's clothes like me, but rode as women in black and red dresses. They bought up girl babies so that many poor families welcomed their visitations. When slave girls and daughters-in-law ran away, people would say they joined these witch amazons. They killed men and boys (Kingston, *Woman* 53).

Smith notes that these avengers represent "all that is unrepressed and violent in ways both sexual and textual, in the narrator herself as well as in the social order" (*Poetics* 159).

Unlike Fa Mu Lan, whose actions work to preserve the status quo, these women use unauthorized power to upset the patriarchal order by literally killing the source of that order. Fundamentally, Kingston's retelling of the Fa Mu Lan myth is an expression of her desire to be valued as males are valued. But before she reaches that point of recognition as an adult, Kingston's anger is expressed as a desire to be a boy. Worn down by countless Chinese maxims, such as "Feeding girls is feeding cowbirds"[15] (54), and "Girls are maggots in the rice" (51), young Maxine responds with screaming tantrums, which only result in her being labeled a "bad girl." Thinking at first that a bad girl is almost the same as a boy, she insists she is not bad, but realizes she might as well have said, "I'm not a girl" (55). Although she fiercely and vehemently resists her parents' construction of femininity, she is not immune to wishing the situation otherwise. She earns straight A's until the emigrant community made it clear that any self-improvement or development in girls was "for the good of my future husband's family, not my own" (56). She goes away to college: "Berkeley in the sixties—and I studied, and I marched to change the world, but I did not turn into a boy. I would have liked to bring myself back as a boy for my parents to welcome with chickens and pigs" (56). That kind of recognition is reserved for boy children, a reality that Kingston recognizes

but cannot accept. Understanding where all roads are supposed to lead for girls, Kingston refuses to learn to cook and breaks dishes every time she washes them. This antipathy toward domestic activity is apparently permanent, according to Kingston, who says she still burns food when she cooks, and leaves her dirty dishes to rot in the sink.

Ultimately, then, the woman warrior proves to be a flawed model of womanhood for an American-born Chinese girl who does not like armies, and whose family, unlike Fa Mu Lan's, did not need a champion. Fa Mu Lan's story valorizes male deeds and the erasure of femininity, but in the real world, Kingston comes to see that martial arts, far from being a sign of male power, "are for unsure little boys kicking away under fluorescent lights" (62). As King-Kok Cheung points out, the contradictions of patriarchal fictions are more easily discerned in everyday life than they are in mythology (88). Proficiency in male activities ensures the warrior woman's success, but it provides no help to young Maxine. Nevertheless, she does find one point of similarity between herself and Fa Mu Lan: "the words at our backs" (63). Noting that the Chinese idioms for *revenge* are "report a crime," and "report to five families," Kingston realizes her skills with words and "talk-story" will allow her to avenge the wrongs inflicted on her by whites and Chinese alike.

The third and fourth narratives are dominated by the stories of Brave Orchid and Moon Orchid, Kingston's mother and aunt, respectively. Although the sisters have very different stories, both are productive of identity formation for Kingston. As I noted earlier, Brave Orchid's contradictory socialization of her daughter allows Kingston to name the inconsistencies and eventually construct a different way of being for herself. Weedon reminds us that "[w]here there is a space between the position of subject offered by a discourse and individual interest, a resistance to that subject position is produced" (109). This process is not without pain for Kingston, however, because, as she writes, she believes that her parents love her in theory, and that they only repeat the maxims because that is "what one says about daughters." Nonetheless, she decides to leave Chinatown because she needs to "get out of hating range," and because she refuses to "shy [her] way anymore" (62).

The "Shaman" narrative follows the story of Kingston's mother, Brave Orchid, and her life in China, before Maxine is born. Brave Orchid's husband has left for the United States, their two oldest children are dead, so Brave Orchid enrolls in medical school and proceeds to create an independent, professional life for herself, even buying a slave girl to serve as her nurse. Like Fa Mu Lan, she is welcomed by villagers wherever she goes, and she exercises great power over the "ignorant" peasants. Refusing to treat dying

people, she is associated only with renewed health, and thus she mythologizes her own success. Among the first women to become doctors in China, Brave Orchid is one of the "new women, scientists who changed the rituals" (88). And yet this is not how her daughter sees her—faced with a mother who is surrounded by mountains of dirty laundry from the business her parents run in America, Kingston cannot appropriate her mother as a model of feminine resistance until her mother talks-story about her life. Indeed, as Brave Orchid tells her, she has "no idea how much I have fallen coming to America" (90); many tellings of this story are necessary before Kingston recognizes the power of her mother's narrative.

As a child, Maxine focuses on Brave Orchid's treatment of the slave girl. Comparing the price of the slave to the cost of her own birth, Kingston believes her mother showed more enthusiasm for the slave than she does for her own daughter. Brave Orchid emphasizes her daughter's worth by telling her that girls were given away free during the war, while Brave Orchid had paid two hundred dollars for Kingston's birth. This might have been her way of showing her daughter that she was indeed very valuable, but Maxine understands it as another threat of being sold or given away because she is female. Her fears are not assuaged by Brave Orchid's midwife stories; upon learning that girl babies were sometimes suffocated in a box of clean ashes kept handy by the birthing bed for just this purpose, Kingston wonders if her mother had ever killed any babies. By extension, the unspoken question for Kingston is whether she would have been killed too, had she been born in China.

As much as Brave Orchid seems to enjoy her independence, when her husband sends for her after fifteen years away, she goes without hesitation and takes up the life she will later describe to her daughter as that of "a wife and slave" without protest (112). At eighty, after years of working long days in the laundry, Brave Orchid still works in California's tomato fields. Her strength is too subtle for the child to see, but as an adult Kingston recognizes that Brave Orchid does not embody the ideal of femininity that she repeats uncritically to her daughters. The model Chinese woman appears instead in the form of Moon Orchid, Brave Orchid's sister, who comes to America at age sixty-seven, having been left behind in China by her husband thirty years earlier. A stunning example of docility and patience, Moon Orchid is a "silly" and childlike woman, even in her sister's eyes. Distracted by bright color and movement and completely unable to perform the simplest tasks, Moon Orchid is the ornament she was raised to be. With Brave Orchid's encouragement, she appears at her husband's door to claim her rights as First Wife. But her husband has laid claim to a very different life in America with a second

wife, so he dismisses Moon Orchid and her family as "people in a book I had read a long time ago" (179). Deprived thus of her sole raison d'être, and completely unprepared for any other role in life, Moon Orchid begins a gradual descent into madness and dies in a California state mental institution. But Kingston admits that this narrative is an embellishment of her brother's brief eyewitness account of the reunion of Moon Orchid with her husband. Like McCarthy, Kingston invents a narrative that renders coherent the few factual details she has in order to confer meaning on her decision to major in math and science.

Moon Orchid's story, like the other stories in *The Woman Warrior*, is instructive, but this time the lesson is immediately clear to Maxine and her sisters: "Brave Orchid's daughters decided fiercely that they would never let men be unfaithful to them. All her children made up their minds to major in science or mathematics" (186). These same children had been dismissive of their aunt when she arrived from China, but her inability to cope with change touches them and teaches them the necessity of self-reliance. Science and mathematics appear particularly solid and reliable against the landscape of human inconsistency and frailty. Here again, Brave Orchid's adaptability and strength is a counterpoint to the idealized image of womanhood that even she presents as desirable. Her life undermines her explicit ideology, and as her daughter notes, while she preaches the virtues of silence, Brave Orchid is in fact a "champion" talker, who, as Cheung argues, "nurtures [her daughter] to entertain contradictions, to doubt absolutes, [and] to see truth as multidimensional" (99). But before she reaches that point, Maxine is effectively silenced by the play of contradictions. As I discussed in relation to Annie Dillard, naming the contradictions in adult ideologies is a crucial step in the adolescent's moral development, but until that naming and subsequent rejection of adult moral hypocrisy occurs, the child experiences confusion. Perhaps this confusion is only constructible by the adult writer in retrospect, but the consequences of a lack of coherent identity is thematized in the immigrant's coming of age. Situated at the crossroads of two cultures, Kingston's confusion is signified by her—literal or figurative—inability to speak. Kingston's mother cuts her frenum—the membrane that "anchors" the tongue—when Maxine is very young, "so that you would not be tongue-tied. Your tongue would be able to move in any language. . . . Your frenum looked too tight to do those things, so I cut it" (190). Maxine questions her mother about this when she is older, naming a contradiction—"But isn't 'a ready tongue' an evil?"—to which her mother responds, "Things are different in this ghost country" (191). Thus, while Brave Orchid explicitly recognizes that her

daughter will need different social skills in America, Maxine suspects her mother has other, more sinister motives because of Maxine's failure to speak in school for three years. In fact, she was silent because she did not speak English, so the tongue-cutting story may be unrelated or, indeed, apocryphal. Regardless, Kingston uses the metaphor of her cut tongue to double the figure of her inability to speak English, translating into a long silence, which may also be apocryphal, but which nonetheless works to embody a conflicted identity. The inability to speak (English) is interpreted by her American school as a lack of intelligence—literally a zero IQ score. Throughout her childhood and adolescence, Maxine struggles with silence, reaching its climactic moment when she cruelly tortures another Chinese American girl who is more silent and passive than Maxine herself has been for years. After many minutes of hair pulling, cheek pinching, and taunting the mute girl, Kingston finally begins to weep, asking her, "Why won't you talk? . . . Do you want to be like this, dumb (do you know what dumb means?) your whole life? Don't you ever want to be a cheerleader? Or a pompon girl?" (210). As painful as this episode is for the other girl, it speaks most clearly to Kingston's own confused identity as she is growing up. She might as well be addressing herself in this passage, but in the process of tormenting the other girl, Kingston betrays her own enormous self-hatred and a desire to be "American-feminine." Like Moon Orchid, the girl at Chinese school is excessively dependent; silenced by both American and Chinese culture, she is at risk, according to Maxine, of being abandoned since she is not marriage material, and further, she will be unable to find work because she does not speak. These are Maxine's own fears; wanting to transgress the norms of Chinese womanhood but fearing the consequences of doing so, she is caught with a half-voice that symbolizes her in-between position. Kingston writes that she feared she would be the token crazy girl that every family or village had: "I thought talking and not talking made the difference between sanity and insanity. Insane people were the ones who couldn't explain themselves. There were many crazy girls and women" (216). With typical subtlety, Kingston marks the plight of women as an inability to speak their experience. Yet she also uses her supposed craziness to her own advantage, driving away suitors, who are advertising for wives, by dropping dishes, picking her nose, and pretending to limp. Thus, silence is not always disempowering, but Kingston is angry with the Americans for not letting Chinese talk, and angry with Chinese for being secretive.

Further complicating the silence valorized by Kingston's parents is her realization that "Chinese women's voices are strong and bossy" (200), and

that "the emigrant villagers are shouters, hollering face to face" (199). A number of scholars have argued that the stereotype of the docile, obedient Chinese is a Chinese American response to fears of deportation, internment, or violence. Elaine H. Kim contends that the lively behavior of Chinese in Chinatowns differs from the silence and inhibition shown by American-born Chinese, arguing that this is evidence of the repressive influence of American culture on Chinese subjectivity (307–09, n.12).[16] In *The Woman Warrior*, Kingston thematizes this point, contrasting the loud emigrants with the whispery "American-feminine" voices the Chinese American girls develop in response to American signifying practices that valorize a demure, self-effacing version of femininity (200). Intriguingly, Kingston blames her mother and Chinese culture for the throat pain that plagues her. In an outburst that signals a pending separation from her family, Kingston tells her mother:

> I don't want to listen to any more of your stories; they have no logic. They scramble me up. You lie with stories. . . . I can't tell what's real and what you make up. Ha! You can't stop me from talking. You tried to cut off my tongue, but it didn't work (235).

But, in fact, it is "American" ideologies that silence Kingston more effectively than her family. I certainly do not want to dispute the confusion that clearly affected her, but while her parents explicitly attempt to enforce silence, there seems to be very little actual silence in her household. Nonetheless, both the explicit lessons taught at home and the implicit lessons learned in the larger American society result in a permanent inability for Kingston to remain silent, symbolized by recurring throat pain, suggesting that this figure signifies her ongoing struggle with identity: "The throat pain always returns, though, unless I tell what I really think, whether or not I lose my job, or spit out gaucheries all over a party" (239). The need to say what she "really thinks" is formed in response to both American and Chinese constructions of femininity, but the throat pain also suggests that Kingston's body is able to signify the depth of her knowledge of what is true *for her*. Further, Kingston's "dried-duck" voice is a metaphor that aptly describes a larger difficulty in identity formation. That is, Kingston struggles with choosing *either* an "American-feminine" *or* a traditional Chinese identity. The narrative functions to reconcile the choices in favor of a *both/and* subjectivity.

Kingston recognizes that each of the available models of womanhood is flawed, but also that there is something she can—and does—take from each example. Elionne L. W. Belden writes that submission to authority and

denial of the self in favor of the collective is highly valued in traditional Chinese culture (22), creating deep conflict for American immigrants who must make their way in a society that valorizes autonomous selfhood. Of course, it can also create new opportunities for individuals who seek alternate ways of being, but choosing an alternative identity exacts an enormous price. For a Chinese girl coming of age, turning one's back on traditional ways is certain to result in at least misunderstanding and disapproval in the best case; in the worst, she may face complete rejection and ostracization by both her family *and* the "American" culture. She may find, with James Weldon Johnson's "Ex-Coloured Man" that she has "sold [her] birthright for a mess of pottage" (211). Unlike Annie Dillard, however, Kingston does not turn to male role models for alternatives; in the process of writing the memoir, Kingston realizes that it is women's narratives that have determined her identity.[17] Furthermore, Kingston suggests that she actively cultivated an American identity, yet *The Woman Warrior* honors the Chinese culture that engendered her, leaving Kingston on the borderlands of cultural identity. As I have argued, a border identity is frequently accompanied by great pain and social confusion, but as Kingston shows, it is also a highly productive location for the creation of alternative subjectivities.

The text does not resolve the question of the nature of Kingston's subjectivity, which ultimately leaves the reader unsettled as well. If Holland is correct in arguing that readers interpret texts through their own identity themes, searching for textual evidence that will confirm a solidly unified identity, then the experience of reading a text like *The Woman Warrior* can only be profoundly unsettling. Kingston is not merely representing a split textual self; she is also creating a split between her text and her reader, and a split *in* the reader. After Benveniste, Belsey terms realistic texts declarative in that their ideological project is to fix the subject as unified and unchanging by smoothing over ideological contradictions and thus reproduce the social order. Classic realism, writes Belsey, "[imparts] knowledge to a reader whose position is thereby stabilized, through a privileged discourse which is to varying degrees invisible" (91). That is, readers are reassured and comforted by the coherent narrative of the realist text. In contrast, *The Woman Warrior* refuses the reader's unity by discouraging easy identification with a protagonist/author whose own identity theme is constantly shifting. This is the hallmark of the interrogative text, which "literally [invites] the reader to produce answers to the questions it implicitly or explicitly seeks" (Belsey 91). Further, the interrogative text "refuses a single point of view, however complex and comprehensive, but brings points of view into unresolved colli-

sion or contradiction" (92). In my view, the coming-of-age narrative is generally an interrogative text, but paradoxically, the refusal of a stable position can also confirm the reader's identity theme *if* that theme is also contingent. Unlike the declarative text, the coming-of-age narrative rarely constructs a seamless reality, and thus cannot confirm the existence of a unified, essential self. But like the interrogative text, the coming-of-age narrative confronts the reader with ideological contradictions and invites or posits answers to the questions it poses. It is, therefore, an ideal form for representing multiple subjectivities. The implied reader of such a text is one whose own identity theme is split, contingent, and fluid. I recognize that dominant Western discourse represses contradictions and privileges the notion of a simple, unitary identity, but in practice, legions of Americans live with the knowledge that their identities are multiple and contradictory. Historically, a multiple or alternative subject position has led to social marginalization, and in recent years, more and more Americans—even middle-class white men—claim marginalization in one sphere or another. But as Cho-yun Hsu has argued, marginality can be somewhat neutrally "defined as one's own ambiguous status of belonging simultaneously to more than one collective entity" (227). Women have long known that identity was complex and contradictory, but in the twentieth century their coming-of-age narratives finally voice this knowledge from their girlhoods and demonstrate that a liminal position in American culture is productive of power and agency.

Notes

CHAPTER 1. IDENTITY AND THE COMING-OF-AGE NARRATIVE

1. Jon Katz. *Geeks: How Two Lost Boys Rode the Internet Out of Idaho.* New York: Villard, 2000.

2. Florence Howe writes of Eliot's status as the century's major poet in the mid-twentieth century and "[o]f course he fit the mold (or was it constructed around him?) of the New Criticism, to practice which one needed only the poem—and the memory of all other poems in the male, white, Western tradition of poetry" (3). Eliot has also been criticized for writing to an audience of men exactly like himself—well-educated, white, and affluent. Howe notes further that Woolf was essentially self-taught, but that she knew from her reading that other women authors had also sought their female literary forebears. Howe contends that "[Woolf] writes critical essays not to rescue a single stream of dramatists or poets, but rescue hundreds of 'lost' female voices, writing often in the forms not usually honored by literary critics—the diary, journal, memoir, autobiography, and letters" (6). Woolf's anger at women's exclusion from the literary realm certainly permeates the text of *A Room of One's Own.* She must have been responding, at least in part, to Eliot's disdain for and neglect of women's writers, and in particular to her own difficulty in achieving respect for her literary work.

3. There is even a term for literary criticism that acknowledges the critic's subjectivity. For a comprehensive view of the debate on the propriety of "the autobiographical move" in literary criticism, see Veeser.

4. Donne, *XVII Meditation. The Complete Poetry and Selected Prose of John Donne.* Ed. Charles M. Coffin. Modern Library, 1952. 441.

5. Some feminist critics also find fault with sentimental literature for its poor quality. Jehlen, for instance, wonders "[I]f the choice is between Susan

Warner and Melville, why were we not all born men?" (589), and Ann Douglas argues that the proliferation of sentimental fiction devalued the work of Hawthorne, Melville, and other high canonical American Renaissance writers. For a spirited and effective defense of this body of literature, see Jane Tompkins, *Sensational Designs: The Cultural Work of American Fiction.*

6. Heilbrun neglects here to account for the work of feminist science-fiction writers such as Marge Piercy, *Woman on the Edge of Time* (New York: Fawcett Crest, 1979); Joanna Russ, *The Female Man* (New York: Bantam, 1975); and Sally Miller Gearhart, *The Wanderground: Stories of the Hill Women* (Watertown, MA: Persephone, 1979). According to Fishburn, these texts reimagine the human condition by inventing a future that valorizes the "feminine" values of nurturing and cooperation. Nonetheless, as Fishburn points out, these new worlds are constructed in terms that reproduce the notion that there is indeed a "natural" difference between the sexes ("Reforming" 32).

7. "Work and wait" is the motto *Little Women*'s March sisters take up at the suggestion of their mother to help pass the time until they are reunited with their father.

8. Belsey, for instance, argues that the classic realist text serves the ideological end of presenting subjectivity as "fixed and unchangeable, an element in a given system of differences which is human nature and the world of human experience, and to show possible action as an endless repetition of 'normal,' familiar action" (90).

9. Joanna Russ posits the existence of humans who possess the stereotypical characteristics—positive and negative—of both men and women, as suggested by the title of her 1975 science-fiction novel, *The Female Man* (Boston: Bantam, 1975). Ultimately, however, Russ condones the female values of oneness with nature and self-in-relation.

10. Although I use the terms "subjectivity" and "identity" more or less interchangeably throughout, I do recognize that these terms are associated with specific philosophical and theoretical traditions. The Oxford English Dictionary traces the word "identity" to the fourteenth century, when a "need was evidently felt of a noun . . . to express the condition of sameness," and indeed, the OED's first definition of the word emphasizes the "condition of being the same." But more pertinent to philosophical usage is the second definition: "The sameness of a person or thing at all times or in all circumstances; the condition or fact that a person or thing is itself and not something else," which is associated with John Locke's philosophy, i.e., "Consciousness always accompanies thinking. . . . In this alone consists personal identity." In other words, identity is a concept strongly associated with the liberal human-

ism of the Enlightenment that posits an opaque, essential selfhood. For marxist and other theorists who critique the liberal humanist paradigm, the concept of identity is a political claim that claims it is not political. The term "subjectivity" then has been preferred by marxists as a way to foreground the claim that identity is constructed, a meaning that the OED has not yet acknowledged. In Foucault's view, for instance, subjectivity is produced by discourse and power relations.

11. Nancy K. Miller contends that women's fiction (and, I would add, women's autobiography) has historically been denied credibility because it so often violates the reader's expectations of plot. Miller reads this as an implicit assumption that literature should "reinscribe received ideas about the representation of life in art" ("Plots" 340). Ideology determines what received ideas are normative, and if a particular event is seen as outside the norm, it is dismissed as implausible. One example of this dynamic: In *Little Women*, Jo March turns down a marriage proposal from a boy with whom she is highly compatible and with whom she shares a warm and egalitarian friendship. This one plot turn has disappointed generations of readers who saw Jo's marriage to Laurie as the expected outcome. Miller might contend that Jo's action is more than adequately motivated by her repeated expressed desire to "paddle her own canoe," and thus within the novel's economy, Jo's decision is entirely plausible.

12. See Williams, *Marxism and Literature*, chapter 6.

13. But in *Mother Nature: A History of Mothers, Infants and Natural Selection* (New York: Pantheon, 1999), Sarah Blaffer Hrdy argues that, in significant ways, human beings *are* born women or men. She argues, for instance, that males are genetically selected to be less likely to care for children than women because they can never be absolutely certain a child is theirs, whereas mothers know that a child is theirs, and thus are biologically more disposed to engage in child care.

14. Again, *Little Women* is exemplary of this pattern.

15. Here I am mindful of Rabinow's call to "anthropologize the West," which he argues would allow us to see "how exotic its constitution of reality has been . . . [and to] emphasize those domains most taken for granted as universal; . . . make them seem as historically peculiar as possible; show how their claims to truth are linked to social practices and have hence become effective forces in the social world" (241). Doing so, according to Rabinow, would shift Western hegemony, and, I would add, begin to address the imbalance of power that has been the result of Western dominance in naming the Other.

16. See also Olga Silverstein and Beth Rashbaum, *The Courage to Raise Good Men* (New York: Viking, 1994).

CHAPTER 2. FEMINISM, AUTOBIOGRAPHY, AND THEORIES OF SUBJECTIVITY

1. The battle over the meaning of rape continues. In their study, *A Natural History of Rape: Biological Bases of Sexual Coercion* (Cambridge, MA: MIT Press, 2000), Randy Thornhill and Craig T. Palmer use an evolutionary framework to argue that the act of rape is an adaptive behavior designed to ensure the propagation of the male's genes. Although they do not unproblematically view rape as a neutral act simply because they believe it is a biologically determined behavior, Thornhill and Palmer tend to discount data that do not support their thesis. For instance, they claim that the fact that most rape victims are of childbearing age supports their argument, while they downplay the psychological consequences and the fact that significant numbers of rape victims are children and elderly women.

2. Sánchez-Eppler argues that the rhetorical strategy of drawing public attention to particularly horrifying and brutal acts upon the body as a means to agitate for change was adapted from abolitionist rhetoric by nineteenth-century feminists. Like the earlier feminists and the abolitionists, second-wave feminist rhetoric invoked the vulnerability of women's bodies in order to demonstrate the secondary status of women (17–21).

3. Teresa of Ávila's 1565 *Life* (New York: Penguin, 1957); *The Book of Margery Kempe* (Liquori, MD: Triumph, 1995), written in 1436; and Harriet Martineau's 1877 *Autobiography* (London: Virago, 1983) are among the texts that have become canonical examples of the women's tradition in autobiography, and early studies of women's autobiography invariably include analyses of them.

4. *The Madwoman in the Attic* is the title of Gilbert and Gubar's highly influential 1979 study that posited an authorial anxiety among British women writers in the nineteenth century due to their perceived lack of literary foremothers.

5. For example, see Miller, *Subject to Change* 106; Hull and Smith, "The Politics of Black Women's Studies"; Rich, "Notes toward a Politics of Location."

6. Cathy N. Davidson, *Revolution and the Word: The Rise of the Novel in America*, and Jane P. Tompkins, *Sensational Designs: The Cultural Work of American Fiction, 1790–1860*.

7. One of the earliest and best-known critiques of the white middle-class bias in feminism can be found in "A Black Feminist Statement," written by the Combahee River Collective in 1977, which argues that although black women have been involved with feminism from the start, the denial of racism as a factor in the oppression of black women's lives in the mainstream feminist movement of the seventies forced the establishment of the National Black Feminist Organization in 1973: "A combined antiracist and antisexist position drew us together initially and as we developed politically we addressed ourselves to heterosexism and economic oppression under capitalism" (15). Furthermore, the statement notes that black women feel a solidarity with progressive black men, since "[o]ur situation as Black people necessitates that we have solidarity around the fact of race, which white women of course do not need to have with white men, unless it is their negative solidarity as racial oppressors" (16). See also Rita Mae Brown, pages 223–39, for an account of the treatment of lesbians in the mainstream feminist movement.

8. Although Belenky et al. are often faulted for essentializing female development, black feminist theorist Patricia Hill Collins reiterates their assertion that while white male philosophers and psychologists tend to use visual metaphors to describe knowledge (i.e., knowledge as illumination, knowing as seeing, truth as light), women tend to ground their epistemological claims in metaphors of voice—speaking and listening—which parallels the traditional African American emphasis on oral culture (113, n. 2).

9. See *How Schools Shortchange Girls: The AAUW Report: A Study of Major Findings on Girls and Education.*

10. It seems to me that Pratt's archetypal framework unnecessarily forecloses the possibility of reading a particular female plot otherwise. For instance, Pratt argues that the conflict between society's expectations of a woman and her own desires "renders characterizations ambivalent, tone and attitude ambiguous, and plots problematic" (11). In my view, that same conflict marks the potential beginning of successful resistance. While the majority of women may not have successfully resisted gender norms, clearly the conflicts and contradictions of the dominant social narratives of womanhood are the most productive sources of resistance.

11. For reports on the controversy over Menchú's book, see Robin Wilson, "A Challenge to the Veracity of a Multicultural Icon," in *The Chronicle of Higher Education*, January 15, 1999, pages A14–A16, and Greg Grandin and Francisco Goldman, "Bitter Fruit for Rigoberta," in *The Nation*, February 8, 1999, pages 25–28.

12. Contemporary autobiography often fits the definition coined by Robert Root, Jr. and Michael Steinberg, of a "fourth genre" or creative

nonfiction. Root and Steinberg's anthology, *The Fourth Genre*, defines its spectrum as encompassing personal essays, memoirs, literary journalism, and academic/cultural criticism, its hallmark a dissolution of old generic boundaries.

13. However, I do recognize that as Douglass rewrote his life story in the 1855 *My Bondage and My Freedom* and the 1893 *Life and Times of Frederick Douglass*, he increasingly distanced himself from the distinctive rhetorical form of the abolitionist slave narrative.

14. Literacy and the lack of any form of education is consistently thematized in the slave narrative genre. James W. C. Pennington, for instance, writes of his inability to forgive slavery for depriving him of an education. See Olney, "'I Was Born,'" 153, 156. See also Gates, *Figures in Black*, and Fishburn, *Problem* 48, n. 26.

15. Evans 92; Papachristou 9–10.

16. Robin Winks characterizes the sexual assaults, brutal whippings, and other acts of brutality of the fugitive slave narratives as "pious pornography" (vi). See also Trudier Harris, *Exorcising Blackness* (Bloomington: Indiana UP, 1984), for a discussion of the literary uses of lynching and other acts of brutality in later African American literature.

17. Male autobiographers (including famous ones) are increasingly including early childhood memories, as public interest in autobiographies grows exponentially to include marginalized and/or unknown subjects, and as the line between private and public spheres grows ever more difficult to distinguish. See, for instance, McCourt.

18. My use of the male pronoun and "man" in this section follows the use and intentions of the philosophers discussed. Elsewhere, I use female pronouns when I am clearly discussing female texts and issues. In all other cases, I use plurals to avoid sexist usage, but also because many of the arguments I make in this study apply to texts written by men who are marginalized in American society.

19. For an overview of studies on sex-role socialization, see Weitzman. Studies have repeatedly confirmed that boy babies and girl babies are handled and perceived differently, and that these differences tend to reinforce social norms of gender.

20. See Jaggar 27–50.

21. See, for instance, Katherine Fishburn's *The Problem of Embodiment in Early African American Narrative*. Fishburn argues that the slave narratives resist the liberal humanist separation of mind and body by positing embodiment as a critical source of knowledge for the slaves. See also Jaggar and Ferguson for definitions of the radical, Marxist, and socialist feminist accounts of subjectivity.

22. I thank Kevin Asman for clarifying this point for me.

23. Feminists have long argued that the cause of much so-called madness in women is a direct result of a conflict between romance and quest. The same conflict is responsible for the limitation in women's narrative plots according to du Plessis (4). Davidson and du Plessis both argue that historically there were only two possible narrative outcomes for female characters—marriage or death. But in the real world, madness and spinsterhood were surely among the (still limited) outcomes for women who either chose not to follow society's script or else tried to forget their own desires when they chose romance. Either way, it is quite clear that most women are not allowed to have both romance and vocation. See Chesler, chapter 1.

24. As Nancy Hartsock writes, "it seems highly suspicious that it is at this moment in history, when so many groups are engaged in 'nationalisms' which involve redefinitions of the marginalized Others, that doubt arises in the academy about the nature of the 'subject,' about the possibilities for a general theory which can describe the world, about historical 'progress.' Why is it, exactly at the moment when so many of us who have been silenced begin to demand the right to name ourselves, to act as subjects rather than objects of history, that just then the concept of subjecthood becomes 'problematic'? Just when we are forming our own theories about the world, uncertainty emerges about whether the world can be adequately theorized?" (196).

CHAPTER 3. COMING OF AGE IN AMERICA

1. For an abstract of a study on puberty in American girls, see Marcia E. Herman-Giddens et al., "Secondary Sexual Characteristics and Menses in Young Girls Seen in Office Practice: A Study from the Pediatric Research in Office Settings Network." [Online] Available http://www.pediatrics.org/cgi/content/abstract/99/4/505. Jan. 25, 2000.

2. See Foucault, *Discipline and Punish* 135–69, on docile bodies.

3. Rabinow 244 (see n. 2, p. 000, below)

4. For sustained critiques of Mead's study of adolescence in Samoa, see Derek Freeman, *The Fateful Hoaxing of Margaret Mead: A Historical Analysis of Her Samoan Research* (1998), and Michael Orans, *Not Even Wrong: Margaret Mead, Derek Freeman, and the Samoans* (1996). Freeman was the first and most forceful critic of Mead and her research, arguing that her stay in Samoa was too brief to allow careful study of Samoan sexuality and that she not only misrepresented herself to the Samoans, but also to her mentor, Franz Boas. Combined with the recantation of one of her Samoan "informants," these critiques

have dealt a serious blow to the reputation of America's most famous anthropologist and forced the discipline itself to reexamine its paradigms. See also Friedan, *The Feminine Mystique*. Friedan critiques Mead for relying on Freudian frameworks which connect creativity and assertiveness with masculinity, and passive receptivity with femininity, while her research showed that anatomy was not, in fact, destiny (chapter 6). Furthermore, Friedan takes Mead to task for writing one version of femininity and living quite a different version.

5. Chesler argues that a great many of women's psychiatric problems historically have been the result of blaming themselves for their disillusionment with their lives instead of turning the blame back on society, which would result in rage, rather than madness.

6. Among the early challenges to monolithic feminism, perhaps the best known is Hull, Smith, and Scott's collection *All the Women Are White, All the Blacks Are Men, But Some of Us Are Brave: Black Women's Studies*. Ed. Gloria T. Hull, Patricia Bell Scott, and Barbara Smith. See also Audre Lorde's "An Open Letter to Mary Daly," in *Sister Outsider*, Trumansburg, N.Y.: Crossing P, 1984, and Paula Gunn Allen, "Who Is Your Mother? Red Roots of White Feminism," in *The Sacred Hoop: Recovering the Feminine in American Indian Traditions*. Boston: Beacon P, 1992 (1986).

7. Chodorow 94.

8. For more on the *Bildungsroman* tradition, see Martin Swales, *The German Bildungsroman from Wieland to Hesse* (Princeton: Princeton UP, 1978; Wilhelm Dilthey, *Das Erlebnis und die Dichtung* (Leipzig and Bern: Teuber, 1929); Marianne Hirsch, "The Novel of Formation as Genre: Between *Great Expectations* and *Lost Illusions*," *Genre* 12 (Fall 1979), 293–311; Jerome Buckley, *Season of Youth: The Bildungsroman from Dickens to Golding*, Cambridge: Harvard UP, 1974.

9. See also Felski 133, and Labovitz 8. For an overview of critical works on the female *Bildungsroman*, see Fuderer.

10. For a detailed discussion of *Jane Eyre* as *Bildungsroman*, see Karen E. Rowe, "'Fairy-Born and Human-Bred': Jane Eyre's Education in Romance" in Abel et al., *The Voyage In: Fictions of Female Development*. See also the introduction in same volume. For a discussion of *Little Women* as a novel of development, see Elizabeth Langland, "Female Stories of Experience: Alcott's *Little Women* in Light of *Work*," in Abel et al., *The Voyage In*.

11. See Leigh Gilmore, *Autobiographics: A Feminist Theory of Women's Self-Representation* (Ithaca: Cornell UP, 1994). See also James Olney's collection, *Autobiography: Essays Theoretical and Critical* (Princeton: Princeton UP, 1980),

and Jeanne Perrault, *Writing Selves: Contemporary Feminist Autography* (Minneapolis: U Minnesota P, 1995).

12. Jehlen argues that the novel is "always about the unitary self versus the others" (595), which is also apt as a skeletal description of the *Bildungsroman*.

13. Here I think of John McCain's narrative of his years as a prisoner of war in Vietnam, which was used relentlessly in his bid for the presidential nomination in 2000—*John McCain: An American Odyssey* (New York: Simon & Schuster, 1999). The implication of this narrative is that McCain is a man who demonstrated great courage in the face of unimaginable adversity, which somehow translates into excellent credentials for the presidency of the United States.

14. One study involved the observation of eleven mothers who were each placed in a room with a six-month-old baby with a doll, a train, and a toy fish. The women who were told the baby was a boy offered him the train, whereas the women who thought the child was a girl picked up the doll for the baby to play with. The baby was, in fact, a boy, but the women who believed he was female commented on "her" obvious femininity. See Jerrie Will, Patricia Self, and Nancy Datan, unpublished paper, cited in Carol Tavris and Carole Offir, *The Longest War: Sex Differences in Perspective*. New York: Harcourt, 1977.

15. See, for example, Willie Morris, *North Toward Home* (Oxford, MS: Yoknapatawpha Press, 1982 [1967]); Frank McCourt, *Angela's Ashes* (New York: Scribner's, 1996); Henry Louis Gates, Jr., *Colored People: A Memoir* (New York: Knopf, 1994); Russell Baker, *Growing Up* (New York: Knopf, 1991).

16. For more of Faulkner's discussion on *The Sound and the Fury*, see Frederick L. Gwynn and Joseph L. Blotner, eds. *Faulkner in the University*. Charlottesville: U of Virginia P, 1959.

17. As Showalter has written, *Little Women* has influenced many remarkable women, and interestingly, not a few women autobiographers mention this novel by name (*Sister's* 42). "I identified myself passionately with Jo," writes Simone de Beauvoir in her 1958 *Memoirs of a Dutiful Daughter.* Many years later, de Beauvoir told her biographer that she had, as a child, taken note of Jo's reluctance to marry, "and I think it was from this book that the idea first came to me that marriage was not necessary for me, even though, of course, Jo does get married. I saw that all the March girls hated housework because it kept them from what really interested them, the writing and drawing and music and so on. And I think that somehow, even when very young, I must have perceived that Jo was always making choices and sometimes they

were neither well reasoned nor good. The idea of choice must have frightened me a little, but it was exhilarating as well" (Bair 69–70). Adrienne Rich also felt an affinity with Jo, sharing a quick temper with the fictional character (*Of Woman Born* 46), and bell hooks remembers reading all of Alcott's books as a girl and finding "remnants of myself in Jo, the serious sister, the one who is punished. I am a little less alone in the world" (*Bone* 77).

18. Though I find *Little Women* and *The Adventures of Huckleberry Finn* equally influential as grand narratives of American childhood, literary maxims hold otherwise. The third edition of *Benet's Reader's Encyclopedia*, published in 1987, calls *Huck Finn* "one of the greatest creations in American fiction" (466). *Little Women*, however, is merely a "widely read story" (575).

19. Again, du Plessis argues that the last act of a female hero in nineteenth-century fiction is to turn herself into a heroine (14). In other words, when a woman relinquishes quest in exchange for romance, she also relinquishes her ability to, in Jo March's words, "paddle her own canoe."

CHAPTER 4. SPECIFYING AMERICAN GIRLHOOD: ANNIE DILLARD AND ANNE MOODY

1. Rich, "Notes Toward a Politics of Location."

2. My use of the phrase "anthropologizing the self," borrows from Rabinow's call for anthropologizing the West as a means of uncovering the constructedness of Western notions of reality (241). "Thick description" is Geertz's preferred method of writing ethnography, which he admits is interpretive, but attempts to avoid imposing coherence (17–18).

3. Dillard consistently thematizes place in her writings, most notably in *Pilgrim at Tinker Creek* (New York: Harper's Magazine Press, 1974), a personal narrative of Dillard's minutely detailed exploration of her own neighborhood in Virginia.

4. Here I am expanding Peter Winch's concept of a "limiting notion." While Winch argues correctly that birth, death, and sexual relations are significant and central to every known human culture (though obviously the form these practices take varies greatly), I argue here that parents, religion, and education function similarly for adolescents in American culture. Winch contends—and I agree—that it is "of the utmost importance to be clear about the ways in which these notions enter into" a given culture (322), so for my purposes in studying narrative constructions of American adolescent girl-

hood, I have substituted the constants with which this group must invariably interact.

5. Not that Dillard acknowledges the onset of puberty; it is a rare coming-of-age narrative that explicitly mentions menarche or other physical changes associated with puberty. Interestingly, of the narratives I discuss in this study, only Kingston and Simon confront cultural constructions of menarche directly. See chapter 6.

6. See *The Feminine Mystique*, chapter 1. Although Friedan's text is now widely criticized for overgeneralizing about women's lives, for a particular class of women—those whose husbands earned enough money to enable their wives to stay at home—the description touched a deep chord. Friedan quotes many women whose complaint is essentially the same: I have everything I wanted, but I'm still unhappy. This is the "problem with no name," and Friedan's thesis holds that the origin of the problem lies in women's enforced isolation from the larger world. Drawing heavily from popular women's magazines, Friedan finds a marked effort to valorize the joys of domesticity and to discourage interest in politics, social issues, and careers.

7. Discussing the books she was reading, Dillard uses the third-person "we": "We read, above all, *The Diary of a Young Girl*." But then she pauses to write "I say 'we,' but in fact I did not know anyone else who read these things" (179).

8. There is one notable exception to my statement that Dillard does not recognize her own whiteness, and even there the recognition is implied. Dillard writes that she had, at sixteen, begun to follow the family maid around the house, "trying to get her to spill the beans about being black; she kept moving" (216).

9. See Lerner, *Majority*, chapters 5, 6, 7, 8; Lerner, ed. *Black Women in White America: A Documentary History* (New York: Vintage, 1972); Collins, chapter 7.

10. For an analysis of the generic conventions of the slave narrative, see Olney, "'I Was Born': Slave Narratives, Their Status as Autobiography and as Literature."

11. See Gramsci, "Notes on Italian History," in *Selections from the Prison Notebooks*, 55–64.

12. According to C. Vann Woodward, lynching "attained the most staggering proportions ever reached in the history of that crime" in the 1880s and 1890s, while advocates of segregation and disfranchisement were simultaneously consolidating their dominance in the American South (43–44). Activism by the NAACP and others helped bring about near eradication of lynching by

the early 1950s, but Southern resistance to the civil rights movement resurrected the practice with a vengeance in 1955 with the murders of Emmet Till and two others (143, 173–74). See also Harris, *Exorcising Blackness*.

13. This, of course, is also Booker T. Washington's position in *Up From Slavery*. There is, however, some evidence that Washington's position was rhetorically calculated to deflect white hostility toward his school and to serve his perennial fundraising needs for Tuskegee Institute. See Louis R. Harlan's introduction to *Up From Slavery*, vii–xliii.

14. Olney 153.

15. Deborah Gray White writes that enslaved parents were particularly concerned with teaching their children to "walk the tightrope between the demands of the whites and expectations of the blacks without falling too far in either direction." For instance, children needed to learn that conversations among blacks were to be hidden from whites (93). White points out how difficult it could be for enslaved children to please both their masters and their parents.

16. Hurston, "Why I Am Not Tragically Colored."

17. See Gates, *Figures in Black: Words, Signs, and the "Racial" Self*, chapter 1.

18. Fishburn argues that "the very bodies that were the occasion of African peoples' enslavement . . . carried with them a tacit, inborn knowledge of our 'relatedness-to Being'" (*Problem* 1), thus inverting the traditional view that bodies were solely problematic for African American slaves.

19. See Christian, *Black Women Novelists: The Development of a Tradition, 1892–1976*, chapter 1.

20. In Ann Petry's novel, *The Street*, Lutie Johnson commits murder rather than assent to a rape that symbolizes her image as an uncontrollably sexual black woman (New York: Houghton, 1946, 1974).

21. Peter Stallybrass and Allon White, *The Politics and Poetics of Transgression* (Ithaca: Cornell UP, 1986).

22. See H-Net discussion, "Teaching Anne Moody *Coming of Age in Mississippi* Discussion, August 1997. Online. <http://www2.h-net.msu.edu/~women/archives/threads/disc-moody.html>. According to *Black Women in America: An Historical Encyclopedia*, edited by Darlene Clark Hine (Brooklyn: Carlson, 1993), Moody left Mississippi in 1964 to become a civil rights project coordinator at Cornell University in Ithaca, New York. The H-Net discussion airs rumors, none of which I can substantiate, about Moody becoming a lawyer in New York City, or living in France, or writing children's fiction. Moody did publish one book of fiction in 1975, titled *Mr. Death: Four Stories*, now out of print, as well as various uncollected stories.

CHAPTER 5. "LYING CONTESTS": FICTIONAL AUTOBIOGRAPHY
AND AUTOBIOGRAPHICAL FICTION

1. Many of the chapters in *Memories of a Catholic Girlhood* were first copyrighted as separate stories in either *The New Yorker* or *Harper's Bazaar.* See McCarthy's copyright page.

2. See also pp. 4, 124, 166 in McCarthy for variations on this assertion.

3. The fourth wall was an innovation of classic realistic drama that attempts to provide an audience with the illusion of a coherent, believable world in which the actors "become" the parts they played. For a discussion of classic realism in literature and the interrogative texts of Renaissance drama, see Belsey, 91–102.

4. See Willett, *Brecht on Theatre*, pp. 192, 125–26.

5. While it is true that earlier writers of both autobiography and fiction have explicitly addressed their readers (i.e., Harriet Jacobs, "Reader, be assured this is no fiction," and Charlotte Bronte, "Reader, I married him" [Jane Eyre]), the direct address I am describing here differs significantly in that the coming-of-age narratives often take the reader "behind the scenes" so to speak, showing the workings of the narrative much as Brecht wanted to show spectators the theatrical machinery that creates the illusion of reality. In this sense, the coming-of-age narrative shares many of the characteristics of metafiction, which, according to Patricia Waugh, "self-consciously and systematically draws attention to its status as an artefact in order to pose questions about the relationship between fiction and reality" (*Metafiction* 2).

6. DuBois, *The Souls of Black Folk*, 45.

7. See Chodorow, Gilligan, Belenky et al.

8. For a discussion of the practice of signifying in African American culture and literature, see Gates, *Figures*, 236–50.

9. See Gates, *Signifying*, 196.

10. See Harlan, introduction to *Up From Slavery*, xxxviii.

11. See Richard Wright, "Blueprint for Negro Writing" (194–205), and Langston Hughes, "The Negro Artist and the Racial Mountain" (91–95) for representative statements arguing, respectively, for the integral role of social protest and the specificity of African American culture in literature. Rpt. in *The Portable Harlem Renaissance Reader.* Ed. David Levering Lewis. New York: Penguin, 1994.

12. Quoted in Hemenway, *Zora Neale Hurston: A Literary Biography*, 241.

13. Letter to Thomas Hamilton, quoted in Gates, *Signifying*, 173.

14. Frederick Douglass writes that he changed his name twice before settling on Douglass at the suggestion of a white abolitionist supporter (322);

Malcolm X, Amira Baraka, and Muhammed Ali are among the more famous twentieth-century examples of the practice of rejecting the names that symbolized the enslavement of African Americans.

15. LeSeur argues that sexual awakening is conventional in the African American female narratives of initiation, and I would not disagree (101). However, it is not conventional in my definition of the coming-of-age narrative, although Janie's sexual awakening as represented by the blooming pear tree is conventional for these texts in that Janie's discourse (of romance, in this instance) *resists* a dominant ideology and attempts to create a narrative of womanhood that honors the integrity of her vision.

16. Belenky et al. refer to the tentative knowledge emanating from a woman's inner voice as a "still small voice," a Biblical reference to the voice of God (I Kings 19: 11–12). According to Belenky et al., Maimonides uses the same phrase to refer to intuitive knowledge.

17. See Mary Helen Washington's foreword to *Their Eyes Were Watching God* and Robert Stepto, *From Behind the Veil.*

CHAPTER 6. "ROOM FOR PARADOXES": CREATING A HYBRID IDENTITY

1. Following the standard usage of literary scholars and historians of Chinese America, I use the term "Chinese immigrant" to refer to Chinese Americans who were born in China; American-born Chinese refers, of course, to the children born in the United States to Chinese immigrants.

2. See "DisseminiNation: Time, Narrative, and the Margins of the Modern Nation," pp. 139–70 in Bhabha, *The Location of Culture.* Also published in *Nation and Narration*, ed. Homi K. Bhabha.

3. Richard Rodriguez, "Does America Still Exist?" (*Harper's*, March 1984) 57-8.

4. The role of biology in identity is a complex issue and beyond the scope of this study. However, questions raised by the activism of intersexed individuals in recent years suggests that sexual identity is not in fact simply a social construct. For instance, the case of John/Joan involved a boy born in the early 1960s who underwent surgical reconstruction of his genitals and hormone therapy after a botched circumcision when he was eight months old. Doctors reasoned that he would suffer emotional trauma if he had to live as a man with a mutilated penis, but with a surgically constructed vagina, hormone therapy, and personal counseling, he could expect a normal life as a

female. The underlying assumptions of this reasoning, according to Diamond and Sigmundson, was that "individuals are psychosexually neutral at birth" and that "healthy psychosexual development is dependent on the appearance of the genitals" (qtd. in Dreger 2). But John/Joan, now an adult, is married to a woman and is the father of their adopted children. In fact, he has revealed that he never felt comfortable with his assigned female identity and had secretly discarded the female hormones he received at puberty. Indeed, at fourteen, he decided to identify himself as male (Dreger, "Ambiguous Sex," 1–2). The outcome of this rather well-known case is anecdotally corroborated by other intersexed individuals who were assigned a gender through surgical intervention but found that the elimination of their sexual ambiguity robbed them of a significant portion of their identity. Many have expressed the wish that they been given the chance to decide if they wanted surgical alteration. The experience of intersexed individuals suggests that gender is significantly determined by biological factors that cannot be erased by social variables. See Bo Laurent, "Intersexuality—A Plea for Honesty and Emotional Support." [Online] Available http://ahp.web.org/pub/perspective/intersex.html; Alice Dreger, *Hermaphrodites and the Medical Invention of Sex* (Cambridge: Harvard UP, 1998).

5. The Venn Diagram uses circles to represent an action in set theory, where the positions and overlap of circles indicates the relationships between the sets. After John Venn, 1834–1923, British logician. See *Webster's Unabridged Dictionary of the English Language* (New York: Portland House, 1989).

6. See *Language as Symbolic Action*, 44–62.

7. See, for instance, Yung, *Chinese Women of America: A Pictorial History*, and Ling, *Between Worlds: Women Writers of Chinese Ancestry*.

8. Again I find Winch's use of "limiting notions" useful. Though I want to be careful not to generalize, the specific limiting notions I attribute to American female adolescents—sexual awakening, body changes, consciousness of difference from males, and the socialization into feminine gender roles—are paradigmatic tropes in the American woman's coming-of-age narrative, regardless of class, ethnicity, place, or time.

9. In their 1999 study *Sparks of Genius: The Thirteen Thinking Tools of the World's Most Creative People* (Boston: Houghton Mifflin, 1999), Robert and Michele Root-Bernstein devote an entire chapter to the concept of "body thinking," which they argue is a mode of knowing common to brilliant scientists as well as artists.

10. *A Wider World* is the title of the second volume of Kate Simon's memoirs (New York: Harper, 1986).

11. See Chun, pp. 79–81. See also Wang for historical contextualization of Chinese American identity.

12. See Chun, chapter 2.

13. Ibid., pp. 128-29. Chun is drawing on David A. Hollinger's work in *Postethnic America: Beyond Multiculturalism*. New York: Basic, 1995.

14. Being born a dragon under the Chinese zodiac is considered lucky and highly desirable; birth rates rise dramatically in dragon years. Dragon people are defined as strong, energetic, authoritative, unpredictable, eccentric, stubborn, selfish, and morally principled. See "The Dragon." [Online.] <http.www.wlu.edu/~hhil/dragon.html.

15. The use of cowbirds in this maxim is surely no accident; these black birds lay their eggs in other birds' nests. They do not raise their own young. For a discussion of parenting in a cross-species context, see Hrdy.

16. See also Benjamin R. Tong, "The Ghetto of the Mind." *Amerasia Journal* 1.3 (Nov. 1971): 1–31.

17. However, in *China Men*, Kingston articulates the male narratives that also work to determine her identity, and that of all Chinese in America.

Works Cited

Abel, Elizabeth, Marianne Hirsch, and Elizabeth Langland. *The Voyage In: Fictions of Female Development*. Hanover: UP of New England, 1983. Introduction. 3–19.

Alcoff, Linda Martín. "The Problem of Speaking for Others." *Cultural Critique* (Winter 1991): 5–33.

———. "Who's Afraid of Identity Politics?" In *Reclaiming Identity: Realist Theory and the Predicament of Postmodernism*. Ed. Paula M. Moya and Michael Roy Hames-Garcia. Berkeley, CA: U California P, 2000. 312–44.

Alcott, Louisa May. *Little Women*. New York: Dell, 1987 (1868).

Althusser, Louis. *For Marx*. Trans. Ben Brewster. New York: Vintage, 1970 (1965).

———. "Ideology and Ideological State Apparatuses." In *Lenin and Philosophy and Other Essays*. Trans. Ben Brewster. New York: Monthly Review, 1971. 127–86.

Antin, Mary. *The Promised Land*. 1912. New York: Penguin, 1997.

Auerbach, Nina. *Communities of Women: An Idea in Fiction*. Cambridge, MA: Harvard UP, 1978.

Awkward, Michael. "'The inaudible voice of it all': Voice, Silence, and Action in *Their Eyes Were Watching God*." In *Black Feminist Criticism and Critical Theory*. Ed. Joe Weixlman and Houston A. Baker, Jr. Greenwood, FL: Penkeville Publishing, 1988. 57–109.

Bair, Deirdre. *Simone De Beauvoir: A Biography*. New York: Summit, 1990.

Bakan, David. "Adolescence in America: From Idea to Social Fact." In *Twelve to Sixteen: Early Adolescence*. Ed. Jerome Kagan and Robert Coles. New York: Norton, 1972. 73–89.

Barthes, Roland. "The Death of the Author." In *Image/Text/Music*. Trans. Stephen Heath. New York: Hill and Wang, 1977. 142–48.

Baym, Nina. "Melodramas of Beset Manhood: How Theories of American Fiction Exclude Women Authors." In *The New Feminist Criticism: Essays on Women, Literature, and Theory*. Ed. Elaine Showalter. New York: Pantheon, 1985. 63–80.

Belden, Elionne L. W. *Claiming Chinese Identity*. New York: Garland, 1997.

Belenky, Mary Field, Blythe McVicker Clinchy, Nancy Rule Goldberger, and Jill Mattuck Tarule. *Women's Ways of Knowing: The Development of Self, Voice, and Mind*. New York: Basic, 1986.

Belsey, Catherine. *Critical Practice*. London: Routledge, 1980.

Benet's Reader's Encyclopedia. 3rd ed. New York: Harper, 1987 (1948).

Benhabib, Seyla. *Situating the Self: Gender, Community and Postmodernism*. Cambridge: Cambridge UP, 1992.

Bentson, Kimberley W. "'I Yam What I Am': Naming and Unnaming in Afro-American Literature." *Black American Literature Forum* 16 (Spring 1982): 3–11.

Bhabha, Homi K. *The Location of Culture*. London: Routledge, 1994.

Biale, David. "The Melting Pot and Beyond: Jews and the Politics of American Identity." In *Insider/Outsider: American Jews and Multiculturalism*. Ed. David Biale, Michael Galchinsky, and Susannah Heschel. Berkeley, CA: U California P, 1998.

Biale, David, Michael Galchinsky, and Susannah Heschel, ed. Introduction. In *Insider/Outsider: American Jews and Multiculturalism*. Berkeley, CA: U California P, 1998.

Blos, Peter. "The Child Analyst Looks at the Young Adolescent." In *Twelve to Sixteen: Early Adolescence*. Ed. Jerome Kagan and Robert Coles. New York: Norton, 1972. 55–72.

Bordo, Susan. "The Body and the Reproduction of Femininity: A Feminist Appropriation of Foucault." In *Gender/Body/Knowledge: Feminist Reconstructions of Being and Knowing*. Ed. Alison M. Jaggar and Susan R. Bordo. 13–33.

Brantley, Will. *Feminine Sense in Southern Memoir: Smith, Glasgow, Welty, Hellman, Porter, and Hurston*. Jackson: U Mississippi P, 1993.

Braendlin, Bonnie Hoover. "*Bildung* in Ethnic Women Writers." *Denver Quarterly* 17 (1983): 75–87.

Braxton, Joanne M. *Black Women Writing Autobiography: A Tradition Within a Tradition*. Philadelphia: Temple UP, 1989.

Brown, Claude. *Manchild in the Promised Land*. New York: Signet, 1965.

Brown, Lyn Mikel, and Carol Gilligan. *Meeting at the Crossroads: Women's Psychology and Girls' Development.* New York: Ballantine, 1992.

Brown, Rita Mae. *Rita Will: Memoir of a Literary Rabble-Rouser.* New York: Bantam, 1997.

Burke, Kenneth. *Language as Symbolic Action: Essays on Life, Literature, and Method.* Los Angeles: U California P, 1966.

Butterfield, Stephen. *Black Autobiography in America.* Amherst: U Massachusetts P, 1974.

Callahan, John F. *In the African-American Grain: The Pursuit of Voice in Twentieth-Century Black Fiction.* Urbana: U Illinois P, 1988.

Campbell, Joseph, with Bill Moyers. *The Power of Myth.* Ed. Betty Sue Flowers. New York: Doubleday, 1988.

Chesler, Phyllis. *Women and Madness.* New York: Avon, 1972.

Chesnut, Mary Boykin. *Mary Chesnut's Civil War.* Ed. C. Vann Woodward. New Haven: Yale UP, 1981.

Cheung, King-Kok. *Articulate Silences: Hisaye Yamamoto, Maxine Hong Kingston, Jocy Kogawa.* Ithaca, NY: Cornell UP, 1993.

Chodorow, Nancy. *The Reproduction of Mothering.* Berkeley: U California P, 1978.

Chopin, Kate. *The Awakening.* 1899. 2nd ed. Ed. Margo Culley. New York: Norton, 1994.

Christian, Barbara. *Black Women Novelists: The Development of a Tradition, 1892–1976.* Westport, CT: Greenwood, 1980.

Chun, Gloria Heyung. *Of Orphans and Warriors: Inventing Chinese American Culture and Identity.* New Brunswick, NJ: Rutgers UP, 2000.

Coles, Robert. *Children of Crisis: A Study of Courage and Fear.* Boston: Little, 1964.

Collins, Patricia Hill. *Black Feminist Thought: Knowledge, Consciousness, and the Politics of Empowerment.* New York: Routledge, 1991.

Combahee River Collective. "A Black Feminist Statement." In *All the Women Are White, All the Blacks Are Men, But Some of Us Are Brave: Black Women's Studies.* Ed. Gloria T. Hull, Patricia Bell Scott, and Barbara Smith. Old Westbury, NY: Feminist P, 1982. 13–22.

Conway, Jill Ker. *True North.* New York: Knopf, 1994.

———. *When Memory Speaks: Exploring the Art of Autobiography.* New York: Vintage, 1998.

Culler, Jonathan. *Literary Theory: A Very Short Introduction.* Oxford: Oxford UP, 1997.

Davidson, Cathy N. *Revolution and the Word: The Rise of the Novel in America.* New York: Oxford UP, 1986.

Davis, Rebecca Harding. *Life in the Iron Mills and Other Stories*. 1861. Ed. Tillie Olsen. New York: Feminist P, 1972.

De Beauvoir, Simone. *Memoirs of a Dutiful Daughter*. 1958. Trans. James Kirkup. New York: Harper, 1974.

———. *The Second Sex*. 1952. Trans. H. M. Parshley. New York: Vintage, 1974.

Diamond, Arlyn. "Choosing Sides, Choosing Lives: Women's Autobiographies of the Civil Rights Movement." In *American Women's Autobiography: Fea(s)ts of Memory*. Ed. Margo Culley. Madison: U Wisconsin P, 1992. 218–31.

Dillard, Annie. *An American Childhood*. New York: Harper, 1987.

Dobroszycki, Lucjan, and Barbara Kirshenblatt-Gimblatt. *Image Before My Eyes: A Photographic History of Jewish Life in Poland, 1864–1939*. New York: Schocken, 1977.

Douglas, Ann. *The Feminization of American Culture*. New York: Avon, 1978.

Douglass, Frederick. *Narrative of the Life of Frederick Douglass*. 1845. In *The Classic Slave Narratives*. Ed. Henry Louis Gates, Jr. New York: Mentor, 1987.

Dreger, Alice Domurat. "Ambiguous Sex—Or Ambivalent Medicine?" *The Hastings Center Report*, Hastings-on-Hudson. 28.3 (May/June 1998): 24–35. [Online] Available http:// www.isna.org/dregerart.html. March 21, 2000.

DuBois, W. E. B. *The Souls of Black Folk*. New York: Signet, 1969 (1903).

du Plessis, Rachel Blau. *Writing Beyond the Ending: Narrative Strategies of Twentieth-Century Women Writers*. Bloomington, IN: Indiana UP, 1985.

Engels, Friedrich. Letter to Joseph Bloch. 1890. In *The Marx-Engels Reader*. 2nd edition. Ed. Robert C. Tucker. New York: Norton, 1978.

Erikson, Erik H. *Identity: Youth and Crisis*. New York: Norton, 1968.

Evans, Sara M. *Born for Liberty: A History of Women in America*. New York: Free P, 1989.

Faludi, Susan. *Stiffed: The Betrayal of the American Man*. New York: William Morrow, 1999.

Faulkner, William. *The Sound and the Fury*. New York: Vintage, 1929.

Felski, Rita. *Beyond Feminist Aesthetics: Feminist Literature and Social Change*. Cambridge: Harvard UP, 1989.

Ferguson, Kathy E. *The Man Question: Visions of Subjectivity in Feminist Theory*. Berkeley: U California P, 1993.

Fetterley, Judith. "*Little Women*: Alcott's Civil War." *Feminist Studies* 5.2 (1979): 369–83.

———. *The Resisting Reader: A Feminist Approach to American Fiction*. Bloomington: Indiana UP, 1977.

Fishburn, Katherine. *The Problem of Embodiment in Early African American Narrative*. Westport, CT: Greenwood, 1997.

————. "Reforming the Body Politic: Radical Feminist Science Fiction." In *Still the Frame Holds: Essays on Women Poets and Writers*. Ed. Sheila Roberts. San Bernardino, CA: Borgo P, 1993.

Flax, Jane. *Disputed Subjects: Essays on Psychoanalysis, Politics and Philosophy*. London: Routledge, 1993.

Foucault, Michel. *Discipline and Punish: The Birth of the Prison*. Trans. Alan Sheridan. New York: Vintage, 1977.

————. "The Discourse on Language." In *The Archaeology of Knowledge and The Discourse of Language*. Trans. A. M. Sheridan Smith. New York: Pantheon, 1971. 215–37.

————. "Revolutionary Action: 'Until Now.'" Reprinted in *Language, Counter-memory, Practice: Selected Essays and Interviews*. Ed. Donald F. Bouchard. Trans. Donald F. Bouchard and Sherry Simon. Ithaca: Cornell UP, 1977. 218–33.

————. "Truth and Power." In *The Foucault Reader*. Ed. Paul Rabinow. New York: Pantheon, 1984.

————. "What Is an Author?" Trans. Josué V. Harari. In *Textual Strategies: Perspectives on Post-Structuralist Criticism*. Ed. Josué V. Harari. Ithaca: Cornell UP, 1979. 141–60.

Franklin, Benjamin. *Autobiography and Other Works*. Ed. Russel B. Nye. Boston: Houghton, 1958.

Freeman, Derek. *The Fateful Hoaxing of Margaret Mead: A Historical Analysis of Her Samoan Research*. Boulder, CO: Westview P, 1999.

Freud, Sigmund. "Femininity." In *New Introductory Lectures on Psychoanalysis*. Trans. James Strachey. New York: Norton, 1965.

————. *Three Contributions to the Theory of Sex*. In *The Basic Writings of Sigmund Freud*. Trans./ed. by Dr. A. A. Brill. New York: Modern Library, 1966.

Friedan, Betty. *The Feminine Mystique*. New York: Norton, 1963.

Frieden, Sandra. "Shadowing/Surfacing/Shedding: Contemporary German Writers in Search of a Female *Bildungsroman*." In *The Voyage In: Fictions of Female Development*. Ed. Elizabeth Abel, Marianne Hirsch, and Elizabeth Langland. Hanover: UP of New England, 1983. 304–16.

Friedman, Susan Stanford. "Women's Autobiographical Selves: Theory and Practice." In *The Private Self: Theory and Practice of Women's Autobiographical Writings*. Ed. Shari Benstock. 34–61.

Fuderer, Laura Sue. *The Female Bildungsroman in English: An Annotated Bibliography of Criticism*. New York: MLA, 1990.

Gadamer, Hans-Georg. *Truth and Method.* 2nd revised ed. Trans. and revised by Joel Weinsheimer and Donald G. Marshall. New York: Crossroad, 1989.

Gates, Henry Louis, Jr. *Figures in Black: Words, Signs, and the "Racial" Self.* New York: Oxford UP, 1989.

———. *The Signifying Monkey: A Theory of African-American Literary Criticism.* New York: Oxford UP, 1988.

Geertz, Clifford. *The Interpretation of Cultures.* New York: Basic, 1973.

Gilbert, Sandra M., and Susan Gubar. *The Madwoman in the Attic: The Woman Writer and the Nineteenth-Century Literary Imagination.* New Haven: Yale UP, 1979.

Gilligan, Carol. *In a Different Voice: Psychological Theory and Women's Development.* 1982. Cambridge: Harvard UP, 1993.

Gilmore, Leigh. "The Mark of Autobiography: Postmodernism, Autobiography and Genre." In *Autobiography and Postmodernism.* Ed. Kathleen Ashley, Leigh Gilmore, and Gerald Peters. Amherst: U Massachusetts P, 1994. 3–18.

Goodwin, Doris Kearns. *Wait Till Next Year: A Memoir.* New York: Touchstone, 1997.

Gramsci, Antonio, *Selections From the Prison Notebooks of Antonio Gramsci.* Ed. and trans. Quintin Hoare and Geoffrey Nowell Smith. New York: International Publishers, 1971.

Griffiths, Morwenna. *Feminisms and the Self: The Web of Identity.* London: Routledge, 1995.

Gusdorf, Georges. "Conditions and Limits of Autobiography." 1956. Trans. James Olney. In *Autobiography: Essays Theoretical and Critical.* Ed. James Olney. Princeton: Princeton UP, 1980. 28–48.

Haley, Jr., Alex. *The Autobiography of Malcolm X.* New York: Grove, 1964.

Hall, G. Stanley. *Adolescence.* 1905. New York: Arno P, 1969. Two volumes.

Hall, Stuart. "New Ethnicities." *ICA Documents.* London: 1988. No. 7: 27–31.

———. "Signification, Representation, Ideology: Althusser and the Post-Structuralist Debate." *Critical Studies in Mass Communication* 2:2 (June 1985): 91–114.

Harper, Frances E. W. *Iola Leroy,* or *Shadows Uplifted.* 1892. Boston: Beacon, 1987.

Harris, Trudier. *Exorcising Blackness: Historical and Literary Lynching and Burning Rituals.* Bloomington, IN: Indiana UP, 1984.

Hartsock, Nancy. "Rethinking Modernism: Minority vs. Majority Theories." *Cultural Critique* 7 (Fall 1987): 187–206.

Hegel, G. W. F. *The Phenomenology of Mind*. 1807. Trans. J. B. Baillie. 2nd edition. New York: Macmillan, 1931.

Hegel, Robert E. "An Exploration of the Chinese Literary Self." In *Expressions of Self in Chinese Literature*. Ed. Robert E. Hegel and Richard C. Hessney. New York: Columbia UP, 1985. 3–30.

Heidegger, Martin. *Being and Time*. 1953. Trans. Joan Stambaugh. Albany, NY: SUNY P, 1997.

Heilbrun, Carolyn G. *Writing a Woman's Life*. New York: Norton, 1988.

Heinze, Andrew R. *Adapting to Abundance: Jewish Immigrants, Mass Consumption, and the Search for American Identity*. New York: Columbia UP, 1990.

Hemenway, Robert. Introduction. *Dust Tracks on a Road*. 1942. By Zora Neale Hurston. 2nd ed. Urbana, IL: U Illinois P, 1984.

———. *Zora Neale Hurston: A Literary Biography*. Chicago: U Illinois P, 1977.

Hite, Molly. Foreword. *Redefining Autobiography in Twentieth-Century Women's Fiction*. Ed. Janice Morgan and Colette T. Hall. New York: Garland, 1991. xiii–xvi.

———. *The Other Side of the Story: Structures and Strategies of Contemporary Feminist Narrative*. Ithaca: Cornell UP, 1989.

Holland, Norman N. "Unity Identity Text Self." *PMLA* 90.5 (Oct. 1975): 813–22.

hooks, bell. *Ain't I a Woman: Black Women and Feminism*. Boston: South End P, 1981.

———. *Bone Black: Memories of Girlhood*. New York: Henry Holt, 1996.

How Schools Shortchange Girls: The AAUW Report: A Study of Major Findings on Girls and Education. Washington, D.C.: AAUW Educational Foundation and Wellesley College Center for Research on Women, 1992.

Howe, Florence. "Introduction: T. S. Eliot, Virginia Woolf, and the Future of 'Tradition.'" In *Tradition and the Talents of Women*. Ed. Florence Howe. Urbana, IL: U Illinois P, 1991. 1–33.

Howe, Irving. *World of Our Fathers*. New York: Harcourt, 1976.

Hsu, Cho-yun. "A Reflection on Marginality." *Daedalus* 120. 2 (Spring 1991): 227–29.

Hull, Gloria T., and Barbara Smith. "The Politics of Black Women's Studies." In *All the Women Are White, All the Blacks Are Men, But Some of Us Are Brave: Black Women's Studies*. Ed. Gloria T. Hull, Patricia Bell Scott, and Barbara Smith. Old Westbury, NY: Feminist P, 1982. xvii–xxxii.

Hurston, Zora Neale. *Dust Tracks on a Road*. 1942. 2nd ed. Urbana, IL: U Illinois P, 1984.

————. "How It Feels To Be Colored Me." In *I Love Myself When I Am Laughing: A Zora Neale Hurston Reader.* Ed. Alice Walker. New York: Feminist P, 1979. 152–55.

————. *Of Mules and Men: Negro Folktales and Voodoo Practices in the South.* New York: Harper, 1970 (1935).

————. *Their Eyes Were Watching God.* 1937. New York: Harper, 1990.

Jacobs, Harriet. *Incidents in the Life of a Slave Girl, Written by Herself.* 1861. Ed. Jean Fagan Yellin. Cambridge: Harvard UP, 1987.

Jaggar, Alison. *Feminist Politics and Human Nature.* Lanham, MD: Rowman, 1983.

Jehlen, Myra. "Archimedes and the Paradox of Feminist Criticism." *Signs: Journal of Women in Culture and Society* 6 (1981): 575–601.

Jelinek, Estelle. *The Tradition of Women's Autobiography: From Antiquity to the Present.* Boston: Twayne, 1986.

Johnson, James Weldon. *The Autobiography of an Ex-Coloured Man.* 1912. New York: Hill, 1960.

Jung, Carl G. "The Stages of Life." In *The Portable Jung.* Ed. Joseph Campbell. New York: Viking, 1971. 1–22.

Kagan, Jerome. "A Conception of Early Adolescence." In *Twelve to Sixteen: Early Adolescence.* Ed. Jerome Kagan and Robert Coles. New York: Norton, 1971. 90–105.

Kaplan, Louise, J. *Adolescence: The Farewell to Childhood.* New York: Simon and Schuster, 1984.

Kett, Joseph F. *Rites of Passage: Adolescence in America, 1790 to the Present.* New York: Basic, 1977.

Kim, Elaine H. *Asian American Literature: An Introduction to the Writings and Their Social Contexts.* Philadelphia: Temple UP, 1982.

Kindlon, Daniel J. *Raising Cain: Protecting the Emotional Life of Boys.* New York: Ballantine, 1999.

King, Sigrid. "Naming and Power in Zora Neale Hurston's *Their Eyes Were Watching God.*" *Black American Literature Forum* 24.4 (Winter 1990): 683–96.

Kingston, Maxine Hong. *The Woman Warrior: Memoirs of a Girlhood Among Ghosts.* New York: Vintage, 1975.

————. *China Men.* New York: Vintage Books, 1989.

Kirkland, Caroline. *A New Home, Who'll Follow?, or Glimpses of Western Life.* 1839. New Brunswick, NJ: Rutgers UP, 1986.

Labovitz, Esther Kleinbord. *The Myth of the Heroine: The Female Bildungsroman in the Twentieth Century. Dorothy Richardson, Simone de Beauvoir, Doris Lessing, Christa Wolf.* 2nd ed. New York: Peter Lang, 1988.

Lejeune, Phillipe. "The Autobiographical Contract." In *French Literary Theory Today: A Reader*. Ed. Tzvetan Todorov. Trans. R. Carter. Cambridge: Cambridge UP, 1982. 192–222.

Lerner, Gerda. *The Majority Finds Its Past: Placing Women in History*. New York: Oxford UP, 1979.

LeSeur, Geta. *Ten Is the Age of Darkness. The Black Bildungsroman*. Columbia: U Missouri P, 1995.

Lim, Shirley Geok-lin. "The Ambivalent American: Asian American Literature on the Cusp." In *Reading the Literatures of Asian America*. Ed. Shirley Geok-lin Lim and Amy Ling. Philadelphia: Temple UP, 1992.

Ling, Amy. *Between Worlds: Women Writers of Chinese Ancestry*. New York: Pergamon, 1990.

Lionnet, Françoise. "Autoethnography: The An-Archic Style of *Dust Tracks on a Road*." In *Reading Black, Reading Feminist: A Critical Anthology*. Ed. Henry Louis Gates, Jr. New York: Meridian, 1990. 382–414.

Locke, John. "An Essay Concerning Human Understanding." 1690. In *Classics of Western Philosophy*. Ed. Steven M. Cahn. 3rd edition. Indianapolis, IN: Hackett, 1977.

Loewen, James W. *Lies My Teacher Told Me: Everything Your American History Textbook Got Wrong*. New York: New Press, 1995.

Lyotard, Jean-François. *The Postmodern Condition: A Report on Knowledge*. 1979. Trans. Geoff Bennington and Brian Massumi. *Theory and History of Literature*, Vol. 10. Minneapolis: U Minnesota P, 1984.

Macherey, Pierre. *A Theory of Literary Production*. Trans. Geoffrey Wall. London: Routledge, 1978.

Marx, Karl. *Contribution to the Critique of Political Economy*. 1859. Preface. In *The Marx- Engels Reader*. 2nd edition. Ed. Robert C. Tucker. New York: Norton, 1978.

Marx, Karl, and Friedrich Engels. *The German Ideology*. 1845–46. In *The Marx-Engels Reader*. 2nd edition. Ed. Robert C. Tucker. New York: Norton, 1978.

McCarthy, Mary. *Memories of a Catholic Girlhood*. New York: Harcourt, 1957.

McCourt, Frank. *Angela's Ashes*. New York: Scribners, 1996.

McKay, Nellie. "'Crayon Enlargements of Life': Zora Neale Hurston's *Their Eyes Were Watching God* as Autobiography." In *New Essays on Their Eyes Were Watching God*. Ed. Michael Awkward. Cambridge: Cambridge UP, 1990. 51–70.

McNay, Lois. *Foucault and Feminism: Power, Gender, and the Self*. Cambridge: Polity, 1992.

Mead, Margaret. *Coming of Age in Samoa: A Psychological Study of Primitive Youth for Western Civilisation*. 1928. New York: Mentor, 1949.

Menchú, Rigoberta. *I, Rigoberta Menchú: An Indian Woman in Guatemala*. Trans. Ann Wright. London: Verso, 1987.

Miller, Nancy K. "Emphasis Added: Plots and Plausibilities in Women's Fiction." In *The New Feminist Criticism: Essays on Women, Literature and Theory*. Ed. Elaine Showalter. New York: Pantheon, 1985. 339–60.

———. *Subject to Change: Reading Feminist Writing*. New York: Columbia UP, 1988.

Minnich, Elizabeth Kamarck. "Transforming Knowledge." 1980. Rpt. in Ruth, Sheila. *Issues in Feminism: An Introduction to Women's Studies*. 3rd ed. Mountain View, CA: Mayfield, 1995. 413–29.

Moody, Anne. *Coming of Age in Mississippi*. New York: Laurel, 1968.

Morgan, Janice. "Subject to Subject/Voice to Voice: Twentieth-Century Autobiographical Fiction by Women Writers." In *Redefining Autobiography in Twentieth-Century Women's Fiction*. Ed. Janice Morgan and Colette T. Hall. New York: Garland, 1991. 3–19.

Morris, Edmund. *Dutch*. New York: Random, 1999.

Morrison, Toni. *The Bluest Eye*. New York: Washington Square P, 1970.

O'Brien, Tim. *The Things They Carried*. New York: Penguin, 1990.

Olney, James. "'I Was Born': Slave Narratives, Their Status as Autobiography and as Literature." In *The Slave's Narrative*. Ed. Charles Davis and Henry Louis Gates, Jr. New York: Oxford UP, 1985. 148–75.

Olsen, Tillie. *Silences*. New York: Dell, 1965.

Orans, Michael. *Not Even Wrong: Margaret Mead, Derek Freeman, and the Samoans*. Novato, CA: Chandler, 1996.

Papachristou, Judith. *Women Together*. New York: Knopf, 1976.

Patai, Daphne, and Noretta Koertge. *Professing Feminism: Cautionary Tales from the Strange World of Women's Studies*. New York: Basic, 1994.

Payne, Charles. "Men Led, But Women Organized: Movement Participation of Women in the Mississippi Delta." In *Women in the Civil Rights Movement: Trailblazers and Torchbearers, 1941–1965*. Ed. Vicki L. Crawford, Jacqueline Anne Rouse, and Barbara Woods. Bloomington: Indiana UP, 1990. 1–12.

Pennington, James W. C. *The Fugitive Blacksmith; or, Events in the History of James W. C. Pennington*. 1849. 2nd ed. London: Charles Gilpin. Reprinted in *Five Slave Narratives: A Compendium*. Ed. William Loren Katz. New York: Arno P, 1968.

Pipher, Louisa. *Reviving Ophelia: Saving the Selves of Adolescent Girls*. New York: Putnam, 1994.

Pratt, Annis (with Barbara White, Andrea Loewenstein, Mary Wyer). *Archetypal Patterns in Women's Fiction*. Bloomington, IN: Indiana UP, 1981.

Pye, Lucian, and Mary W. Pye. *Asian Power and Politics: The Cultural Dimensions of Authority*. Cambridge: Belknap, 1985.

Rabinow, Paul. "Representations Are Social Facts: Modernity and Post-Modernity in Anthropology." In *Writing Culture: The Poetics and Politics of Ethnography*. Ed. James Clifford and George E. Marcus. Berkeley, CA: U California P, 1986. 234–61.

Rich, Adrienne. "Notes Toward a Politics of Location." In *Blood, Bread, and Poetry: Selected Prose, 1979–85*. New York: Norton, 1986. 210–31.

———. *Of Woman Born: Motherhood as Experience and Institution*. 1976. New York: Norton, 1986.

———. "Women and Honor: Some Notes on Lying." In *On Lies, Secrets, and Silence: Selected Prose, 1966–1978*. New York: Norton, 1979. 185–94.

Root, Jr., Robert L., and Michael Steinberg. *The Fourth Genre: Contemporary Writers of/on Creative Nonfiction*. Boston: Allyn, 1999.

Rousseau, Jean Jacques. *Émile*. 1780. London: J. M. Dent, 1948.

Russ, Joanna. "What Can a Heroine Do? Or Why Women Can't Write." In *Images of Women in Fiction: Feminist Perspectives*. Ed. Susan Koppelman Cornillon. Bowling Green, OH: Bowling Green UP, 1972. 3–20.

Russell, Bertrand. *A History of Western Philosophy*. New York: Simon, 1945.

Said, Edward. *Orientalism*. New York: Vintage, 1978.

Salinger, J.D. *The Catcher in the Rye*. New York: Bantam, 1951.

Sánchez-Eppler, Karen. *Touching Liberty: Abolition, Feminism, and the Politics of the Body*. Berkeley, CA: U California P, 1993.

Schlegel, Alice, and Herbert Barry III. *Adolescence: An Anthropological Inquiry*. New York: Free P, 1991.

Showalter, Elaine. *A Literature of Their Own: British Women Novelists from Brontë to Lessing*. Princeton: Princeton UP, 1977.

———. *Sister's Choice: Tradition and Change in American Women's Writing*. Oxford, England: Clarendon, 1991.

———. "Toward a Feminist Poetics." In *The New Feminist Criticism: Essays on Women, Literature, and Theory*. Ed. Elaine Showalter. New York: Pantheon, 1985. 125–43.

Simon, Kate. Bronx Primitive: *Portraits in a Childhood*. New York: Viking, 1982.

Smith, Patrick. "What Memoir Forgets." *The Nation*, July 27, 1998. 30.

Smith, Richard J. *China's Cultural Heritage: The Qing Dynasty, 1644–1912*. 2nd ed. Boulder: Westview P, 1994.

Smith, Sidonie. *A Poetics of Women's Autobiography: Marginality and the Fictions of Self-Representation*. Bloomington: Indiana UP, 1987.

———. *Subjectivity, Identity, and the Body: Women's Autobiographical Practices in the Twentieth Century*. Bloomington, IN: Indiana UP, 1993.

Smith, Sidonie, and Julia Watson, eds. *Women, Autobiography, Theory: A Reader*. Madison: U Wisconsin P, 1988.

Sommers, Christina Hoff. *Who Stole Feminism? How Women Have Betrayed Women*. New York: Touchstone, 1994.

Spiegelman, Art. *The Complete Maus*. CD-ROM. Voyager, 1991.

Stanley, Liz. *The Auto/biographical I: The Theory and Practice of Feminist Auto/biography*. Manchester, UK: Manchester UP, 1992.

Stepto, Robert B. *From Behind the Veil: A Study of Afro-American Narrative*. Chicago: U Illinois P, 1979.

Stinchcombe, Arthur L. *Rebellion in a High School*. Chicago: Quadrangle, 1964.

Stoll, David. *I, Rigoberta Menchú and the Story of All Poor Guatemalans*. Boulder, CO: Westview, 1999.

Swales, Martin. *The German Bildungsroman from Wieland to Hesse*. Princeton: Princeton UP, 1978.

Tanner, J. M. "Sequence, Tempo, and Individual Variation in Growth and Development of Boys and Girls Aged 12 to 16." In *Twelve to Sixteen: Early Adolescence*. Eds. Jerome Kagan and Robert Coles. New York: Norton, 1972. 1–24.

Tompkins, Jane P. *Sensational Designs: The Cultural Work of American Fiction, 1790–1860*. New York: Oxford UP, 1985.

———. "Sentimental Power: *Uncle Tom's Cabin* and the Politics of Literary History." In *The New Feminist Criticism: Essays on Women, Literature, and Theory*. Ed. Elaine Showalter. New York: Pantheon, 1985. 81–104.

Veeser, H. Aram. ed. *Confessions of the Critics*. New York: Routledge, 1996.

Walker, Alice. "Zora Neale Hurston: A Cautionary Tale and a Partisan View." In *In Search of Our Mothers' Gardens*. New York: Harcourt, 1983. 83–92.

———. "Looking for Zora." In *In Search of Our Mothers' Gardens*. New York: Harcourt, 1983. 93–116.

Wallace, Michele. "A Black Feminist's Search for Sisterhood." In *All the Women Are White, All the Blacks Are Men, But Some of Us Are Brave: Black Women's Studies*. Ed. Gloria T. Hull, Patricia Bell Scott, and Barbara Smith. Old Westbury, NY: Feminist P, 1982. 5–12.

Wang, L. Ling-chi. "Roots and Changing Identity of the Chinese in the United States." *Daedalus.* Spring, 1991: 181–206.

Washington, Booker T. *Up From Slavery.* 1901. New York: Penguin, 1986.

Washington, Mary Helen. Foreword. *Their Eyes Were Watching God.* By Zora Neale Hurston. New York: Harper, 1990 (1937). vii–xiv.

———. "'I Love the Way Janie Crawford Left Her Husbands': Zora Neale Hurston's Emergent Female Hero." In *Invented Lives: Narratives of Black Women, 1860–1960.* New York: Anchor P, 1987. 237–54.

Watson, Barbara Bellow. "On Power and the Literary Text." *Signs: Journal of Women in Culture and Society* 1.1 (1975): 111–18.

Waugh, Patricia. *Feminine Fictions: Revisiting the Postmodern.* London: Routledge, 1989.

———. *Metafiction: The Theory and Practice of Self-Conscious Fiction.* London: Methuen, 1984.

Weedon, Chris. *Feminist Practice and Poststructuralist Theory.* 2nd edition. London: Blackwell, 1997.

Weitzman, Lenore J. *Sex Role Socialization: A Focus on Women.* Palo Alto, CA: Mayfield, 1979.

White, Deborah Gray. *Ar'n't I a Woman? Female Slaves in the Plantation South.* New York: Norton, 1985.

Willett, John, ed. *Brecht on Theatre: The Development of an Aesthetic.* Trans. John Willett. New York: Hill, 1957.

Williams, Raymond. *Marxism and Literature.* Oxford: Oxford UP, 1977.

Willis, Susan. *Specifying: Black Women Writing the American Experience.* Madison: U Wisconsin P, 1987.

Winch, Peter. "Understanding a Primitive Society." *American Philosophical Quarterly* 1.4 (October 1964): 307–24.

Winks, Robin. General Introduction. *Four Fugitive Slave Narratives.* Reading, MA: Addison-Wesley, 1969.

Wittig, Monique. *Les Guérillères.* Boston: Beacon, 1969.

Wolff, Maria Tai. "Listening and Living: Reading and Experience in *Their Eyes Were Watching God.*" *Black American Literature Forum* 16 (Spring 1982): 29–33.

Wong, Sau-Ling Cynthia. "Ethnicizing Gender: An Exploration of Sexuality as Sign in Chinese Immigrant Literature." In *Reading the Literatures of Asian America.* Ed. Shirley Geok-lin Lim and Amy Ling. Philadelphia: Temple UP, 1992. 111–29.

Woodward, C. Vann. *The Strange Career of Jim Crow.* 2nd revised edition. New York: Oxford UP, 1966 (1955).

Woolf, Virginia. *A Room of One's Own*. New York: Harcourt, 1929.

Wright, Richard. *Black Boy (American Hunger)*. 1945. New York: Harper Perennial, 1991.

———. *Native Son*. 1940. New York: Harper, 1992.

Wurtzel, Elizabeth. *Prozac Nation: Young and Depressed In America*. New York: Riverhead, 1994.

Yezierska, Anzia. *Bread Givers*. 1925. New York: Persea, 1975.

Yung, Judy. *Chinese Women of America: A Pictorial History*. Seattle: U Washington P, 1986.

Index

Consigned
relegated